THE
LUMINOUS
PORTRAIT

THE LUMINOUS PORTRAIT

Capture *the* Beauty *of* Natural Light
for Glowing, Flattering Portraits

ELIZABETH MESSINA *with* Jacqueline Tobin

AMPHOTO BOOKS

an imprint of the Crown Publishing Group
New York

Photographs copyright ©2012 by Elizabeth Messina

Text copyright ©2012 by Elizabeth Messina and Jacqueline Tobin

Published in the United States by Amphoto Books, an imprint of
the Crown Publishing Group, a division of Random House, Inc.,
New York

www.crownpublishing.com

www.amphotobooks.com

AMPHOTO BOOKS and the Amphoto Books logo are trademarks
of Random House, Inc.

Library of Congress Cataloging-in-Publication Data

Messina, Elizabeth.

 The luminous portrait : capture the beauty of natural light for
glowing, flattering portraits / by Elizabeth Messina with Jacqueline
Tobin. — 1st ed.

 p. cm.

 Includes bibliographical references and index.

 ISBN 978-0-8174-0012-5 (alk. paper)

1. Portrait photography. I. Tobin, Jacqueline, 1950- II. Title.

 TR575.M565 2011

 779—dc23

 2011020989

Printed in China

Cover and interior design by Jenny Kraemer

Cover photographs by Elizabeth Messina

10 9 8 7 6 5 4 3 2 1

First Edition

FOR MY LOVING HUSBAND & OUR THREE BEAUTIFUL
CHILDREN, WHO MAKE MY LIFE SIMPLY LUMINOUS

—ELIZABETH

CONTENTS

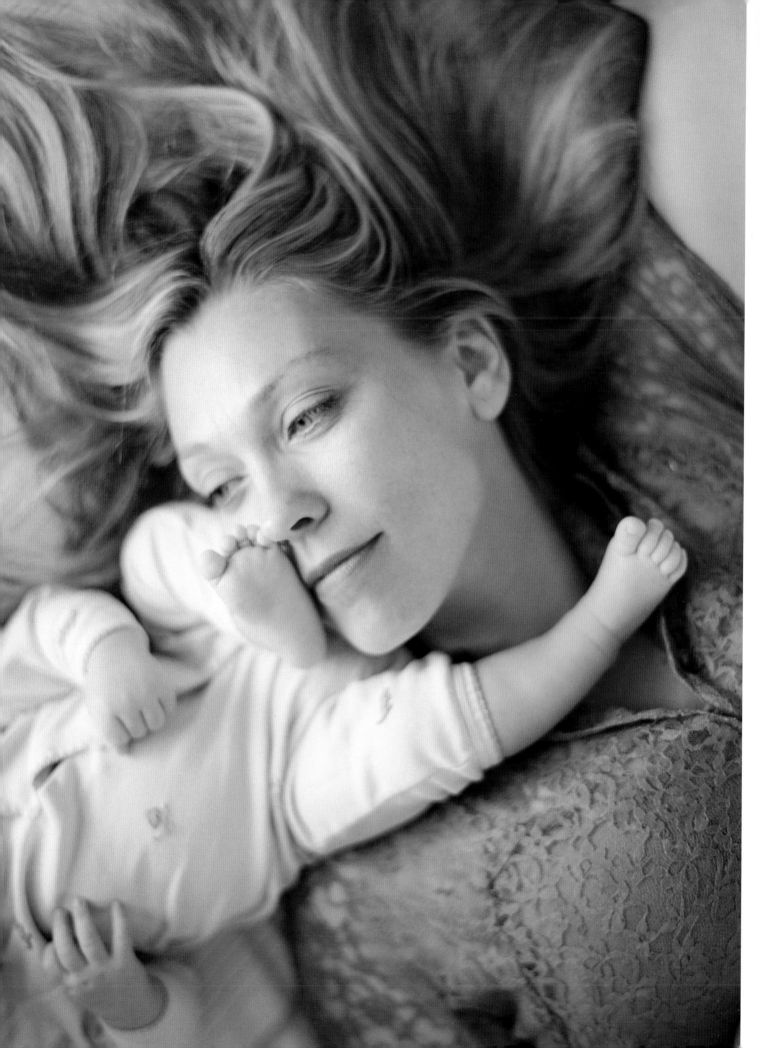

FOREWORD

I first met Elizabeth Messina at the wedding reception of Tori Spelling and Dean McDermott in Los Angeles. At the time, I was in the early stages of pregnancy with my first child, and apart from my husband, Elizabeth was the first person I told, despite her being a complete stranger to me. This is the immediate effect she has on people: You instantly get the feeling that this is a woman you can trust with your deepest secrets and your biggest joys. Many months later, I hired her to take my pregnancy photos, and since then she's worked with me on several magazine shoots, has photographed my family repeatedly, and has become one of my closest friends.

Beyond being a dear friend, Elizabeth is also an exceptional photographer, her success due partly to how well she relates and responds to others. She possesses an innate sense of how to work with natural light and expose film in a way that gives her images a uniquely luminous quality. By working with fixed lenses, she's forced to work up close with her subjects—something she loves to do—and to physically move with and around them, creating truly intimate images. Because she's working with film, she can create wonderful little breaks during the shoot while she or one of her assistants reloads the camera. This is a special time for Elizabeth, when she might happen upon an unguarded moment or an introspective glance from her subject that emerges naturally. All these elements are inherent in an Elizabeth Messina shoot, creating a sense of oneness between herself and her subject as they work together in a graceful collaboration that ultimately results in an image reflecting the subject's innermost beauty and, more importantly, true self.

Which brings me back to that first encounter with Elizabeth. Right then I knew that a very special person stood before me, someone who effortlessly brings out the beauty in other people. This is ultimately why Elizabeth's photographs glow. When I look at the portraits she has taken of me over the years, I feel she's captured a little piece of my heart. Her photographs convey what I look like when I'm living fully in the moment, when I've let go of all my sorrows and worries and there's pure joy radiating from my soul. This is what Elizabeth creates with all her subjects and what, in addition to her exceptional use of natural light, sets her apart. Elizabeth's images elicit a visceral response because they are created with love and light. This is the mark of a true artist.

—Ulrica Wihlborg
West Coast Weddings Editor, *People* magazine

Sweet Ulrica with her newborn son. (Every mother has feet in her face at some point!) The bright warm light came in through a window on a sunny afternoon.

Contax 645 with 80mm Zeiss lens, Fuji 800 NPZ film, f/2 for 1/60 sec.

INTRODUCTION
PHOTOGRAPHY: A LOVE AFFAIR

I fell in love with photography at the tender age of twelve. I was a tangle of awkward limbs and unspeakable shyness as my words often found it difficult to leave my mouth. Then my mother gave me a camera for Christmas, a Nikon FE2, and I was instantly intrigued. The moment I held that camera in my hand, I longed to be a photographer, though without the faintest idea what that entailed. Thus began an intense love affair that would unfold throughout the course of my life, and continues today, with no end in sight.

Portraiture quickly became my genre of choice, as my first attempts at photo shoots were of my friends, whom I instinctively directed and styled without reserve, always in natural light. After applying copious amounts of makeup to their faces, I'd ask them to sit in certain places and turn their heads this way and that. At the time, I had no idea what I was doing, and I was taking just awful photos, but I loved every minute of it. Unfortunately, I didn't have anyone I could turn to for guidance as my passion for photography grew deeper. My entire family (with the exception of a concert violinist grandfather) was made up of traditionally educated professionals, mostly lawyers. It wasn't until my third year of college that I took an elective photography class—and when I did, it was as though the clouds had opened up and light poured into my heart. There was a name for what I wanted to be: a photographer. Although my plan had always been to go to law school, the trajectory of my life changed forever as I became more and more immersed in photography.

I subsequently dropped out of college (unbeknownst to my parents) and applied to the San Francisco Art Institute (SFAI). I can still remember the day I drove by myself to San Francisco to drop off my application and portfolio, and then walked back to my car and burst into tears. I was so full of hope and so anxious to be a photographer, but I was certain I wouldn't be accepted. I had jumped off a cliff, figuratively speaking, and did not know where I would end up.

Luckily, I was accepted into SFAI's photography program and the rest, as they say, is history. While in art school I earnestly developed my own film and prints under the glow of a red light while surrounded by other creative people who shared my passion. It was everything I'd longed for. The more I learned, the more I was enraptured with natural light and images. To this day I remember being inspired by legendary photographers like Henri Cartier-Bresson, Sally Mann, and Julie Margaret Cameron, as the language of photography opened my heart and made me hungry for more.

A room filled with floor-to-ceiling windows gave me the perfect light to capture this beautiful girl's steady gaze. The ambient light lit up not only her face but also the lace detail of her dress.

Contax 645 with 80mm Zeiss lens, Fuji 800 NPZ film, f/2 for 1/60 sec.

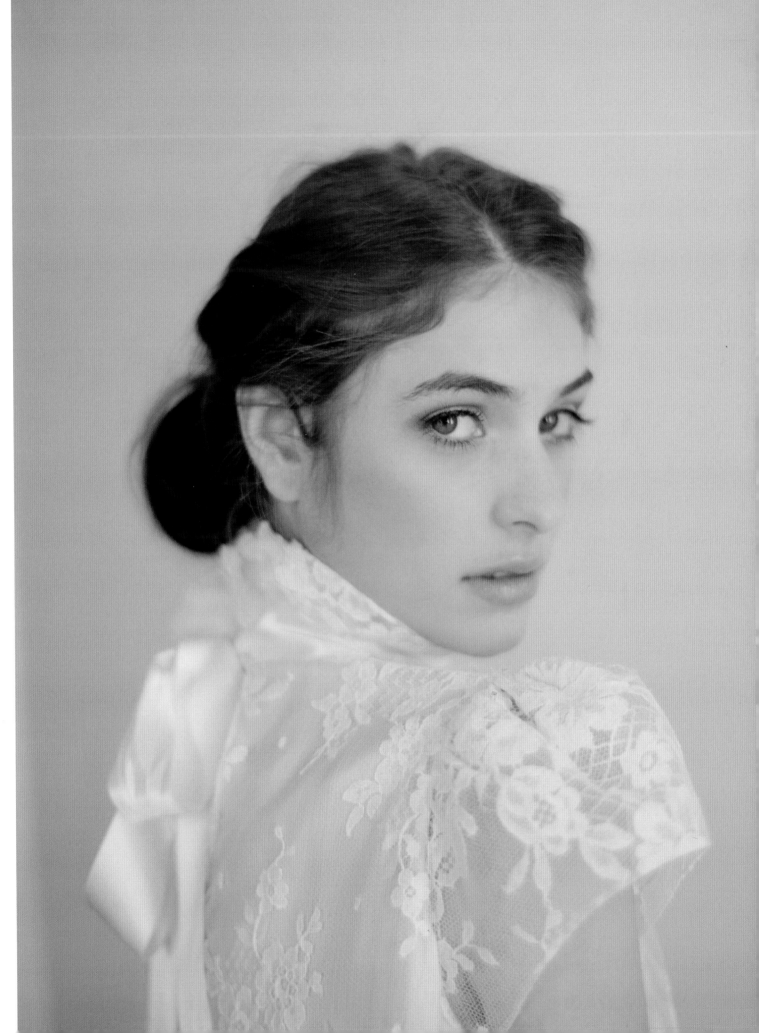

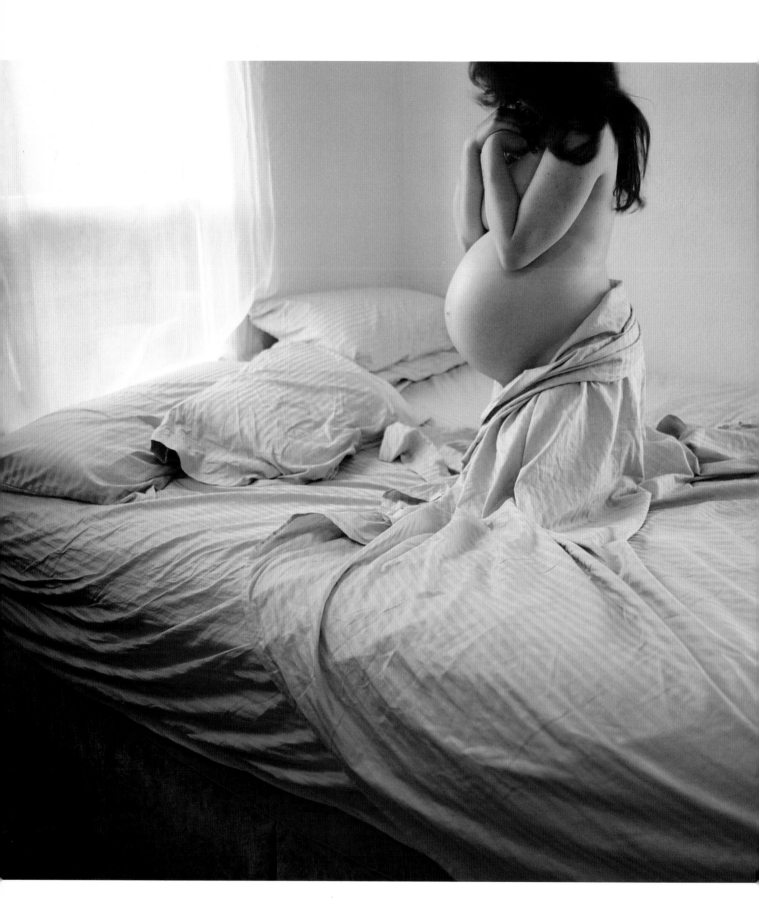

After graduating from SFAI with honors, I still felt somewhat lost, afraid to become a full-fledged photographer. I was an adult, yet a bit of that shy, twelve-year-old girl remained inside and I didn't know what to do next. I waited tables, saving my tip money to buy film and conduct photo shoots (again, of my friends in natural-light situations). In fact, I photographed all the time. I carried my Nikon FE2 on my shoulder everywhere, always prepared if I saw something I wanted to photograph. I think this helped develop my eye and my ability to frame shots and respond quickly. It was also during this time that I fell in love with a boy. He invited me to bicycle cross-country with him, so I did— I followed him across the country, camera and heart in tow. I cannot fully explain how much this contributed to my ability to see and to work in different natural-light situations and settings. I had a little bag attached to my handlebars that was just big enough to hold the camera my mom had given me.

One of the best ways to learn about light and photography is to take self-portraits. I made many, many self-portraits during my time at the SFAI. When you are creating images of yourself, you can take your time figuring out the light and how you want to set your camera without a client waiting and wondering what you are doing. It is best to have a tripod, but you can also use a dresser to strategically support your camera. This image was taken the day before the birth of my third child. I cleared out my bedroom so all that was visible were my sheets, pillows, and a window. I had my nine-year-old daughter sit where I intended to be and focused on her (you can do the same thing with an inanimate object). After I had my focus where I wanted it to be, I set up my favorite camera (a Contax 645 with an 80mm Zeiss lens), mounted it on my tripod, set the exposure to f/2 for 1/60 sec., set the self-timer, made my way over to my bed with just enough time to pull the sheet around me, and voilà, a self-portrait at nine months' pregnant. Self-portraits are a wonderful way to expand your knowledge about yourself, your camera, and the light all around you.

Contax 645 with 80mm Zeiss lens, Kodak Portra 400CN black-and-white film (printed sepia), f/2 for 1/60 sec.

13

For the next three months, I photographed my way across the United States, developing my eye, my perspective, and an ability to respond to the ever-changing light along the way. When we reached our destination, I took a job as a staff photographer for a newspaper in Vermont. I can still recall being on assignment and having very little information or time to get a photo, yet it still had to be unique and tell a story. Eventually, my newspaper experience evolved as my relationship with the boy ended, but both were invaluable in getting me to where I am today.

Working for the newspaper was a wonderful experience until I became a news story myself. One winter night, there was a loud banging on my door and I awoke to discover that our apartment was on fire. My roommate and I ran through a fiery hallway to safety. Everyone in the building survived, but we stood helplessly by as our home burned to the ground. I lost every piece of work, every photograph, every negative that I had created up to that point—more than ten years of work in all—and barely escaped with my life. Luckily, the coat I was wearing had two rolls of film in the pocket, and because I had fallen asleep with my camera (I literally had it with me all the time), I was able to photograph my house burning down, destroying everything I owned.

There I was, at the ripe old age of twenty-five, with virtually nothing left. I journeyed to India—one of the most exotic, magical, faraway places I could think of at the time—with just me, my camera (still the one my mom had given me), and 150 rolls of film. I traveled through India for six months, and although I was at times afraid and uncertain, I was also inspired by and in awe of such a completely different environment. India took me outside my comfort zone, which is incredibly important for a photographer. The experience made me see differently, pay attention, and engage more with whatever I was shooting.

At this point you may be wondering what any of this has to do with taking portraits using beautiful, natural light. My answer is this: absolutely everything. Everything I've experienced up to this point (dropping out of college, biking across the country, heartbreak, a devastating fire, traveling to India, and more) has helped define who I am as a woman and a photographer. The

two constants since I first held my Nikon at age twelve have been natural light and photography, and all of my subsequent experiences have influenced my art. I think this is true for all photographers, whether they are aware of it or not.

I like to push the boundaries of portrait photography, even "massage" the definition of what a portrait is. The literal definition of *portrait* is "to display the likeness, personality, and even mood of the person." Every time I shoot a portrait, I strive to achieve an emotional response within both my subjects and my viewers. The first images I submitted to SFAI with my application were close-up portraits of a female friend as she acted out different facial expressions. I received an A in my first photography class for those images, and they helped me get into art school. (Sadly, those photos were destroyed in the fire.) My first love has always been portraiture, which I've incorporated into almost all my work in one way or another, whether editorial, weddings, or lifestyle and family.

There are several components that make up a beautiful, luminous portrait, including how you interact with your subject, composition and balance, finding the perfect moment and location, and, of course, the light. When I create a photograph, I seek to capture that sweet space where art and life merge in a moment bathed in natural light.

This is what I see every day when I walk into my studio: a mélange of personal photos and inspiration. I think it is important for every photographer to create a special space to work in, even if it's just a little desk in the corner. When I walk into my space and see my board of images, I feel happy; it is a place I always want to be.

Contax 645 with 80mm Zeiss lens, Fuji 800 NPZ film, f/4 for 1/60 sec.

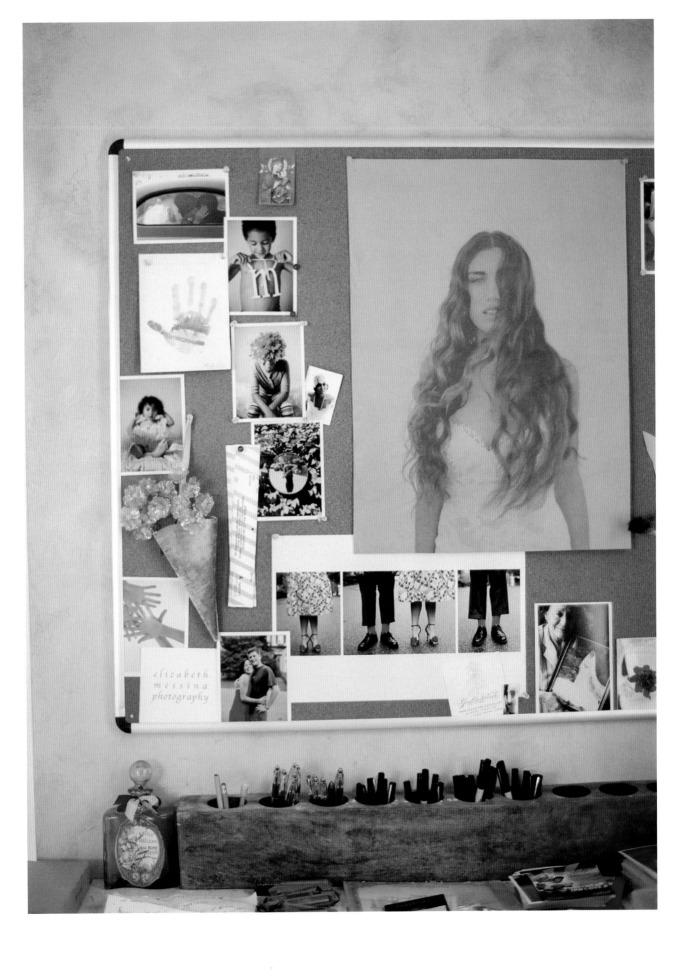

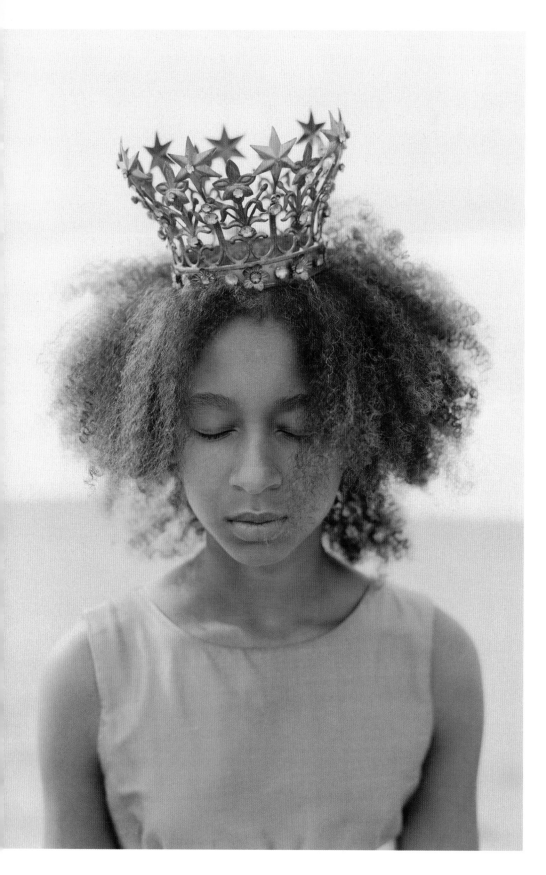

I have been working on a series of crown portraits for the past several years. This image of my daughter Mykela was the first crown portrait I ever made. I placed the crown that had been on my wedding cake upon her head and the series began. This photo was taken on a semicloudy day on the beach.

Contax 645 with 80mm Zeiss lens, Kodak Portra 400CN film (printed sepia), f/2 for 1/60 sec.

The lighting choices I make in every image help me convey a mood or feeling. I want my viewers to pause, catch their breath, reflect, remember, dream. When I fell in love with photography, I learned with film and natural light, so the two are irrevocably intertwined for me. To this day I remain a passionate film photographer who shoots primarily with available light (although I do own and am quite capable of photographing with digital cameras). Many budding young photographers today fall in love with photography while learning with digital cameras. Other photographers who learned with film still develop a love and affinity for digital cameras and images. I wholeheartedly support and respect all photographers. The light is all around us, ready to illuminate your final images, no matter what equipment you use.

I tend to not use a lot of technical jargon when I talk about lighting, and my kit is very minimal. Quality portraiture is about seeing, first; equipment, second; and creativity, third—a philosophy I hope to convey in every page and image of this book. Almost every

photo you will come across was shot with one camera, one lens, and, for the most part, very little variation of aperture and exposure. I almost always expose for the shadow, which results in the lighter parts of the image being even more illuminated and glowing.

In the beginning chapters, I emphasize how important it is to know your equipment as well as to find your own style and vision to keep your images authentic. Once you discover the lighting choices that exist in nature and how they can be used within an image, then you can start experimenting, incorporating reflectors and scrims if you so choose to bounce or diffuse the light to create mood or tone. In later chapters, I apply what I've discussed to specific genres, including boudoir and maternity, children and babies, celebrities, and weddings. Once you develop a signature style, you will not only establish yourself as a certain type of photographer but also be able to define your success by building a client base, getting published, and marketing your imagery in your own unique way, which I explain in the marketing-oriented chapters near the end of the book.

Our cameras are extensions of our eyes, and the light we choose is the heart of our images. My love affair with photography is passionate and ongoing, and while I still have hard days, with challenging shoots and images that don't work, I also have moments of great joy and revelation. My devotion to photography will continue as long as I have eyes to see the beautiful qualities of life and light around me. I hope you find some inspiration throughout the pages of this book. May you be blessed in your pursuit of photography, may you always follow your dreams, wherever they may lead, and may your images be as luminous as your heart.

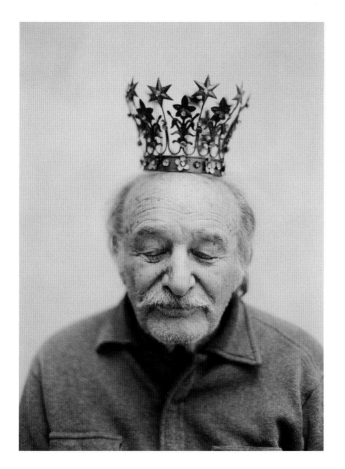

This portrait of Stephen Hahn is another image from my "Crown" series. It was a cloudy day, with gentle, even light surrounding his Santa Barbara home. To me he is, and will always be, a king.

Contax 645 with 80mm Zeiss lens, Kodak Portra 400CN film (printed sepia), f/2 for 1/60 sec.

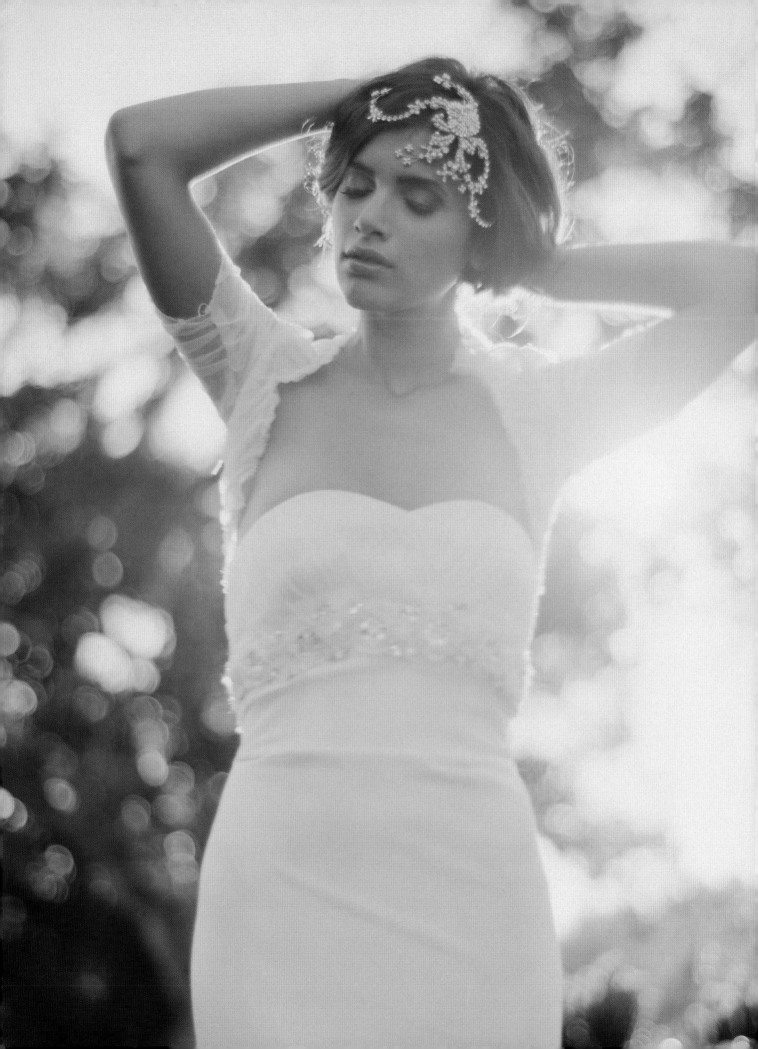

An Inspired Vision

This image was created with the late afternoon sun directly behind the model. Everything about her look and the feel of the image is soft—from the style of her dress to the gentle way her hands are lifting the hair off the nape of her neck. The light is slightly diffused by trees in the background and is also blocked by her left arm. I knelt down so that I could use her arm to block the brightest light from overwhelming my frame. I also exposed for the darkest point (the shadows on her face), resulting in a soft, ethereal image.

Contax 645 with 80mm Zeiss lens, Kodak Portra 400CN black-and-white film (printed with a sepia tone), f/2 for 1/60 sec.

Photography is the language of memories. Its ability to capture a glimpse of time with a fragment of light is truly extraordinary. Every image is a tangible piece of history you can hold in your hands and reminisce over again and again. The art of photography has always moved and inspired me, and it is the combination of natural light and film photography that are the most powerful instruments for my creativity. The beauty of natural light within an image is sublime and full of possibility. Film allows me to slow down and be fully connected to my surroundings, to my subject, and to the light.

With every portrait I create, my intention is to create stirring, meaningful, and luminous images that will linger with and inspire others. After I assess the light, I take into account everything else that can influence my craft—the color of the sky, a good meal, my children snuggling with me in the evenings. These are the unexpected inspirations that I express and share in my images. As you grow and develop as a photographer and look for inspiration, be sure to utilize the most important source of creativity: yourself. Do not limit yourself by only looking at other photographers. Instead, examine your own life: What are you drawn to? What light do you prefer? What is your personal style? The only truly unique element you can bring to your photographs is yourself.

All photographers have a point a view that they can combine with natural light. The goal is to balance your own creativity with an awareness of the light and the presence of your subject. As you read through this book, you will discover time and time again that if you learn to use and expose natural light, master your equipment, and develop a good rapport on shoots, you can count on the light to wrap around your subjects and create truly stunning images every time. Your inspiration comes from what is in front of you as well as what is in your heart. Inspired images come from careful preparation and knowledge of light and equipment, combined with your artistic perspective. Let's look at each of these elements and how they contribute to a creative, inspired vision.

Why Natural Light Is Best

Gentle, even light from a nearby window illuminates Ashlyn Pearce's face as she holds a flower. The light source is at the left of my frame and casts a subtle shadow on the right. I exposed for the darkness within the shadow, which gives the image an overall "light" feeling.

Contax 645 with 80mm Zeiss lens, Fuji 400 NPH film, f/4 for 1/60 sec.

Over the years, I've been able to master the art of creating luminous portraits by merging the abundant natural light in our world with the light that exists within every human being. Keep in mind that whenever I talk about natural light I'm sharing a personal choice, discussing what works best for me. Ambient light has a softness and an ability to almost caress a subject and make anything and anyone more beautiful. When I'm taking photographs, I'm seeking out the natural beauty in everything around me: the light, the subject, a natural emotion. I always strive to capture something authentic, and to me natural light innately possesses that quality. It resonates with and envelopes its subjects, allowing their natural beauty to emerge, as opposed to bringing lights into a shooting situation to create the feel of what already may exist in an environment. When it comes to making beautiful images, I find it incredibly satisfying to use what is already there.

One suggestion for using natural light during a shoot that may sound very elementary is to make sure any bright light source (i.e., the sun) is *behind* or *to the side of* your subject. This way you won't have issues with your subject squinting or being unable to look at you. And more importantly, when you put the light behind (or to the side of) your subject and expose for the shadow (with her face in shadow, since the sun is behind her), you will get a luminous feel, with an overexposed background and an open, light aesthetic. It's a very flattering effect and allows you to use sunlight to create almost a halo around your subject. It is also important to make sure there is ambient light on your subject's face. You can do this whether you are near a window, in open shade, or sometimes by using a reflector.

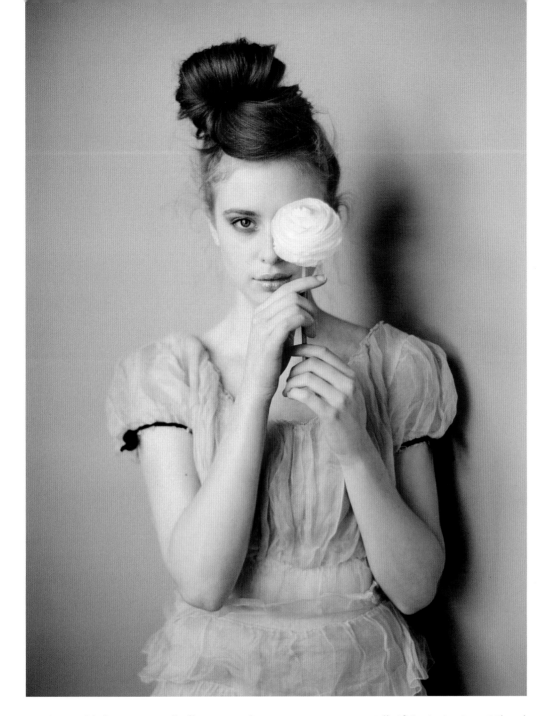

Natural light is especially flattering when you use a wide aperture to create a shallow depth of field. A low f-stop helps create a softer, more luminous image. If you set your camera to f/2 and you focus on someone's eye, for example, the rest of the image will soften up—the background, even other parts of the face. This shallow depth of field helps accentuate the impact of your image.

You can be a natural-light shooter under any circumstances, even the intense pressure of a magazine shoot. Most of my work, including the magazine covers I shoot, is done in natural light with film. On some jobs I use reflectors and/or scrims to balance out the light, es-pecially if I'm trying to get the clean, clear look of a cover shot (as well as some of the more atmospheric images for which I've become known). For example, if I have a subject in front of me and the light is slightly behind her or to the side, I will have an assistant stand next to me with a white reflector to bounce that sunlight back toward the subject. It's much less intense than if she is facing the sun, so by bouncing it, you still get a little more light on the face but you won't have that extreme glare that you would have if the sunlight were directly in her face. It's a more gentle effect, and the bounced light still fills the skin tone with a little more light.

Variations on the light from an ever-changing sky. My biggest advice about light is this: Get outside and familiarize yourself with the light around you. Go for walks in your neighborhood at different times of day, and observe and photograph. Photograph the sky. I find that shooting the sky adds a sweet element to any photo shoot. I love to include a sky shot for a wedding couple so that they always know what the sky looked like on the day they exchanged vows. For any portrait, shooting the sky is a way to remember the feel of the day, or a specific moment in time.

Contax 645 with 80mm Zeiss lens, Fuji 400 NPH film, f/4 for 1/125 sec.

For groups and couples that I shoot outside, I love to use backlighting or open shade. I avoid dappled lighting, since that can be uneven and more challenging to work with. Flat, softer light is more flattering and ensures that everyone is lit more evenly. My aperture varies a little when I am photographing a group. This is basically the only situation in which I will stop down to f/5.6. I do this with a group of people to ensure that everyone will be in focus. Although I still expose for the shadows within the frame, setting my camera at f/5.6 gives me a more traditional portrait. The majority of my images, however, are created with my aperture at f/2. This setting gives me a very shallow depth of field, which is one important factor in why my images feel luminous and soft. The other critical factor is how I expose for light. It is this combination of f-stop and exposure that defines most of my work.

Opposite: Trees within a wooded area in France provided plenty of shade for me to compose this image. Although the models are completely in shade, there was still plenty of abundant light around them.

Contax 645 with 80mm Zeiss lens, Ilford 400 XP2 film, f/2 for 1/60 sec.

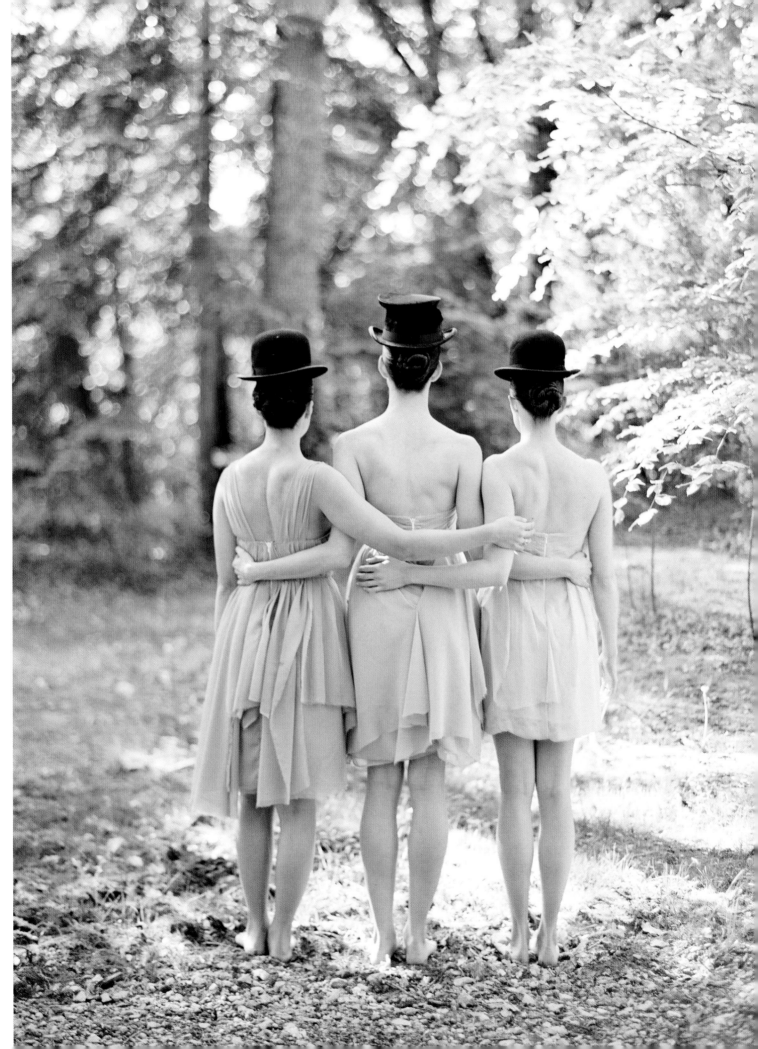

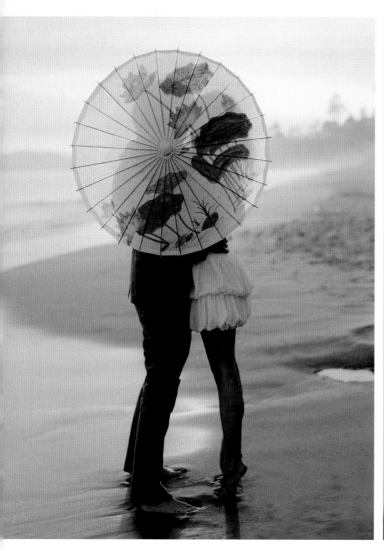 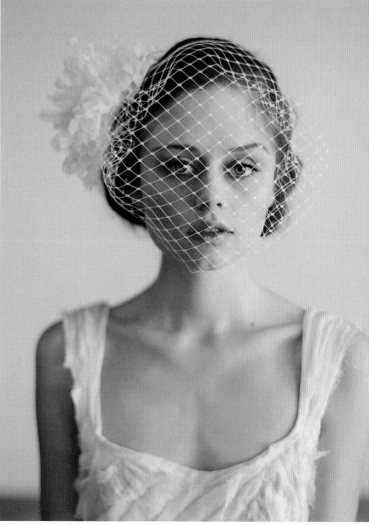

This image was taken on the beach, just as the sun was setting after a full day of working on an editorial assignment. I only had time for a few more shots, so I took the opportunity to create this intimate shot by having the couple hide behind an umbrella. This accomplished two things: First, it created a feeling of intimacy, as though they were sharing a secret, or a kiss, and second (and more important), as the sun went down, its warm last glow was caught in the frame of the umbrella. I love the warmth of this shot, both in the couple's posture and the hue of the light around them.

Contax 645 with 80mm Zeiss lens, Fuji 800 NPZ film, f/2 for 1/60 sec.

This portrait was made in a large warehouse in Portland, Oregon. There were two walls full of windows, which provided ample natural light. I focused on the model's eyes and exposed for the shadows.

Contax 645 with 80mm Zeiss lens, Fuji 400 NPH film, f/2 for 1/60 sec.

Opposite: This couple was practicing the traditional postnuptial carry in a Southern California park. I love how the moment is between them and yet still includes me (conveyed by the way she smiles over her shoulder at me). This fall afternoon was beautiful; the sunlight was diffused by the trees around them, so it wasn't too harsh. This same image was used as a cover for the lifestyle magazine *805 LIVING*.

Contax 645 with 80mm Zeiss lens, Fuji 400 NPH film, f/4 for 1/60 sec.

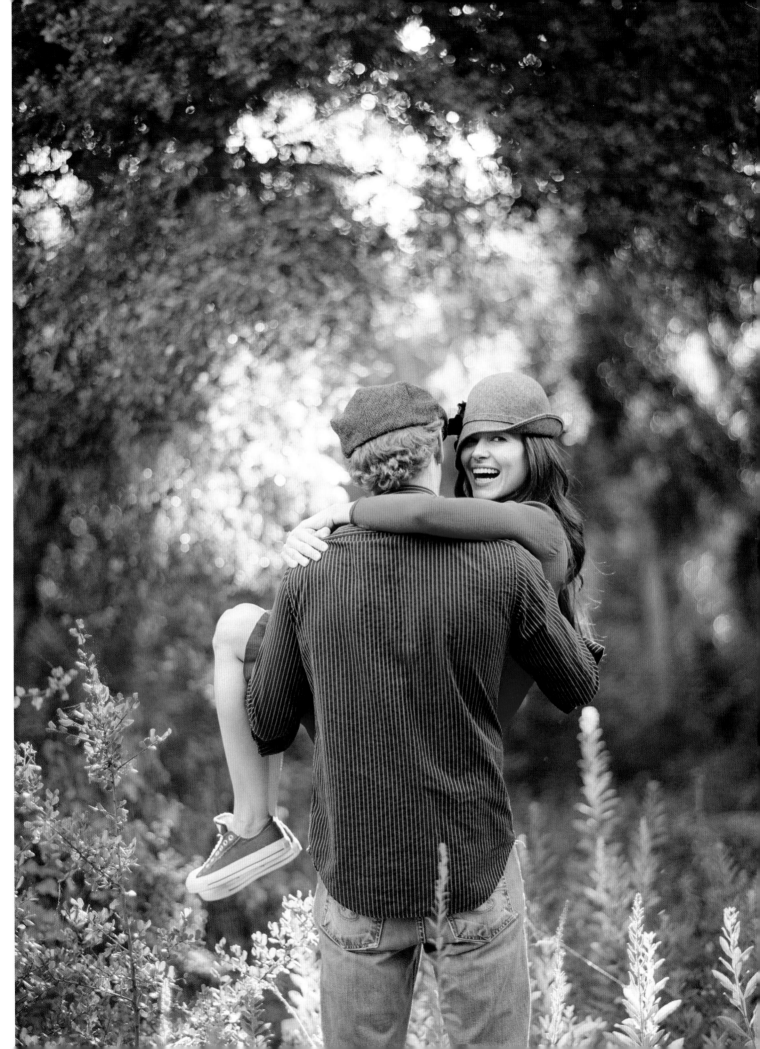

Know Your Equipment

The single most important factor for any photographer is experience. Get experience holding your camera and making images (and mistakes). It is essential to become comfortable and confident with your tool, no matter what type of lighting you use. You can't go to a shoot with a paying client and wing it. Educate yourself, read photography books, take a class if you can, and take lots of pictures—you have to get your hands dirty.

My camera is a catalyst connecting me to my subject and the light. Every time I load my film, I feel inspired and ready for the process to unfold. Your camera is an extension of your eye, and you must thoroughly know and understand its capabilities. As an artist, I chose a camera that best fits my personal aesthetic; I encourage you to do the same. In the beginning, this may seem rather daunting, as there are many things to consider when choosing from among all the options out there on the market. The only way to figure it out for sure is through research and trial and error. If you are in school, there may be cameras available to use through your photo department. If you are not in school, try your local photo store. Many stores have rental cameras available. You can also scour the Internet for information and ask your friends or other professionals for advice. There is nothing, however, that matches the experience of holding a particular camera in your hand. You need to determine if you like the weight of it, the sound of the shutter, the format you see through the viewfinder, and so on.

I own and use several different cameras, but my camera of choice is my Contax 645 with an 80mm Zeiss lens. It is a little heavier than a classic 35mm camera, and the shutter is a bit louder than I'd like, but the quality of the images it produces is so amazing that I am willing to overlook these things. I was only able to come to this decision, though, after using it and several other cameras. I made an educated decision after years of trial and error. Do not feel frustrated if you have a hard time feeling comfortable and fluid with your camera. As you spend more time with a particular camera, playing around with the buttons, before long you'll know how to work it without even thinking. Now

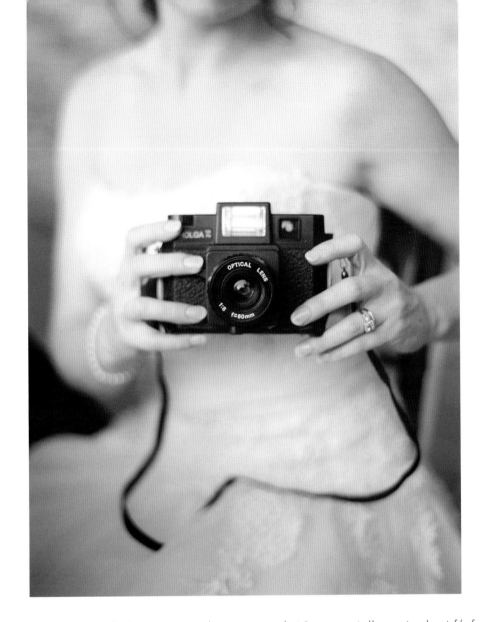

A camera is just a tool. You are the most important component in any image you create, and you are in control of the framing, the exposure, and the perspective. You can shoot with the fanciest digital camera available or a plastic Holga (pictured here). Experimenting and learning about different cameras is a wonderful way to find out what your tool of preference is. This was taken at the end of the day and depicts a bride having fun with her Holga. I love the way her white dress frames the camera.

Contax 645 with 80mm Zeiss lens, Fuji 800 NPZ film, f/2 for 1/60 sec.

when I shoot, I feel so in sync with my camera that I can be fully present in the moment. I can interact with my client, assess the light, set up my frame, and move fluidly. My camera and I are bound by so many moments and shutter releases, we are one while I am on a shoot. My camera allows me to share the secrets of my heart, and in time yours can, too.

In the beginning, it is important to take a light meter with you. While you take readings, look around and pay attention to the light, too, so that you can develop your eye and not always have to rely on a meter. For example, let's say the light reading tells me I should be exposing at f/4 for 1/250 sec. Knowing my personal preference for overexposure, I might stop down to f/2 for 1/125 sec. and overexpose the image a little. When you are starting out, it makes sense to shoot what the light meter says and then play off it. So if the light meter

tells you to shoot f/4 for 1/250 sec., try going down to 1/125, then down to 1/60, and then even handhold at 1/30 to see what happens. This way you will be able to see where your sweet spot is when it's really working for you. And once you start getting more comfortable and see what shooting at f/4 for 1/250 is like, you might decide you prefer how the image looks at f/4 for 1/60, and so on. Experiment again and again until you know where you like to be. At the next shoot, you will have a better understanding of light as well as more creative freedom and range.

Before you find yourself on a shoot with all the pressures of performing, do your homework and take the time to meter and experiment with your camera. Get a friend or family member to pose for you so that you can thoughtfully slow down and experiment with exposure to get what you want every time.

Elizabeth's CAMERA BAG

Cameras and Lenses

Contax 645

This is my favorite camera. It is a large-format camera that performs like a 35mm camera. It takes 120 film; I love the large negatives. I always bring at least three of these cameras to a photo shoot.

I have two favorite lenses for this camera:

- An 80mm F2.0 Zeiss lens. Most of my images are created with this lens. The glass is absolutely beautiful, and I love that the aperture goes down to f/2 (I never use a lens slower than that). The focal length of this lens on the large-format camera is comparable to a 50mm lens on a 35mm camera. (I also use an extension tube with my 80mm lens from time to time, which converts this lens into a macro lens.)
- The 45mm F2.0 lens. This one is great for small spaces and large groups. Although I do not use it as often as my 80mm, it is an essential part of my gear.

Widelux

This is a vintage, fully mechanical swing-lens panoramic camera first developed in Japan in 1948. The lens actually moves from left to right when you take a photo. It requires no batteries. Mine is a 35mm camera and takes 35mm film.

Polaroid SX-70

I love Polaroid cameras—they provide a wonderful accent to any photo shoot. I encourage you to have at least one "fun" camera in your bag to help stimulate your creativity.

Fuji Instax

I love this new Polaroid, which is made by Fuji and gives you beautiful miniature Polaroid images.

Insight

I prefer to use fast film and rarely shoot anything under ISO 400. I like having as much freedom and versatility with my film as possible, so it's usually 400 or faster.

Holga

Again, I love to have a simple artistic option in my bag. This is a very inexpensive camera and a wonderful option for any digital shooter interested in experimenting with film.

Film

Color

My favorite color film is Fuji 400 NPH, which I use most of the time. It has beautiful luminosity and tonal range. I usually have a minimum of one hundred rolls of 120 film on hand at any photo shoot, as I never want to run out. I also bring a few rolls of 35mm for my Widelux camera.

In addition, I bring a few boxes of Polaroid film, which I get from the Impossible Project (www.impossibleproject. com), a company that began making Polaroid film after it was discontinued a few years ago.

Lastly, I use Fuji Instax film for my Instax camera, which is so much fun even my children enjoy taking pictures with it.

Sepia

For sepia images, my film of preference is Ilford XP2. This is a black-and-white film that is processed with C-41 color film

This image was created in Golden Gate Park with a Widelux camera, which has a long, narrow, horizontal frame. To properly balance the image, the girl needed to be slightly more in the right-hand part of my frame. The overcast but fairly bright day gave me the perfect light for this photograph.

Widelux, Kodak Portra 400CN film, f/4 for 1/125 sec.

chemicals. There is no visible grain, and it prints in sepia beautifully, although you can also make black-and-white prints with it. I have at least fifty rolls of this film in 120 in my bag at all times, along with a few rolls of 35mm for my Widelux.

Black and White

For artistic, grainy black-and-white images I use Ilford 3200. This film is perfect for low-light situations, and provides a classic black-and-white result. I love the visible grain; it is a perfect balance to my color and sepia images. I usually carry about fifty rolls of this film in my bag.

Miscellaneous

Batteries

These are among the most important items in my camera bag. My Contax 645 takes 2CR5 batteries, and I carry no fewer than ten batteries in my bag at all times, sometimes as many as twenty if I am at a destination job. I learned early in my career never to run out of batteries. At one of the first weddings I ever shot, I had my Nikon FE2 (yes, the one my mother got me when I was a little girl) and only the battery that was in it. The battery died during the reception. In a panic, I called

several photographer friends. Luckily, someone answered and I sent my assistant to get a battery for me. In the meantime, I pretended to shoot until she got back. Needless to say, I never, ever went to a wedding again without extra batteries.

Backup Camera

If you only have one camera, consider renting a backup camera for a shoot. If you can't rent one, borrow one from a friend. Being prepared for the worst possible situation, such as your camera not working, is part of being a professional photographer.

White Reflector

I always have a white reflector with me. It is a perfect addition to any portrait shoot. My assistant will use it to bounce light back toward my subject, or sometimes as a shield, to protect my camera from excessive glare.

Umbrellas

I have two umbrellas on hand—they are useful when you have unexpected rain. I'll have my assistant shield me with one umbrella and let my client use the other for cute photos in any weather.

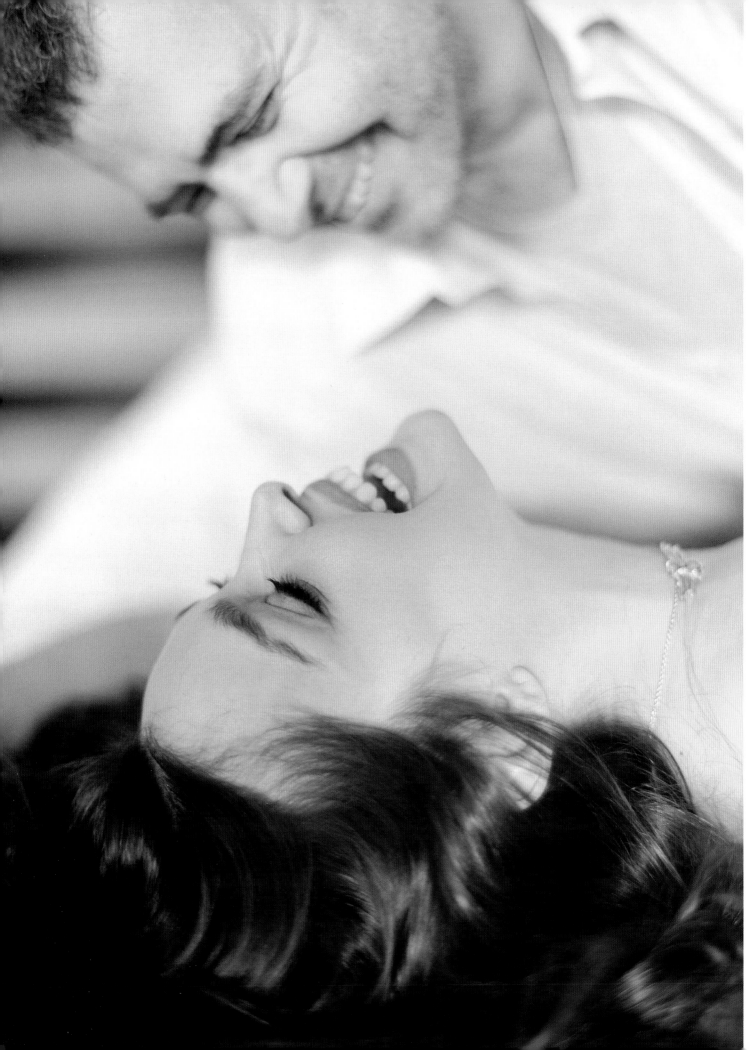

The Parameters of a Shoot

I smile every time I see this image. It was taken during an engagement shoot with a wonderful couple, Gina and Lee. They were lying on a bed near a wall of windows, where the available light was truly abundant. We had taken several intimate, quiet images of them embracing, and they just started laughing. It was such a real and beautiful moment, full of love and light. Since the light was so bright, my camera was already set at f/2 for 1/250 sec., so I was able to capture the moment and their laughter with relative ease.

Contax 645 with 80mm Zeiss lens, Fuji 400 NPH film, f/2 for 1/250 sec.

When you have all the practical issues in order—knowing your equipment, knowing what exposures work best, and so on—only then can you be really creative. Creating a comfortable, safe space at a photo shoot is another part of that process, an essential tool for capturing inspired, authentic portraits. The calmer and more aware you are, the easier it will be for your subject to relax and connect with you. Only when I feel comfortable with all these things can I allow myself to be inspired, as well as to inspire the subject to be more comfortable—to get a girl to jump in her wedding dress on her bed, to get a model to lie in the grass, to get a baby to look right at the camera even though he or she has been shy all day. Pulling out that inspiration makes a shoot your own.

If you are photographing a child or making a family portrait, for example, you want your subjects to feel as if it's just another day in their living room or the park rather than an involved undertaking with big lights and lots of equipment and people. I find that the more natural a shoot is, the better your chance to really connect with and capture something authentic and natural from your subject. I'll sit and play with the child and let him look at and even touch my camera. I want him to feel at ease and comfortable in his environment. When I'm shooting a pregnant woman, it is crucial for her to be both physically and mentally comfortable, so I often prefer to do these shoots in her home. Natural light enables you to work in a variety of locations while creating special, timeless images. The less overwhelming my presence as a photographer is, the more I can concentrate on beautiful light and eliciting something natural from the subject.

This beautiful model wanted to take a break during a shoot in France, but I continued to shoot. It is often these in-between moments that are truly wonderful to capture. This image has a balance of light and dark tones. This day was overcast, and the antique stool was as dark as the trees behind her. The darker tone helps ground the image and also creates a little contrast so that we can see the smoke leave her lips.

Contax 645 with 80mm Zeiss lens, Ilford XP2 film, f/2 for 1/125 sec.

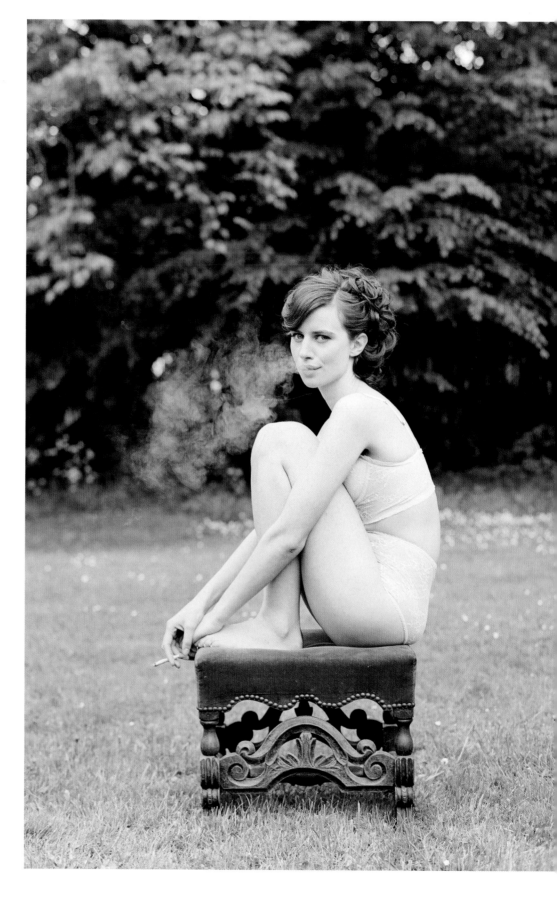

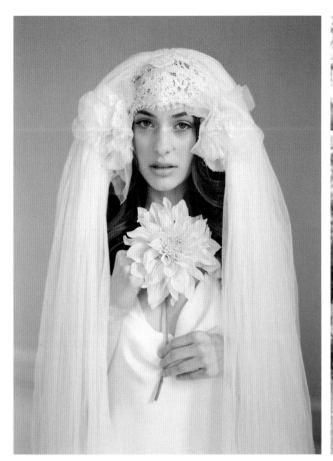

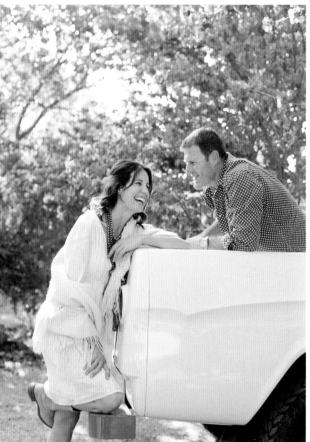

While shooting for an amazing French designer (Delphine Manivet) in New York, I had to strike a balance between capturing this lovely veil and my desire to use the flower in the shoot. I think this image is successful in showcasing the veil for a couple of reasons: First, we were in a beautiful space with amazing floor-to-ceiling windows, and although the day was a bit overcast, there was still plenty of gentle light coming through the windows. Second, the pale peach dahlia is similar to the model's skin tone and the color of the walls. And the light worked really well with the pale color palette. This is something I love to create, a color image with very little color. I focused on the model's eyes, with my camera set at f/2 for 1/60 sec. The end result feels timeless.

Contax 645 with 80mm Zeiss lens, Fuji 400 NPH film, f/2 for 1/60 sec.

This was done on assignment for *Santa Barbara Magazine*, and I had the opportunity to photograph amazing floral designer Mindy Rice with her husband. It was a long day with lots of different setups, and then they shared a moment while he sat in the back of their pickup. It was a beautiful sunny afternoon, with the sun behind them (and a little to the left of my frame). I had my assistant directly to my right bounce a little light back toward them with my white reflector.

Contax 645 with 80mm Zeiss lens, Fuji 400 NPH film, f/4 for 1/125 sec.

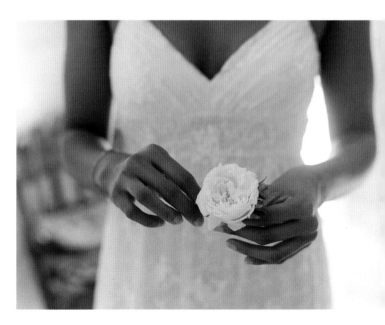

This is a lovely shot of a woman getting ready on her wedding day. Her hands are so beautiful, and as she held a single flower to put in her hair, sunlight filled the bathroom where she was getting ready for her walk down the aisle. When I saw her hands holding the flower and the light around her, I asked her to hold still just for a moment. I love this image—it is a moment before a very important moment. I also love that there is no ring on her finger, but soon there will be. Notice how the flower is the same tone as her gown and how the light floods in behind her.

Contax 645 with 80mm Zeiss lens, Fuji 800 NPZ film, f/2 for 1/60 sec.

The Beauty of Film

This Victorian home was the perfect backdrop for Claire Pettibone's new line of lingerie, with moody dark walls illuminated by abundant natural sunlight. I focused carefully on the model's face and set my aperture to f/4. Setting my camera on a tripod, I could use a slightly longer exposure and still be sure the final image was clear. The film just drinks in the light. The result is an image saturated with color and warmth. Natural light and film are the perfect combination.

Contax 645 with 80mm Zeiss lens, Fuji NPH film, f/4 for 1/15 sec.

For me, the last tool of my vision is film. Film and natural light are a marriage made in heaven, like chocolate and peanut butter. Film is luminous by nature, responds to light well, and allows a lot of leeway with exposure. I also think film forces you to be in the moment, connecting you both to what you're seeing (in terms of seeing the light, the quality of light, and how it relates to your subject) and to the act of photography itself. Since I can't look at and check the back of my camera, it forces me to be more engaged in the moment of creation, the composition, and the quality of light.

I use Fuji color film almost exclusively—mostly 800 NPZ and 400 NPH now (because they stopped making 800 NPZ); they're both fast, beautiful films. I prefer faster film because it gives me more versatility, since I like to photograph in a variety of lighting situations. For black-and-white images, I use both Ilford XP2 (a C-41 processed film) and Ilford 3200. I do love to overexpose (let more light in) with all the film types I use. With film, I'm connecting, I'm stopping, I'm talking, I'm seeing, I'm slowing down. Film helps me create a rhythm within the shoot and physically connects me to what is going on around me. It allows me to continue to see and relate to the situation rather than just shoot through it.

I love film both for its tonal qualities and for the way it responds to light. I also love the process of loading film into my camera and how it enhances my ability to remain engaged in a moment by slowing me down. I work hard to be aware of the natural light in any given situation and expose accordingly. All my images are composed and exposed within my camera. I do not manipulate or change my work in postproduction. I encourage you to strive for the same thing. Do not rely on Photoshop or any action to "fix" your images; rely on yourself to create the best possible photograph while you are shooting. This is so valuable no matter what type of camera or format you are working with. The more you can develop your eye and know your lighting options, the more often you will create inspired photographs.

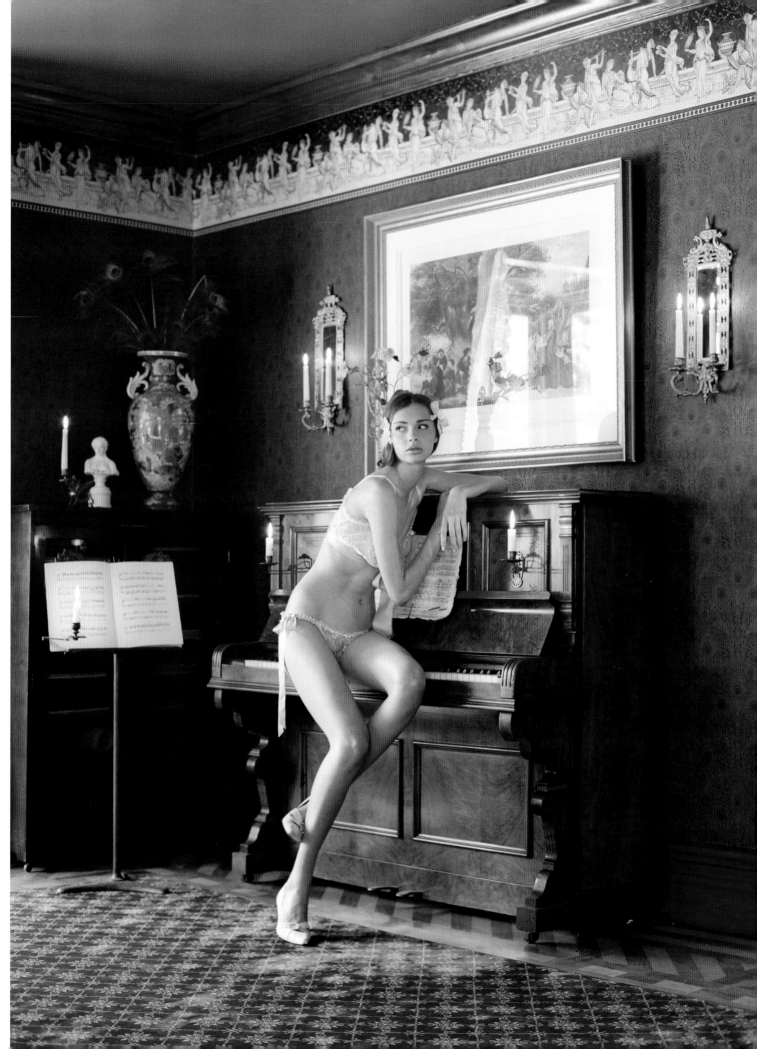

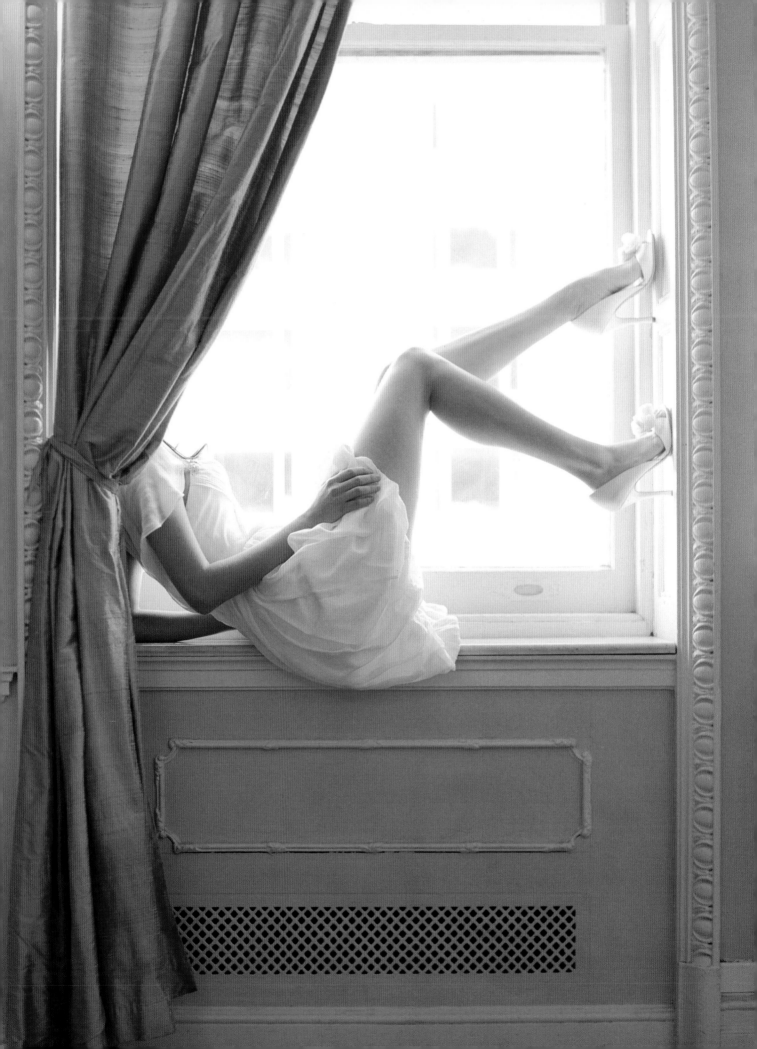

Discovering the Light Around Us

Everything about this image whispers—the light, the lilt in the subject's posture, the fact that we can see her and yet we don't really see her face at all. The window beckons us to come closer. I like that we can see the detail in the curtain and in the girl's skirt even though the window is almost completely overexposed. The image still works even though, technically, it might be considered wrong.

Contax 645 with 80mm Zeiss lens, Fuji 400 NPH film, f/2 for 1/60 sec.

Light is air to a photograph; it gives an image life. In a great portrait, the presentation of light—or lack of light, as manifested in shadows—emphasizes the subject's features as well as mood. We cannot explore the wonder of photography and its power to transcend verbal language without fully embracing how the light works within our photographs. A poignant, luminous composition depends on a basic foundation of light and exposure—otherwise, none of the other qualities of a strong portrait can fully emerge.

Once you discover the light around you, you need to learn to adapt it to your image, depending on what you would like to convey. For instance, you'll notice that I use the term *overexpose* a lot. I always expose for the darkest part of my image, the shadow. If you can see detail in the shadows, the lightest areas will be a bit overexposed, thus creating a feeling of luminosity in your photographs. Of course, you can also create that feeling in postproduction (either in the printing process or on your computer), but my goal is to make the best possible image in camera by using the best possible exposure. Not only is it critical to see the light, it is also important to shoot a lot while continuing to vary your exposure (known as *bracketing*), especially when you are just starting out.

Learning to understand the different lighting situations in nature will help you translate them into specific exposure and camera settings, so you can confidently approach whatever natural-lighting situation you find yourself in. Ask yourself every time if the light is accentuating the feeling or mood you want to convey. It should be. And remember: When you create something that works for you, take note of it, either mentally or by literally writing it down. Paying attention will help you consistently capture lighting and create shots that work, time and time again.

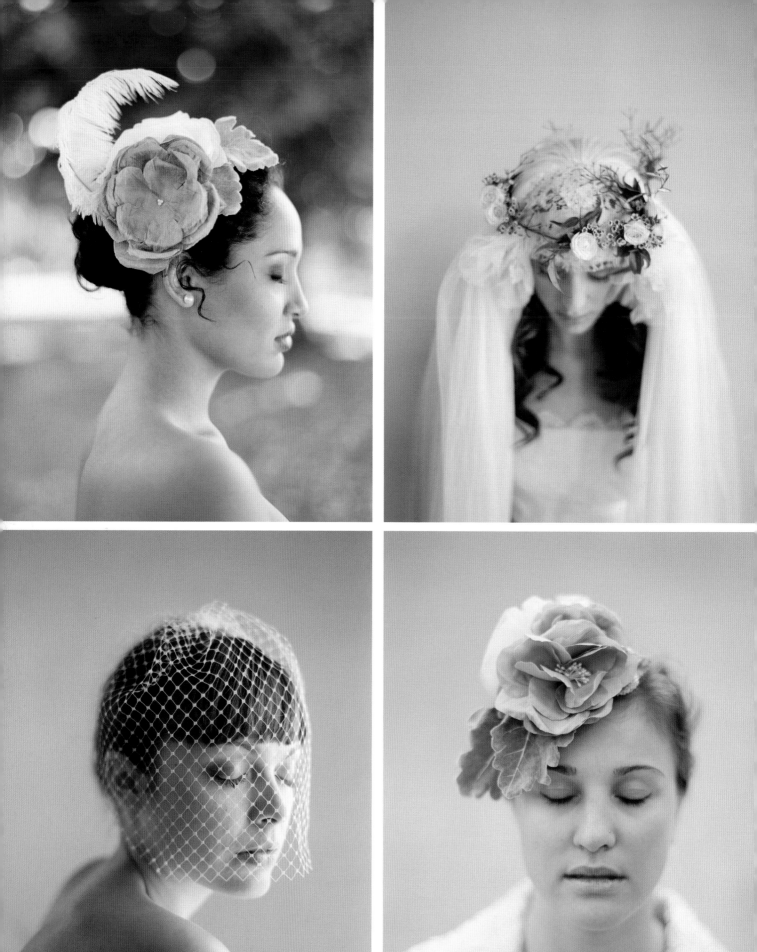

These four different portraits all share a soft, still, gentle look, yet they all show different women in different lighting situations. They perfectly illustrate the theme running throughout this book: that you can find flattering light in (almost) any situation.

Opposite, top left: I shot this portrait outside one morning in Kentucky. The sun was bright but not intense, situated behind the right side of my subject. Notice how the flower and the tendril of her hair are sharp, while her face is softer and the background is completely out of focus—this is the beauty of a shallow depth of field. I exposed for the cheek closest to me, so the detail and tone there are clear and clean. The edge of her face is overexposed, slightly blown out by light, yet it still holds up within the image. If you look into the background, you can see glimpses of sunlight coming through the trees. You know the sun is out, but it doesn't overpower the image.

Contax 645 with 80mm Zeiss lens, Fuji 400 NPH film, f/2 for 1/60 sec.

Opposite, top right: I shot this in New York City at noon on a bright autumn day against a plain wall in a large, empty room. To the right of my subject are huge floor-to-ceiling windows with light streaming in from every side, causing the walls to act as my reflector, bouncing the light all around my subject.

Contax 645 with 80mm Zeiss lens, Fuji 400 NPH film, f/2 for 1/60 sec.

Opposite, bottom right: This image was photographed in Napa Valley on an overcast, drizzly day. Clouds filtered the light, mimicking the look of window light bouncing off white walls. The subject is about three feet away from the wall, so although the background is smooth and clean, it's not in focus.

Contax 645 with 80mm Zeiss lens, Fuji 800 NPZ film, f/2 for 1/60 sec.

Opposite, bottom left: This portrait was taken at 3 p.m. in my home in California. I set her at the edge of my bed, as close as possible to a small window on the right-hand side. To me, this image is most similar to the portrait taken in Kentucky (top left), yet they were taken at completely different times of the day in completely different parts of the country.

Contax 645 with 80mm Zeiss lens, Fuji 800 NPZ film, f/2 for 1/60 sec.

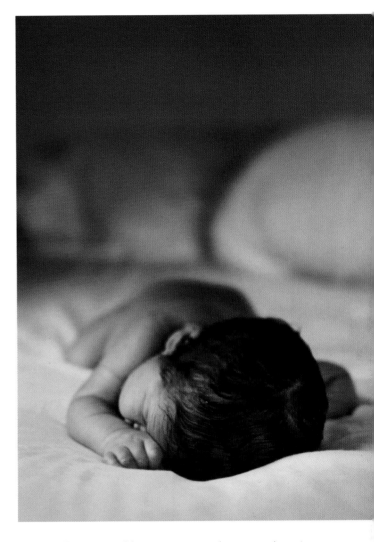

There are few things in life as inspiring as a sleeping newborn. I took this image of my son as he lay in the middle of our bed by the window on a summer afternoon. I focused on his head, with my camera set at f/2 for 1/60 sec. Once I felt that I had gotten the image I wanted, I put the camera down and curled up next to him for a much-needed nap.

Contax 645 with 80mm Zeiss lens, Kodak Portra 400CN black-and-white film, f/2 for 1/60 sec.

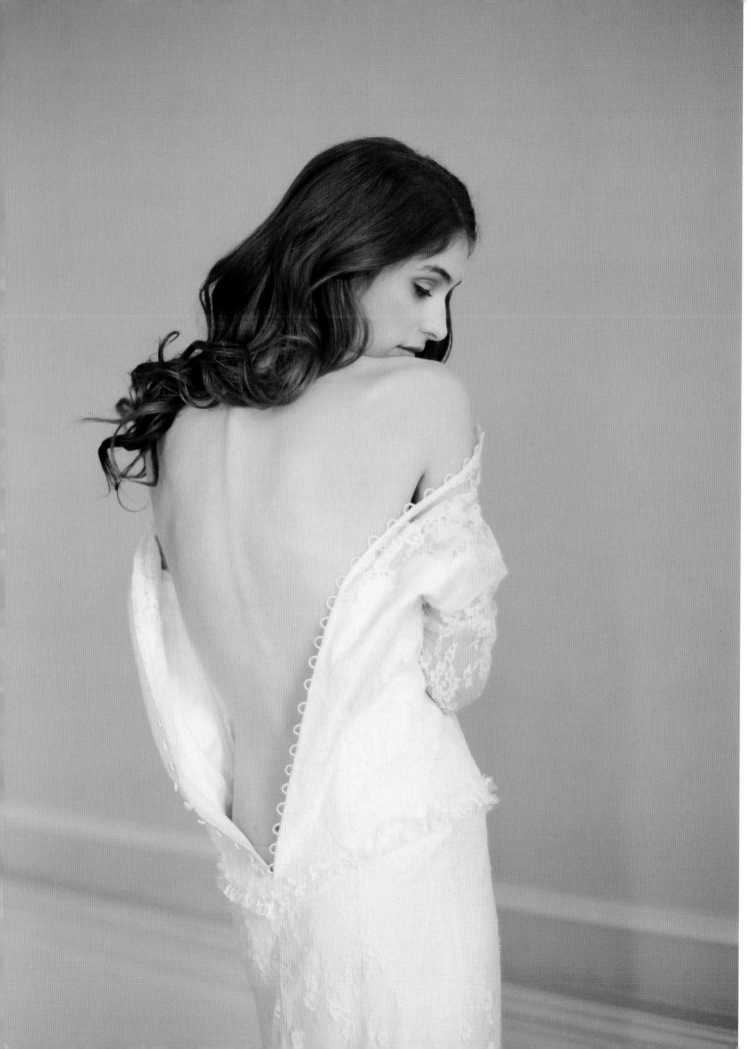

The Importance of Seeing

While I was shooting for French designer Delphine Manivet, this model was about to change dresses when I asked her to pause for a moment. There was abundant, bright light coming from the huge windows in this historic New York building, and the windows were behind me and slightly to the right.

Contax 645 with 80mm Zeiss lens, Fuji 400 NPH film, f/2 for 1/125 sec.

When it comes to creating photographs, the more we see beyond what is in front of us, the more we will become better image-makers. I realize the act of "seeing" may seem obvious, but in fact, it takes a thoughtful eye to evaluate the available light and options of your surroundings. When I am at a location, I look around first with no camera—just to assess my surroundings—and then again with my camera to see how the light reflects off certain objects. At the same time, I am also asking myself important questions about the light: Is it strong, gentle, or somewhere in between? How does it change if I move the object or subject slightly to the left or right? Sometimes it's easy to fall into the habit of letting our cameras do the work, but I think that takes much of the creativity and fun out of photography. I prefer to tell my camera what to do. Rather than setting it on automatic, I always use manual controls to determine what the best aperture and exposure will be. The more you see and shoot in varying lighting situations, the more the act of "seeing" will come naturally to you, as will your decisions about exposure and where to place your subject. Try to refrain from relying on your camera more than on your own instincts. Trust your eye; trust yourself.

Natural Light as an
Essential Element OF A PORTRAIT

This may sound obvious, but the lighting you choose for an image plays an important role in your end result. That is why I love to experiment and try lots of options in my exposures and light source, as well as in my framing and composition. Each element, particularly the light, helps capture the nuances of an image's mood.

Many photographers prefer to use strobes, tungsten, or other lighting setups to mimic and intensify this crucial element of a portrait, but I prefer to work with what is already around me. For instance, clouds are a natural reflector, and if you are shooting outside on an overcast day, the resulting effect can be a clean, even, beautifully lit image.

The two portraits shown here are both of husband and wife Adam and Kim, and they show how different lighting decisions contribute to two different moods. In the first portrait, I brought Adam and Kim outside and had them lie down on the grass. This is one of my signature compositions—to frame two subjects upside-down next to each other—because it adds a playful, sweet feeling to the image. The sky was my softbox, or filter, and as a result, I could see each subject's facial details and expressions quite clearly. Because there were two people in the frame, I stopped down from f/2 to f/4 (at 1/60 sec.), to prevent the image and focus from going too soft. As I stood above the couple, I posed them with their heads together, then got close to zero in on their faces; anything going on in the background was irrelevant. I paused for a moment to take the flower that had been in Kim's hand and place it on her and Adam's faces. The moment and smiles that followed were real and spontaneous. I love how Adam is gently reaching for Kim and how her smile perfectly represents their relationship—they are one of the happiest, loveliest couples I know, and the open, clear light reinforces this feeling.

In comparison, the second image depicts Adam and Kim, now indoors, being framed by a window. I changed just a few elements from the first shot and suddenly the image has taken on a different tone and mood. This shot was more of an experiment—it was the same overcast day, but I wasn't sure I would get enough backlight from the window for a successful image. When I am unsure in that way, I still go ahead and shoot. The only way to know if something will work is to try it. (Digital shooters, you have an advantage here, because even though I personally don't think you should check the back of your camera, you still can!) As I'm shooting film, I just have to go for it and take risks, which I'm so glad I did in this situation.

This image feels more voyeuristic, as I pulled back to create more of a private moment between them, a feeling the light only enhances. My exposure is exactly the same as in the first shot, f/4 for 1/60 sec., but the feeling is utterly different because the couple is backlit and I exposed for the shadow to play up the intimacy between them. We can still see the detail in the darker areas of the image, and the light feels warm and affectionate while also slightly moody and even sexy.

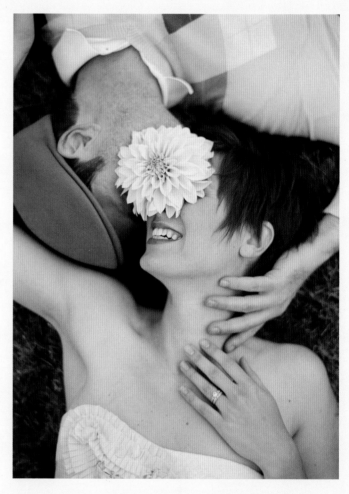

Here, I'm standing directly over the couple and zooming in tight to exclude any hint of background or extraneous light. In this type of setup, sidelighting would not be appropriate because part of the strength of the image lies in seeing Kim's smile, the detail of the flower, and so on. There is a lightness between the two of them, complemented by a clean, even composition.

Contax 645 with 80mm Zeiss lens, f/4 for 1/60 sec.

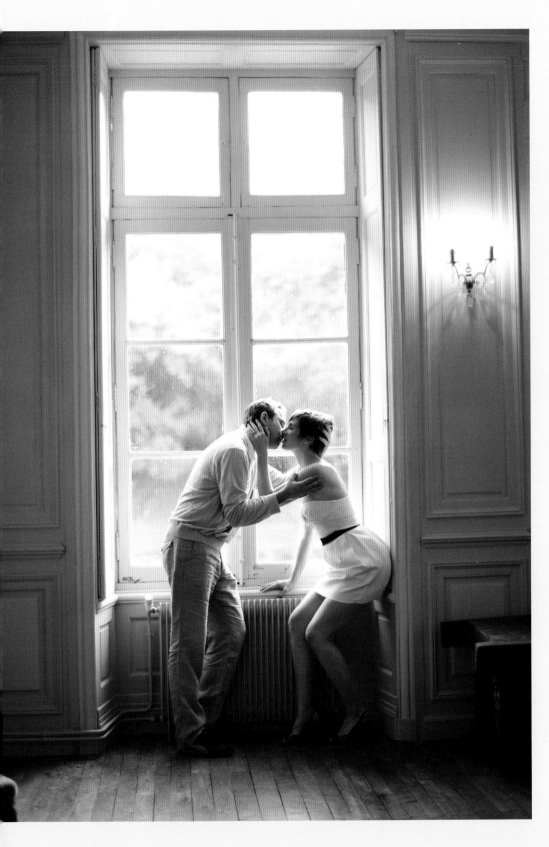

In this shot, Adam and Kim are backlit by the window source. The feeling is utterly different than in the previous image, because the couple is backlit and I exposed for the shadow to play up the intimacy between them.

Contax 645 with 80mm Zeiss lens, Kodak Portra 400CN film (printed sepia), f/4 for 1/60 sec.

Variations on Luminosity

The wonderful thing about natural light is that it is abundant—every day the sun rises and provides another opportunity to create beautiful, luminous images. This is true even on the cloudiest of days. All it takes to make a stunning portrait is the realization that every type of natural light (sunlight, window light, open shade, overcast light, and so on) can be simply breathtaking in your work if you know how to see the light and use it to your benefit.

THE SWEETNESS OF SUNLIGHT

Sunlight is perhaps the most obvious natural-lighting situation, but understanding sunlight and knowing how to work with it can be challenging. For instance, when you find yourself outside on a particularly bright day, there is one thing you must always remember: Backlight your subject. This will often go against the wishes of your clients, who typically prefer to see the sun glinting off the face as the subject smiles at the camera; but bright sunlight in your subject's face is the culprit behind many a photo gone awry, as well as a hard habit for the nonprofessional photographer to break.

People often squint or close their eyes inadvertently in direct sun. Bright sunlight is also unflattering. The best thing to do is to have your subjects face you with the sun behind them, so their faces are in shadow. Then simply expose for the shadow. Not only will you will get a more relaxed facial expression, without squinty eyes, but you'll also end up with a truly stunning "lit from within" portrait.

Understanding your exposure in this type of situation is crucial, whether you use a handheld meter or the camera's built-in light meter. You must have your camera on manual so that you can control your exposure. When metering, you'll find that if you expose for the bright sunlight, you may be at f/4 for 1/1000 sec. or even faster, but when you meter for the shadow, you'll be at f/4 for 1/125 sec. This may seem like too much of a range, but trust me, it isn't. When you properly expose for the shadow, the overexposed sun creates a beautiful glow.

If you are shooting directly toward the sun, be aware of unwanted flare going directly into the lens. There are, of course, times when lens flare is absolutely delicious, like later in the afternoon (more on this in chapter 4), but when it's very bright and the sun is high in the sky, it's a bit difficult to control the amount of flare. I sometimes use a tree to minimize the direct sun from going through my lens, or I'll have my assistant help shield my lens with a reflector to give me a little more protection. (For more on using reflectors, see page 67.)

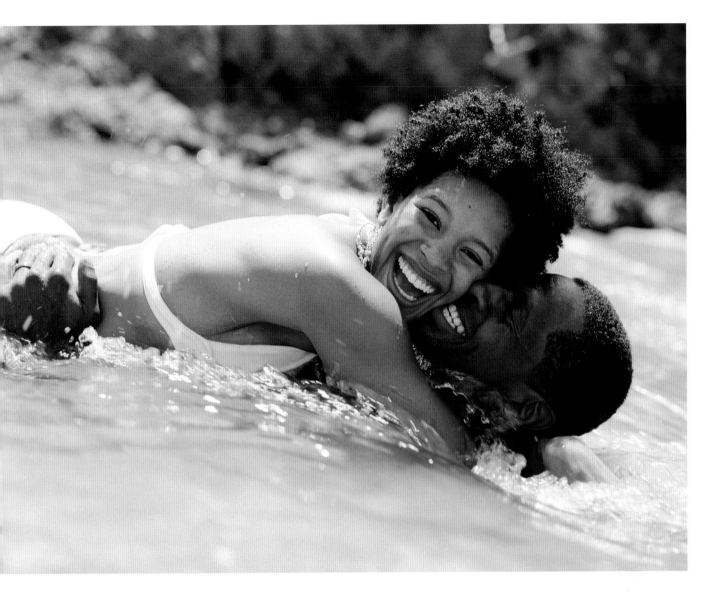

This image was taken on a beach in Cuixmala, Mexico. It was midday, about ninety-five degrees. Fortunately it didn't take much encouragement to get this couple to play in the water. The sunlight, although quite bright and intense, is mostly behind them. Their faces are in shadow, so I got down in the water (fully clothed) and took a series of photographs while exposing for the shadow. Their laughter here was natural, and I just love the warmth of the light. This is one of my favorite images.

Contax 645 with 80mm Zeiss lens, Fuji 800 NPZ film, f/4 for 1/125 sec.

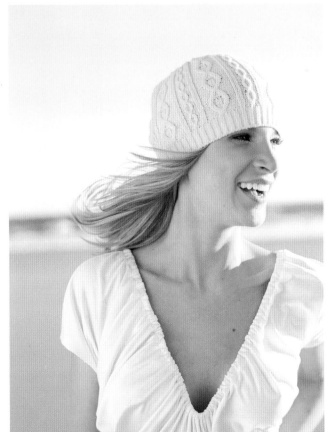

I love how light and clean this shot is. The image feels warm (even though it was a bit nippy that day), and the light and glow are lovely.

Contax 645 with 80mm Zeiss lens, Fuji 800 NPZ film, f/4 for 1/500 sec.

This simple, straightforward portrait utilizes beautiful, soft light from an overcast day. The light here is gentle and even, allowing the model's strong gaze to shine through.

Contax 645 with 80mm Zeiss lens, Ilford 400 XP2 film, f/4 for 1/125 sec.

THE OVERCAST SKY IS A SOFTBOX

Cloudy days make me a little weak in the knees, not because I miss the sun but because I can pretty much shoot outside all day long from virtually any angle I want. Overcast days are Mother Nature's gift to photographers.

Why is overcast light so amazing? It's gentler than direct sunlight. The softness of a cloud literally translates to softness on your subject. Overcast conditions diffuse the light, much as a softbox will in a studio or the way a scrim will filter the bright sunlight on a summer day. You may have a disappointed client who thinks sunlight is best, but it is your job to reassure her that this soft light is not only ideal but also very flattering.

Even though you can almost do no wrong in this kind of light, it's important to take time again to "see." Walk all the way around your subject to see the face from all angles. There may be subtle differences in the way the light caresses the facial contours; if you are not sure which angle is best, shoot images from several different angles. Learning to see often requires you to shoot and compare your images with what you thought was working. Sometimes you'll be spot-on, and other times what you thought you saw won't translate onto your image. I am a big believer in the idea that making mistakes is the best way to learn about light. It's a process that connects you, your camera, your subject, and the available light.

On an overcast day, I also like to overexpose my shots. I love the depth of field I get and the way the light becomes almost celestial looking. I still bracket to make sure I am getting the best possible exposure, but nine times out of ten, my shutter is at f/2 and my exposure is 1/60 sec. Most of my work is shot like this.

When I have my shutter wide open and I am creating a portrait, I focus on the person's eyes. If the eyes are in focus, the viewer will be engaged with the image, and even if everything else looks soft and out of focus, the image will have an undeniable impact. When my focus is on the eyes and my exposure is 1, 2, or sometimes even 3 stops over, the image is absolutely luminous. This soft look is very flattering and evocative. It's what allows someone to feel the image, not just look at it.

The more you see the light and are aware of how to capture it, the more your images will be transformed from "nice" portraits into ethereal images with true impact. Just look outside: If it's overcast, please put down this book, grab a friend, and start shooting. You'll be so glad you did.

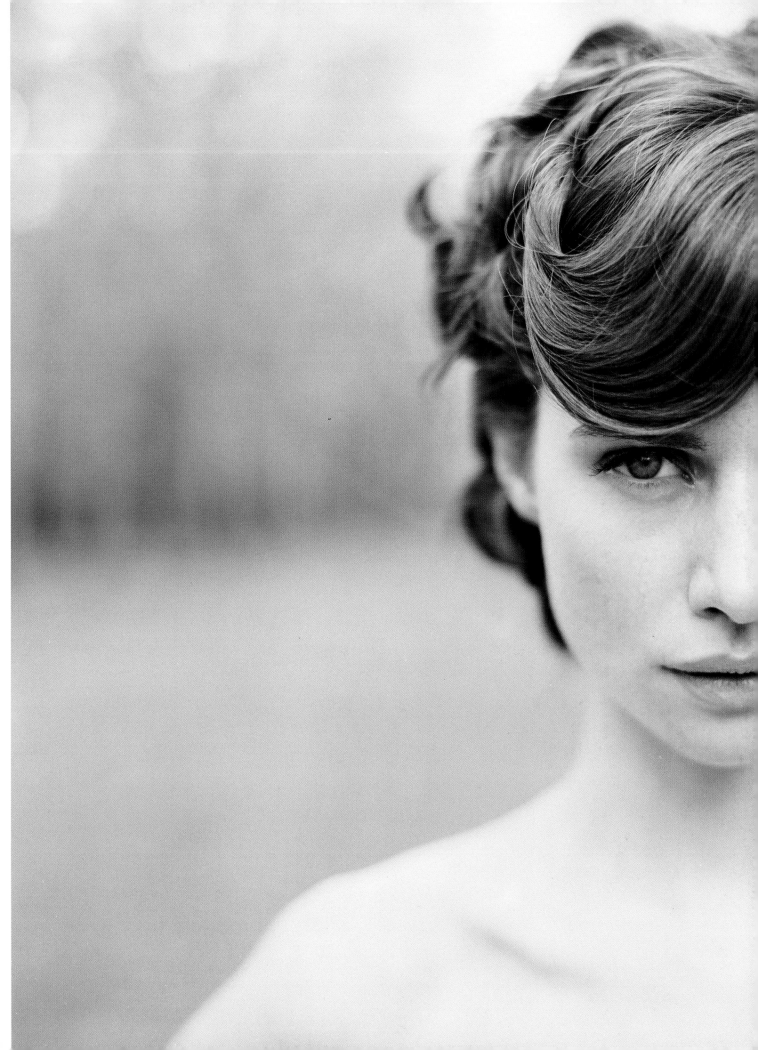

THE WHISPER OF WINDOW LIGHT

There is something so quiet about window light. It whispers to you, and it beckons you to come closer. It's gentle, it caresses your subjects, and it protects them from even the brightest, harshest light of day.

Believe it or not, there is a right and a wrong way to see window light. The first thing I do when I'm in someone's house is to make myself at home. I walk through the house, assessing all the windows, observing the light, and deciding which windows will provide the most beautiful light. If the sun is coming directly through a window, it becomes the same lighting scenario as a bright, sunny day, and you will need to backlight your subject and expose for the shadows (see pages 20 and 62).

But that's not my favorite type of window light. I usually avoid direct sunlight coming through a window and look for softer, gentler light instead. The gentler the light, the moodier the image. I prefer to have my subject stand near the window so that it is adjacent to her. Then I'll stand in front of my subject, so the window is to the

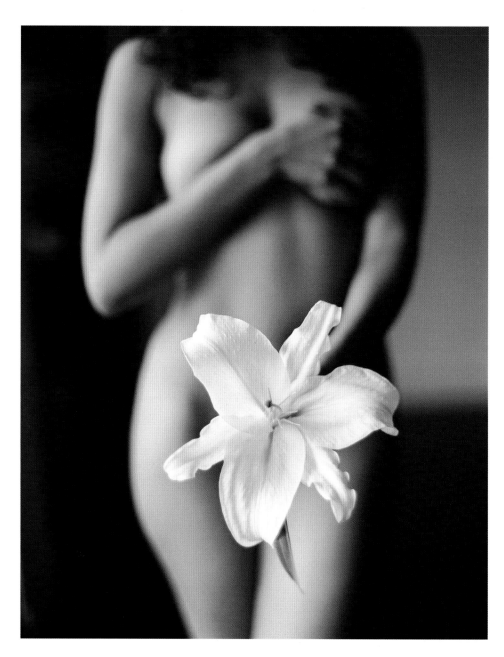

Soft window light worked well in this portrait of a newly pregnant woman. The flower (a gift from her husband) not only gently covers her body but also catches the light.

Contax 645 with 80mm Zeiss lens, Kodak Portra 400CN film, f/2 for 1/60 sec.

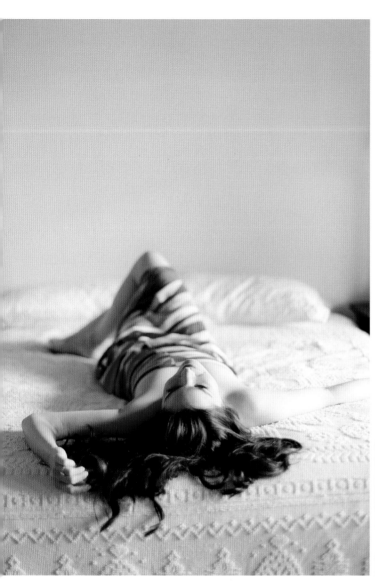
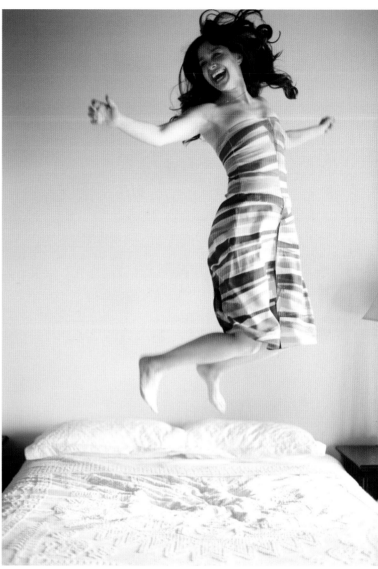

Window light and a bed are a perfect combination for a fabulous image. The image of the woman lying on the bed is subtle and calm, while the one of her jumping is so full of energy and youthfulness. The two images were taken mere moments apart with the same wide-open aperture, yet different shutter speeds give each a completely different tone, mood, and feel. The shutter speed used in the second shot—1/250 sec.—freezes the motion, so we see her in the air and not the trail of her going up and down, but still allows enough light into the frame to create that luminous quality.

Left: Contax 645 with 80mm Zeiss lens, Fuji 800 NPZ film, f/2 for 1/125 sec.; Right: Contax 645 with 80mm Zeiss lens, Fuji 800 NPZ film, f/2 for 1/250 sec.

side of me, as well. The light is a bit more on one side than the other, but since it's such gentle, filtered light, it's still soft. In this situation, I always expose for the shadow, or for the side of the face farthest away from the light. Exposing for the shadow is one of the best ways to create a luminous image—the light will just glow.

If you're photographing in a room with more than one window, don't worry about light from one window competing with that from another. The only time it might be an issue is if you have direct sunlight coming in harshly and creating a contrasty look. Otherwise, the more windows there are, the better the portrait will be. If there is direct light coming in through a window and it is more than you want, use a reflector to block some of it from hitting your subject, thereby diffusing it. You can even hang a sheer curtain on the window and close it to diffuse the light. Always check out your space and take advantage of what is already in the room. (Remember: A room with light walls will bounce the light; a room with dark walls absorbs the light.)

Be aware of and purposeful with your focus as well as your exposure: If your subject is looking directly into your lens, focus on her eyes; if she is not looking at the camera, you have a little more leeway to be creative. Perhaps you'll focus on the side of the cheek, the shoulder blade, or the mouth. Just experiment. Your exposure and focus are related to each other; when both are done well, the image can have tremendous impact.

Whenever possible, I set my camera at f/2, and just as with an overcast day, I prefer to expose at 1/60 sec. I've even handheld my camera as low as 1/30 or 1/15 sec. in a window-light situation, although this is a little risky; while the light may look beautiful, you have to have a very steady hand to avoid getting any movement in the image—hard to do but fun to experiment with.

OPEN SHADE

Open shade is a desirable lighting option on a particularly bright day. *Open shade* refers to an area that is protected from direct sun yet still full of ambient light. I usually look for this type of light near a building or under the protection of trees. A building can also act as a large reflector, creating beautiful light all around your subject.

When using the shade from a building, look at the light and be sure you are not getting a severe line in the background from the sun. Also, be sure the shade you use is big enough to frame your subject. When using an area shaded by trees, orient the sun behind your subject; otherwise, you may get dappled light. Although dappled light can be pretty at times, in general it's not very flattering. I like to put the sun behind my subject, in the open shade of trees, and then expose for the shadow. This produces a beautiful, soft look, similar to open backlit sunlight but a little more mellow. This effect is wonderful for group shots and can also come in handy at weddings.

Once you've discovered how to see the light around you, the next step is to learn different ways to work with it, so that you can choose whichever one is most advantageous to the type of portrait you are taking. This includes understanding how to guide your subject

Opposite: On a hot, bright Los Angeles day, I wasn't sure how I was going to create flattering portraits until I found this outdoor patio, which was shielded from the direct sun. The open shade gave me plenty of flattering light.

Contax 645 with 80mm Zeiss lens, Fuji 800 NPZ film, f/4 for 1/250 sec.

into the most flattering light; how to choose which part of your subject to expose for; and how to use various tools, such as reflectors and scrims, to block, bounce, or diffuse the light. Understanding light and exposure is a process. The best way to learn is to try again and again. Over time, you will understand which lighting situations and exposures work best for you.

The portrait shown opposite, top, is a good example of how open shade can be used to accommodate the harsh light of a very bright day. We were on a patio in a Los Angeles hotel during late afternoon, with the sun still strong and bright. I found a spot protected from the harsh rays near a colorful wall. The shade was full of even, flattering light. As the model lay on the couch, I focused on her face and exposed for the shadow. The shutter speed (1/250 sec.) was fast enough to capture her natural laughter but slow enough to fill the frame with light. In the final image, we see everything clearly— some of the lighter areas may be slightly overexposed, but they hold up. And although I am ten feet away, a sense of warmth still emanates from the image, accentuated by the light and the genuine gesture of body and smile. The image is posed yet relaxed, in focus and still full of light.

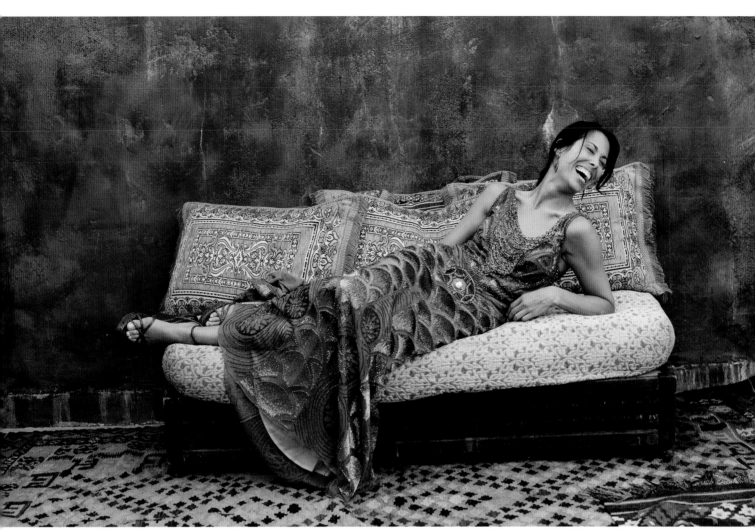

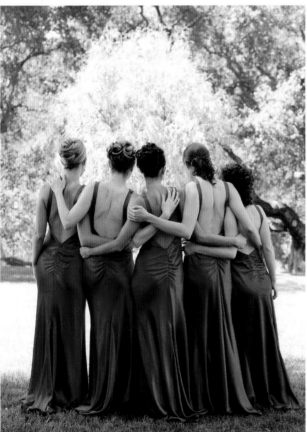

This image was shot in super bright afternoon sunlight, but I managed to find a little nook of shade and organized the girls in a row. After taking a series of "proper" portraits (with all of them facing me), I asked them to turn around and pretend I was on the other side. The result is one of my all-time favorite group shots. You don't always need to see a person's face in order to call an image a "portrait."

Contax 645 with 80mm Zeiss lens, Fuji 800 NPZ film, f/5.6 for I/125 sec.

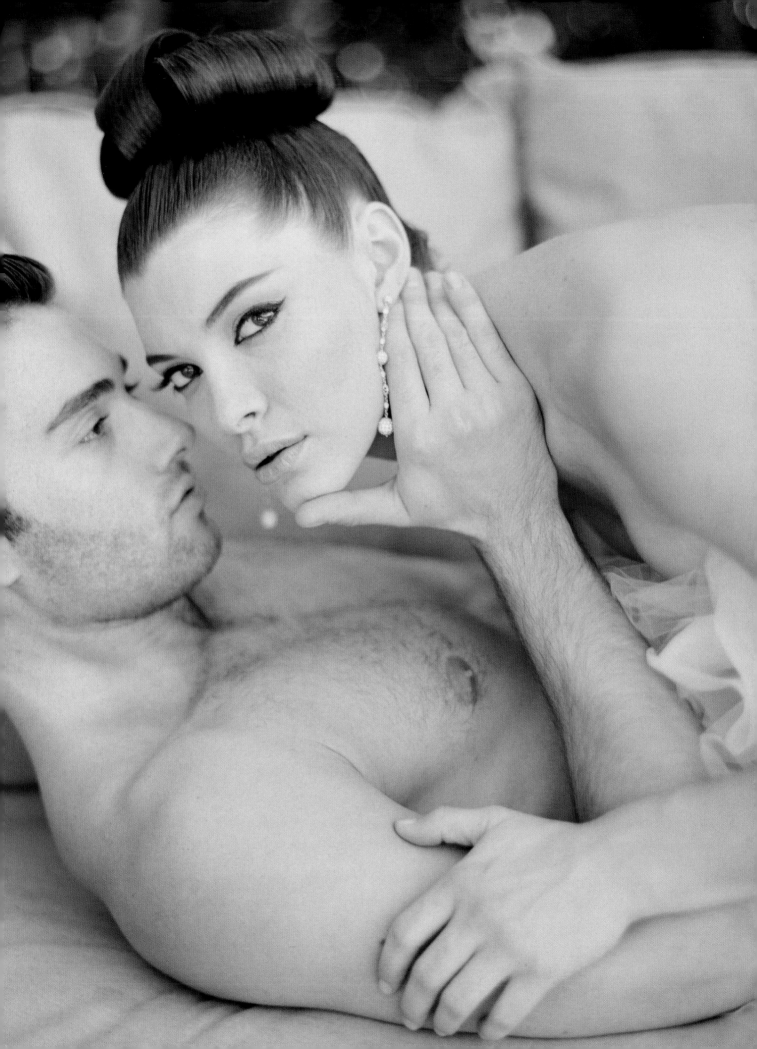

The *Anatomy* of a *Portrait*

This image perfectly shows the power of focus and light. I focused on the woman's eye while leaving the man's face soft and the background blurry. We shot this outside in bright sunlight, with the couple positioned on a couch. I had my assistant use a reflector to block the direct sunlight.

Contax 645 with 80mm Zeiss lens, Ilford 400 XP2 film, f/2 for 1/60 sec.

When it comes to creating a portrait, I never just walk into a shoot, pick up my camera, and start clicking away. The more you shoot, the more you discover that many elements need to be considered to successfully orchestrate a portrait shoot: technical factors, the light, the location, the creative aspects, the mind-set of your subject, and so on.

I always want to relate and connect to my subject, but that doesn't mean I do the same thing every time. Try not to be too overbearing in your personality or direction of how you shoot, because the real beauty of a portrait is in capturing something unique about your subject. The more open and responsive you are to that person's personality, the better the portrait will be. Some people are more lighthearted, others more subdued, even shy, and it's your responsibility to make them feel comfortable and alleviate their fears. Respond to who they are as individuals rather than having preconceived notions of what will work.

My philosophy on approaching a photo shoot is this: Connect with your subject, adapt to your location, and apply a new way of thinking creatively each time you pick up your camera. I never go to a photo shoot thinking it will be an easy shoot or that I'll approach it the same way as the last one. It doesn't matter how many beautiful photos I've taken—every time I go to a shoot, it's the first time I'm in that situation. There will always be parts of the shoot that don't go well, and there will always be unexpected challenges, but part of being a good photographer is being able to navigate through all that without letting your subject know you are struggling in any way. Don't be dissuaded if it's challenging. I expect it to be challenging every time, just in different ways. It's the challenges that keep you creative.

Understanding Your Subject

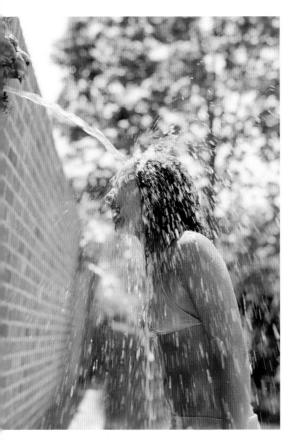

When photographing children, it is often helpful to capture what they are doing rather than try to make them do something you have in mind. This is especially true when I photograph my own children. On a very hot day in Virginia, my daughter was cooling off under a fountain. I jumped up and grabbed my camera and was able to catch a few shots before she jumped back in the pool. I bring my camera almost everywhere I go, always ready for unexpected beauty.

Contax 645 with 80mm Zeiss lens, Fuji 800 NPZ film, f/4 for 1/250 sec.

There are no two ways about it: When it comes to making beautiful portraits, you need to first relate to your subjects. If they are shy, be patient. I can relate to this because I myself tend to be very shy, so I never minimize a subject's fear or shyness; that's the worst thing you can do. Instead, talk to your subjects and delay picking up your camera right away. Even though you are there to photograph them, and even though you are there to make a great image, you *don't* have to pick up your camera the moment you walk in the door. The sooner you make the photo session about relating to them as people and not just about their having to sit a certain way and be photographed, the sooner you will convey a more relaxed atmosphere in your shoot. You can then gently and slowly introduce your camera without overwhelming your subjects.

The second thing I do, and this relates more specifically to posing, is ask shy, reticent, or uncomfortable subjects *not* to look at me. I've found that when subjects look directly into the camera, it can be terrifying if they are already feeling uncomfortable. On the other hand, for example, if I ask a woman to look down toward her feet, look to the side, or gaze out a window, then I can take my time composing and thoughtfully choosing the prettiest angle and the most flattering light without eliciting that stressed look or tension in her eyes. After shooting like that for a little while, I find that there is a natural build or flow to a shoot that will emerge on its own. For instance, let's say I am photographing someone who is supershy and she is looking down, and I'm focusing on her eyelashes (which can be really beautiful and flattering in an image). I might then start echoing what I'm seeing, saying things like, "Oh, wow, it looks so beautiful." More often than not, the woman will naturally smile in response to my positive feedback.

Another thing I like to do is move my camera down so that it is under my chin, rather than right at my eye, and while I'm speaking and interacting my subject will look at me and interact, too. This helps me take a photo that is less forced rather than looking through the camera and creating a boundary between photographer and subject. I try to make it so there is no boundary. And this is not a one-time thing. I keep

up constant dialogue and interaction with my subject the whole time I am shooting, never allowing the camera to become the center of attention.

While most people feel a little uncomfortable being photographed, some are just the opposite. There are occasions when I'll have a very outgoing and expressive subject. In these situations, I tend to follow my subject's lead as much as possible, while sometimes giving a small suggestion or direction. For instance, if she is smiling and talkative, I might ask her to hold still and giggle for me. This is congruent with her energy and also helps me avoid awkward mouth contortions. (Giggling, in general, is better than smiling because it is more interactive— even a fake giggle will undoubtedly lead to a real one.) Overall, being observant and receptive to your subjects, whatever their temperaments, will help you create beautiful images. A real moment captured with beautiful natural light is, in my humble opinion, a perfect image.

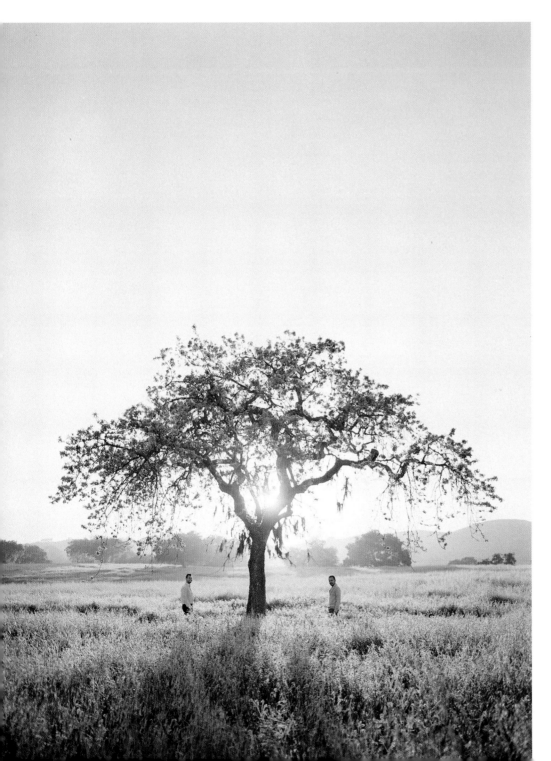

This engagement portrait of Jose Villa and Joel Serrato is very special to me. It is always an honor to photograph another photographer. I know how much Jose and Joel like the trees and natural landscape surrounding their home, so it was only fitting to shoot them in a place that had special meaning to them. It was late in the afternoon, and the sun flare coming through the tree cast a lovely soft light throughout the image.

Contax 645 with 80mm Zeiss lens, Ilford 400 XP film, f/4 for 1/60 sec.

55

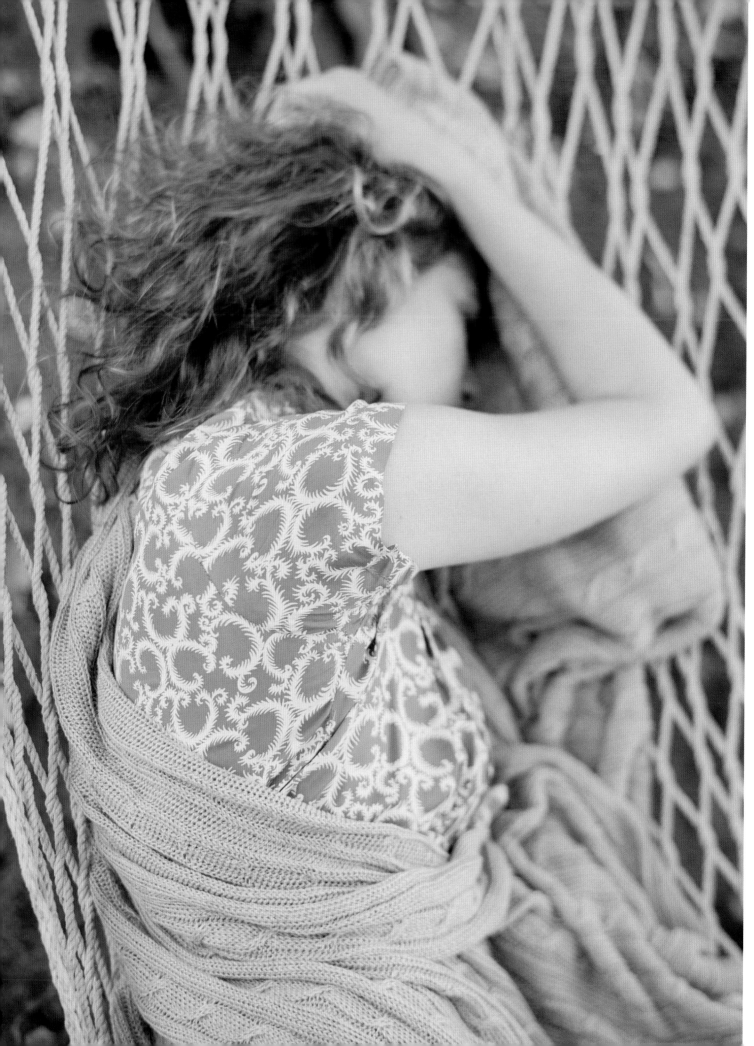

Opposite: This was shot on a very cloudy day outside of Chicago. The light fell on the woman beautifully as she curled up in the hammock. I stood above her and focused on the edge of her dress. There is something so balanced in the composition; the way her arm curls around her head and the blanket wraps across her body creates a beautiful tension.

Contax 645 with 80mm Zeiss lens, Fuji 800 NPZ film, f/2 for 1/60 sec.

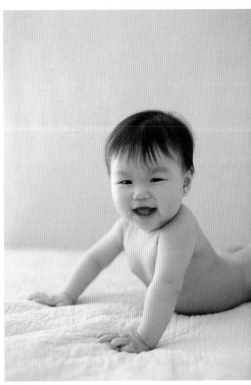

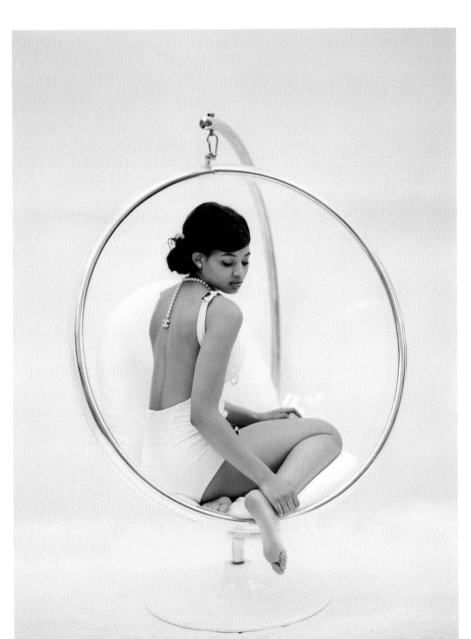

Above, left: I'll sometimes encourage children to be playful so that I can capture them off guard. This photo was taken in the open shade near a wall.

Contax 645 with 80mm Zeiss lens, Fuji 800 NPZ film, f/2 for 1/125 sec.

Above, right: Babies are so full of life, but they can also be challenging to photograph. This sweet girl kept wiggling around and pushing herself up. Instead of trying to make her look or sit a certain way, I watched and waited. In this moment, she pushed up and looked at me with a big smile, so proud of her achievement. A single window was nearby, and the sidelight cast a lovely glow on the little girl's face.

Contax 645 with 80mm Zeiss lens, Fuji 400 NPH film, f/2 for 1/60 sec.

Left: While shooting a cover for *RUE* magazine, the model climbed into a modern chair in front of a white seamless backdrop. The day was overcast, and the light was even and flattering. I asked her to sit comfortably, knowing that the more natural she felt, the more natural the overall image would feel.

Contax 645 with 80mm Zeiss lens, Fuji 400 NPH film, f/4 for 1/60 sec.

57

Location, Location, Location

When choosing your location, it's obviously important to consider the light. Light is a huge component of your portrait shoot, no matter what. But don't forget to also consider the desired end result of the portrait as well as the subject.

To consider the end result, ask yourself, What's the point of the portrait shoot? Is it to commemorate a special time in the subject's life? Is it something to be used for business or as a gift for someone else? Determining the desired end result will help dictate some of the choices you make about location. If I am, say, doing a boudoir shot for a woman who intends to give the images to her husband, I will suggest we shoot in her home. Subjects who are comfortable in their environment will, in turn, be more at ease during the photo shoot. I might clear out an area near a window so that there is no clutter; the only thing you'll see in your frame is the woman's body and the gentle light from the window. If I am working on a family portrait, I may prefer to shoot in a park or a more open area that provides not only natural outdoor light but also plenty of room to set up the portrait. Thinking ahead and knowing both what your subject wants and what you'll need in terms of location and light will greatly enhance the consistency of your images.

Also, factor your subject into the equation. Especially when working with shy or uncomfortable subjects, including them in your decision-making process about location is another way to create a more relaxed dynamic. If you find someone's favorite chair to sit in, make that the first place you take a photo, even if it isn't in the best light. It will relax your subject and ensure you are accommodating the subject's needs. If you find a personal item or discover a prop that is meaningful to the person you are photographing but is not in the best light, move that element to where you feel you can get a better shot.

In my house, there is a window that I love right next to my bed. I often photograph my children and friends sitting on the edge of my bed with the light of that window caressing their faces. Every house has a spot like that; you just have to find it. Sometimes you may have to move furniture or clutter away to best utilize the spot you want to shoot in. This is how you, as a professional, can help get the most out of a shoot, by being part of the decision making while respecting the needs of your subject.

58

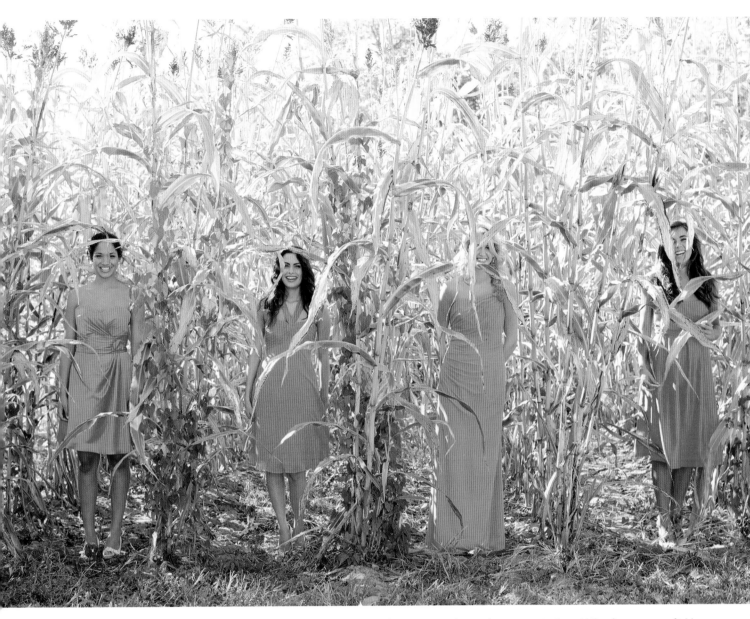

On an editorial shoot in Kentucky, we chose a spot in the middle of a sugarcane field. The bright light was a great way to showcase the hot pink dresses. To be sure I could clearly see all four girls, I stopped down my lens to f/5.6; my exposure was at 1/60 sec. to let lots of light into the frame.

Contax 645 with 80mm Zeiss lens, Fuji 400 NPH film, f/5.6 for 1/60 sec.

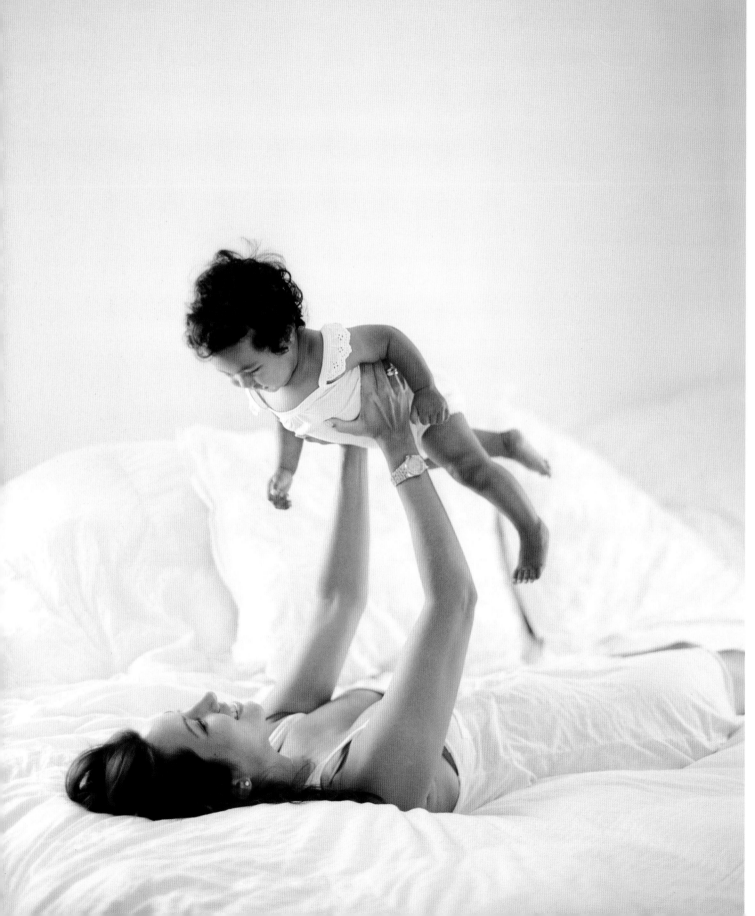

Guiding Your Subject to the Best Light

Opposite: This sweet image of a mother and child was taken in a white room with windows on either side (just outside the frame of the image). It was a sunny day, so the room was bathed in beautiful sunlight. As Stephanie held her little daughter above her, I took many, many images. (Whenever I photograph children, I shoot a lot. They are often moving targets, so the shoot can sometimes be unpredictable.) I love this shot, because it captures a special moment between them, and the image is so full of light. You can almost feel the warmth of the summer day.

Contax 645 with 80mm Zeiss lens, Fuji 800 NPZ film, f/4 for 1/125 sec.

Always orient your subject toward the most flattering light. What is the most flattering light? Window light that is diffused and soft, light that casts an even glow. I seek out light that illuminates my subjects but doesn't overpower them. What I avoid is really harsh sunlight. A sunny day can be amazing to experience, but harsh sunlight accentuates bad angles and wrinkles, and will detract from your portrait. In my work I seek softness and beauty every time.

Guiding someone into the best light is rooted in direction. Once you've identified the most flattering light source, encourage your subject into the light. If a subject is feeling shy or turning her head away from me, I gently encourage her to turn toward the window. The key here is that it's not just about seating her next to a window; it's about asking her in the right way to tilt her head toward the light.

Always offer positive feedback, especially when you are directing and posing. Any time you give guidance, like "Turn your head this way" or "Walk over here," make sure the dialogue between you and your subject is not about the photograph but about connecting in a different way, on a more human level. (For more on posing, see chapter 4.)

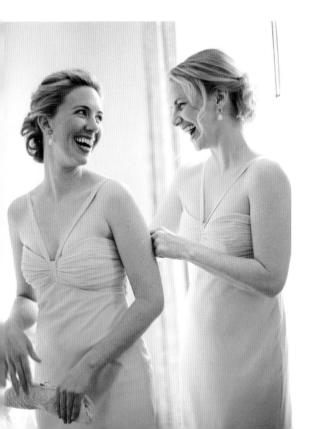

Left: One of my favorite times to photograph on a wedding day is while the bridal party is getting ready. These two bridesmaids shared a laugh while helping each other dress. You have to be prepared for these types of photojournalistic moments. I had noticed the two near a window where bright light flooded into the room. I watched, and as they started to laugh I was ready, camera in hand.

Contax 645 with 80mm Zeiss lens, Fuji 400 NPH film, f/4 for 1/60 sec.

The Nuances of Exposure

I always expose for the shadows. It is the most consistent element in my photographs. Shadows are the darkest part of your frame; if there isn't a clear and evident shadow, then expose for whatever is the darkest part of your frame, whether a dark shirt, a pair of blue jeans, or whatever requires the most light. If you have the darkest part, or the shadow, exposed properly, the lightest parts of the image will fill with a little more light to create a luminous look. It's not always the person's face I'm focusing on, though I certainly look to see if there are any shadows in the face, because I think it's critical to have the face glow and be as full of light as possible.

There are two ways to find out what the proper exposure for the darkest part of your frame should be. The first and most accurate is to use a spot meter. Hold the meter close to the shadow and take a reading. Then take a reading in an area that is lighter. You'll notice a difference in the results—the darker-shadowed area will require a longer exposure. That is the setting I use virtually every time. The second way is to use your camera to do the same thing—take readings from different areas of lightness and darkness. With your camera, get up close to your subject to obtain the most accurate reading.

Although a spot meter and your camera are good tools to figure out your exposure, nothing compares with experimentation: bracketing your exposures and making mistakes. If you shoot a variety of exposures and look at those images side by side, you will begin to see what works best for you in a particular lighting situation. You can then start to apply what you've seen firsthand at other shoots. Mistakes are the best learning tools and have always helped me. The first time I used a spot meter, I read it wrong and underexposed my images by more than 4 stops. I cried when I realized how badly I'd messed up—but I never made that mistake again.

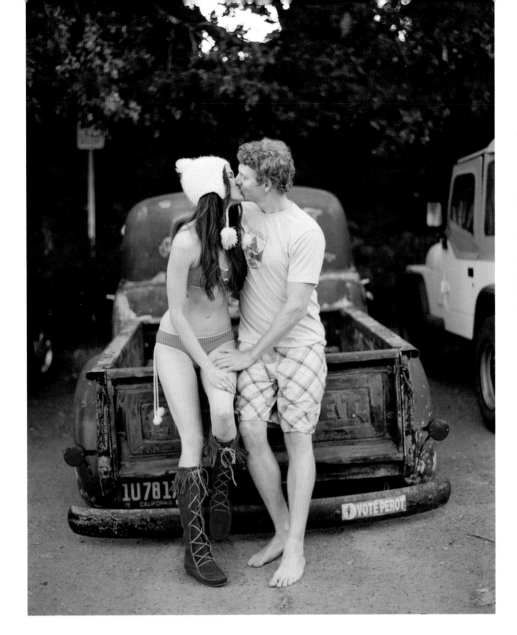

Love is beautiful. Here I'm on an engagement shoot with a sweet couple who had a little moment in the back of an old pickup truck. The day was overcast, which provided the flat, even light. I took several images of them embracing and then we headed down to the beach.

Contax 645 with 80mm Zeiss lens, Fuji 400 NPH film, f/4 for 1/60 sec.

When I look through my camera, I instinctively look at all the edges within the frame to assess certain things:

· Is the image framed as I want it to be? (We'll discuss composition more in chapter 4.)
· What is the darkest part of the frame?
· Where am I focusing?
· Where is my exposure? Keep in mind that I'm constantly asking myself these questions and making decisions, but it's all happening within split seconds.

As you shoot and compare different lighting situations and exposures, you'll begin to figure out what you prefer. You must see tangible results that you can assess by yourself. My preference is exposing for the shadows every time I shoot—this contributes to my signature style. When you are just starting out, you may have to meter or look at all corners of your frame and decide what works best. If you are metering for the darkest parts of your frame, you have to understand what that is doing to the lighter parts. As you expose for the darkest shadow, the lighter parts of your image will be overexposed, ensuring a luminous image virtually every time. I have incredible leeway with film; it's very forgiving and allows me to overexpose at will and still maintain the integrity of my image. With digital, you have to be a little more aware of how much light you are letting in and that you have less latitude with your exposures. The upside of digital, however, is that you have the freedom to check your image right there on site and assess your exposures and decisions along the way.

Here is my rule of thumb when it comes to aperture:
If I am less than ten feet away from my subject,
I use f/2. If I am more than ten feet away, I often
stop down to f/4 to ensure a clean and clear image.

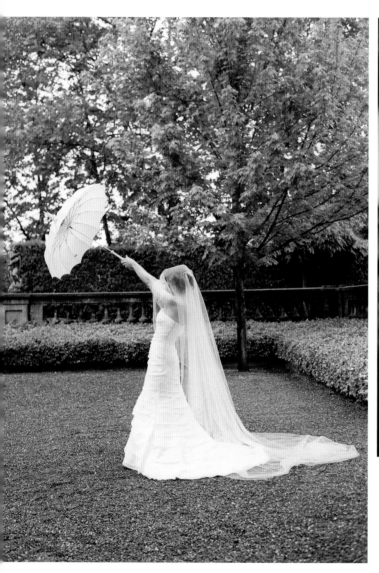

Even on a rainy day, wedding portraits can be luminous. The forecast called for rain, so this lovely bride came prepared with a beautiful umbrella the same color as her dress. Although it was drizzling, she was willing to have some photos taken outside.

Contax 645 with 80mm Zeiss lens, Fuji 800 NPZ film, f/4 for 1/60 sec.

This is a portrait of my father. He had been visiting for his birthday, so we made him a big chocolate cake. I lit the candles and made him wait for me to get a few images before he blew them out and we dug in. There is a large window directly behind me and another one at the other end of the house behind him. Although it was close to the end of the day, the windows provided just enough light to capture this moment. Remember: As you are building a body of work, you are not limited to using images from jobs. I often incorporate images from day-to-day life in my portfolios. I am always a photographer, even at home.

Contax 645 with 80mm Zeiss lens, Fuji 400 NPH film, f/2 for 1/30 sec.

The nuances of exposure are significant. The luminosity that appears in an image taken at f/2 for 1/60 sec. will be lost at 1/125 sec. Keep in mind that 1/60 is more than twice as long as 1/125. You are letting in twice as much light. (Every time you lower your shutter speed [say, from 1/60 to 1/125 or from 1/125 to 1/500], you are simply cutting the amount of light that comes into your frame by half.) This is why it is so important to vary your exposures, especially when you are just starting out. Try taking the same photo with two different shutter speeds, and then compare the images side by side. Notice the difference between the amount of light you've let in to each frame. Part of this is something you are doing at the shoot, and part of it is something you are doing when you are editing, looking at your work with a critical eye. As you compare your images side by side, figure out the nuances in different exposure settings You are then ready to deal with other parts of the shoot, like your subject's mood, or the light or weather that day, the location, and so on.

A lot more went into this playful shot than meets the eye. While shooting in a field for French designer Delphine Manivet, one of my assistants tirelessly combed through the grass collecting all the dandelions she could find—I think there were four in all— and I shot the image from several angles until we ran out of dandelions. My exposure was a little faster than normal (at 1/125 sec.) so that I could freeze the dandelion seeds as they dispersed in the air.

Contax 645 with 80mm Zeiss lens, Fuji 400 NPH film, f/2 for 1/250 sec.

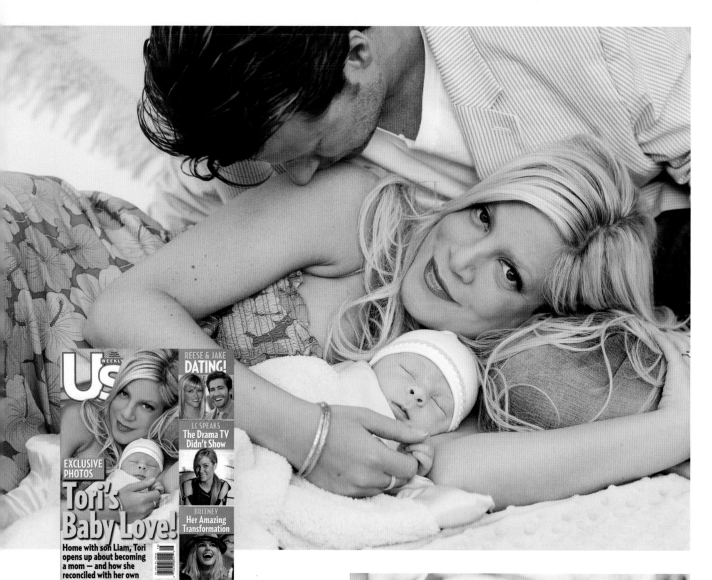

Above: This image of actress Tori Spelling with her husband, Dean McDermott, and their newborn son was created on a warm, bright spring day in the actress's backyard. The creative director had a specific spot in mind for the shot, and because it was very sunny I had to use a scrim or the light would have been way too harsh, especially for a baby. My assistant held a large scrim to soften the direct sunlight, so there were no harsh contrasts or shadows and the light was even and flattering. I focused on Tori's eyes while her husband snuggled her. Here's the image as I took it, and how *US* magazine cropped it for the cover.

Contax 645 with 80mm Zeiss lens, Fuji 800 NPZ film, f/5.6 for 1/60 sec.

Using Reflectors and Scrims

Reflectors can be wonderful tools for natural-light photographers like myself. I don't use them every time I shoot, but sometimes when I am backlighting a subject, I'll have an assistant use one to bounce some light back toward her to bring a little warmth back into her face. My favorite reflector is a simple white one, because the light reflected off it is not too intense. (Metallic reflectors can create a little too much contrast for my taste.) I suggest that you try as many different ones as you can and see which you like best.

I often use reflectors for editorial shoots when I am trying to get a cover image. When I am outdoors and backlighting my subject, a reflector helps me balance the light and tones of my image, slightly illuminating the shadows and creating a balance between sunlit background and my optimal exposure. (Reflectors aren't necessary for an overcast day.)

The best way to describe a scrim is that it's like a big reflector that you use to *filter* the sunlight rather than reflect it. If I wanted to shoot outside on a very bright day and mimic the feel of an overcast day, for example, I'd have my assistant hold a scrim between my subject and the sun to soften the light. Sometimes I simply use my reflector the same way, to filter the sun. You can get huge scrims and mount them on stands, but I prefer to move freely and change position a lot, so it works better for me not to use stands. I don't use scrims often, but when I do, I love how they soften direct sunlight. When I'm shooting for a magazine, I will often have a scrim on hand so that I can control my lighting options. If it's a really bright day, a scrim can be the perfect way to get the look I want.

The bottom line is this: I want to be able to control how I use the light. Just because it's natural doesn't mean you don't have options. You always have options, and the more you understand what they are, the more you can make images that are luminous, no matter what the lighting situation.

Creativity & Composition

This playful image of a mother and daughter outside their Virginia home was taken on a bright, sunny day in open shade. The shadow of their home gave us a perfect spot to be creative while providing soft, even light. I stood above the little girl and had her mom lie down next to her. I love the juxtaposition of their bodies, upside down and yet still connected. My camera was set at f/2 and my exposure was 1/125 sec., so the image is full of light. You can glimpse a little bit of movement and almost feel the pair's laughter.

Contax 645 with 80mm Zeiss lens, Fuji 400 NPH film, f/2 for 1/125 sec.

The key to unlocking your creativity and composing unique, impactful portraits time and again is a mix of solid artistic principles and an affinity for thinking outside the box. Before you press the shutter, you need to be aware of your artistic vision. Think about what inspires you and what type of images you want to create. If you are consistent in your technical execution, artistic expression, and compositional strength, you will be a successful photographer.

In art school, many students learn about design principles like the Rule of Thirds (a method used to determine where to place the main elements in an image's frame) and how to create clarity within the frame. Although a good foundation is important, there is so much more. Even more important than learning how to use the light to create luminous portraits is figuring out how to release your own creativity and vision. Once you've learned the basics of balancing a composition, operating your camera, and exposing properly, you can begin to explore your style. If you want to lure viewers into your portrait, you need to grab their attention within the first few seconds. How do you do this? Think of yourself as a chef with a camera. The rules you've learned are your recipes, and rather than using a measuring spoon, you season your work with your fingers, adding a dash of this or that, mixing in just the right ingredients to achieve the most enticing recipe. The best chefs, just like the top photographers, don't always follow written rules but instead improvise, experiment, and trust their instincts.

In this chapter I hope to help you discover your own artistry by suggesting certain creative tactics, such as overexposing your image, using lens flare, learning how to tell a story with one image, and, most important, trusting in yourself and your creative impulses.

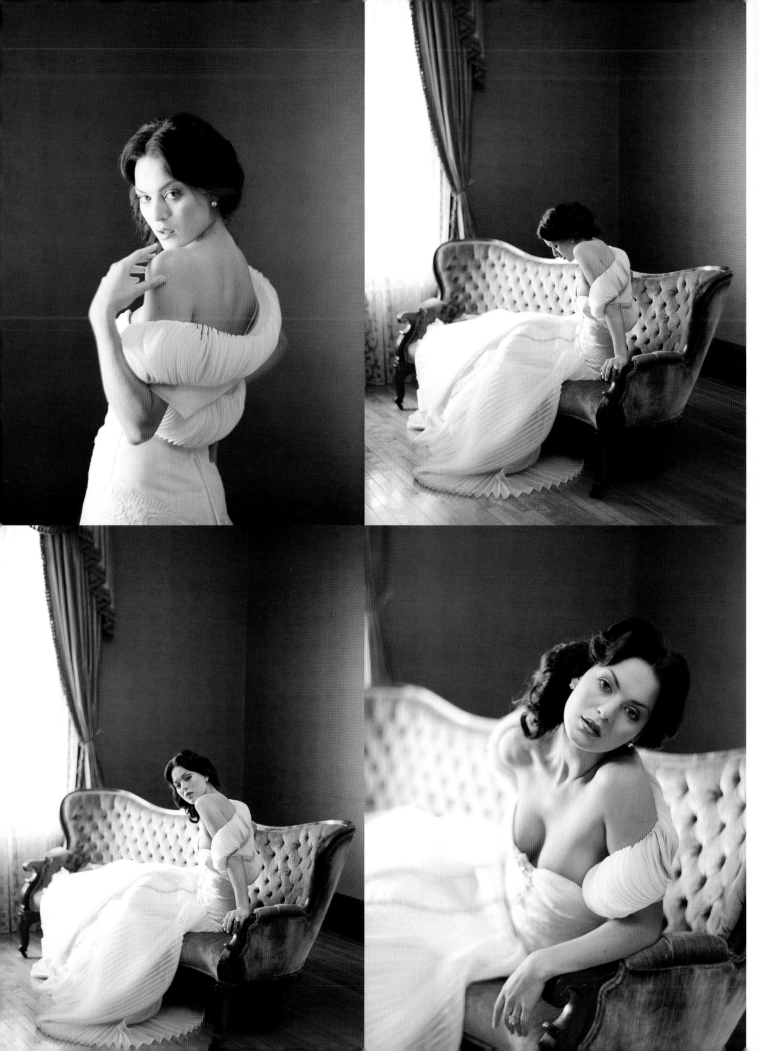

Accessing Artistry

Photography is an art form, and your artistry is most accessible when your skills and knowledge are solid and you can pursue your own creative vision. The most artistic images are those that are evocative and elicit a visceral response—perhaps the image triggers a memory in viewers or tugs at their heartstrings. When we capture a pure human emotion in an image, and it is beautifully lit and composed, we are not just photographers, but also artists.

While lighting and exposure are important elements of any good photograph, it is your personal artistry, individual style, and unique approach that contribute to a truly luminous portrait. For instance, let's say you've arrived at your location and met your subject, and after scouting the area you've found a couple of beautiful lighting situations, such as a large window in a bed-room or open shade in the backyard. You've also come prepared with all your gear—cameras, film or digital cards, extra batteries, and anything else you may need. Everything is charged, organized, and ready to go. Now what? This is when your style and creative vision step in and guide you to truly connect with your subject. Have you ever been at a portrait shoot, framing the subject through your lens, accessing the light and readying your exposure, when suddenly you get this feeling and just *know* that you need to push the shutter? Trust that feeling. The more in tune you are with yourself and the artist within you, the more you will recognize that moment when your creative spirit is driving you and your images.

Something that works for me as an artist is to constantly move around while I shoot—I hardly ever use zoom lenses but instead prefer a fixed-focal-length lens. This way I am physically part of the process in the composition of all my images. I am always framing and moving and framing again, which I find helps me remain continuously connected with my subject and the image throughout the course of the shoot. I never rely on my camera to do something I can do myself (like move around). By moving, I am also seeing the nuances of light and how it is hitting my subject from different angles.

Accessing your artistry begins when you trust your own instincts. As you move, you are orchestrating your composition as well as enabling yourself to constantly see light from different vantage points. If you do this while also interacting with and guiding your subject, you'll be on your way to creating an end product of which you can be proud. This is how you nurture the artist within you and begin to create a unique "style" in your photographs. There is only one you.

This series of images was done for a cover shoot of a wedding magazine. Here you can see how I move during a shoot. I always have the same focal length on my Contax 645 with 80mm Zeiss lens, so every change in composition and framing is due primarily to my changes in angle and closeness to my subject. I am also offering gentle guidance to my subject along the way, like "Look at me," "Tilt your head," and so on. A huge window in the old Victorian house we were in provided the only light source, but I did have my assistant stand to my right holding a white reflector to bring a little more light back toward the model's face. Although these images are still and quiet in feeling, there was a lot of movement behind the scenes. I was constantly moving my body to change the framing of the images, and had my assistant move with me. This movement is important to me. I prefer to rely on my body and my eye to compose the best image rather than on using a zoom lens. I feel that when I am closer to my subject, it is easier to capture a truly intimate moment.

Contax 645 with 80mm Zeiss lens, Fuji 800 NPZ film, f/4 for 1/60 sec.

Shooting from above, as well as posing my subjects upside down and backwards, often helps create a dynamic composition. It also allows an uncomfortable subject to become more relaxed. This image was created during a fashion shoot for *Grace Ormonde Wedding Style* magazine. The balance between intimacy and style was crucial here, and I love the way she is resting on him and he is gently touching her arm. It was also important to clearly see the beautiful earring that is framing the side of her face. In order to get even light, I had my assistant stand next to the couch with a white reflector and carefully shield the direct sunlight from my subjects. Meanwhile, I stood above them (rather precariously) and took a series of images.

Contax 645 with 80mm Zeiss lens, Ilford 400 XP2 film, f/4 for 1/60 sec.

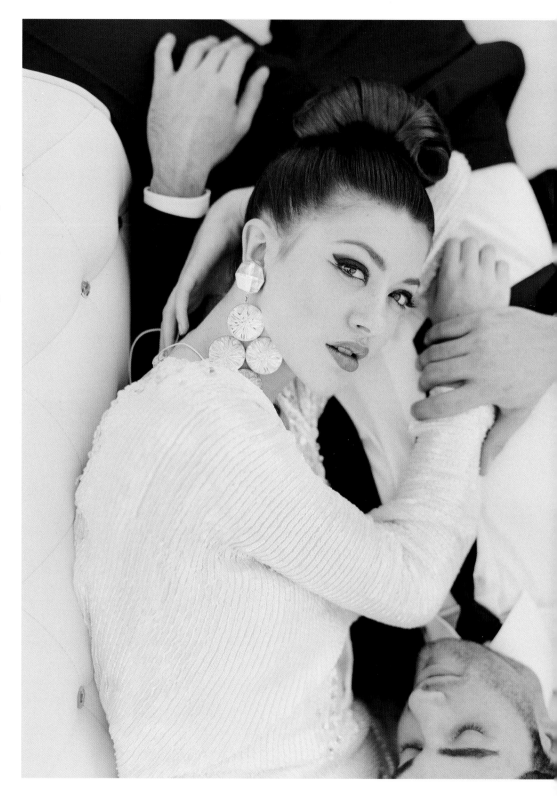

This was taken on a beach in Mexico right after this couple exchanged their wedding vows. We walked along the ocean's edge to take some images of the two of them together, and during our portraits, the groom was playing around a little. It was a particularly windy day, and he pretended to be swept back, as if the wind were blowing him away. It happened so fast, and I was only able to get a couple of frames of this moment and then it was gone. The day was overcast, and there was a lovely muted light all around us. Moments like this are ones you just can't plan for, but instead must always be ready to respond to.

Contax 645 with 80mm Zeiss lens, Fuji 800 NPZ film, f/2 for 1/250 sec.

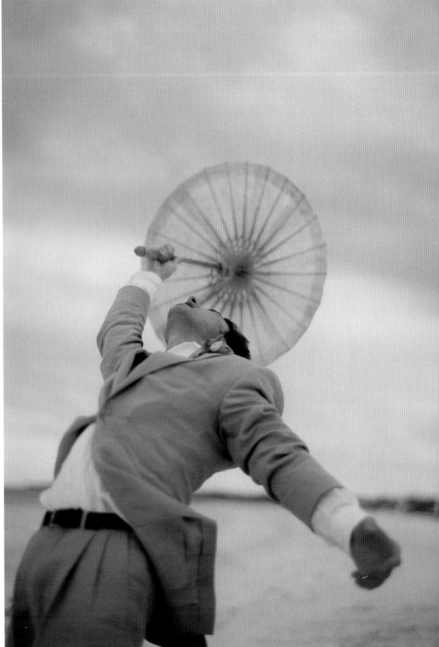

This image is a mix of opportunity, light, and magic. On a beautiful afternoon in Paris, I saw a little girl standing on a small brick wall, holding her arm up high and feeding a group of fluttering birds. I stood below her and began shooting (after asking her permission, of course). These little birds were moving really fast, and it was a bright day with a few fluffy white clouds, so I used a faster shutter speed while attempting to frame the birds and get a balanced, well-composed image. I shot through three rolls of film for this shot, but it was worth it. Sometimes, to get that one image you love, you have to make a lot of mediocre images along the way. It is part of the journey to becoming the photographer you want to be.

Contax 645 with 80mm Zeiss lens, Fuji 800 NPZ film, f/4 for 1/250 sec.

The Dance of Posing and Composing

Is there anything cuter than a baby's toes? Sometimes, if I really want to emphasize something, I'll crop out everything else. I placed this newborn boy in the middle of his parents' bed, and there were windows nearby that illuminated him perfectly. As I stood above the little one, he kept kicking his feet, and I just had to photograph them.

Contax 645 with 80mm Zeiss lens, Fuji 400 NPH film, f/2 for 1/125 sec.

The most important element to consider when posing your subject is, as ever, the light—always let the light determine where you will shoot. So consider yourself an observer of the light first, and a guide second. Your client has not just hired you for the end result, but for making the decisions and offering the direction that will lead to a beautiful portrait. For instance, if there is an interesting chair that you'd love to use in your shoot but it's hidden away in a dark corner, move it near a window, into the middle of the room, or, if you're feeling ambitious (and have permission), outside in the backyard. Always think outside the box and don't limit yourself to what is right in front of you. Participate and guide your subject into the most beautiful light.

As you encourage your subject to move and begin to pose her, remember to be gentle and respectful. When I am suggesting poses to a client, I think of it as a starting point, or a nudge. If I have moved that chair near a window or into a field, I'll ask my subject to sit in it and cross her legs or arch her neck. Always be polite and never, ever criticize. I stay positive while I work and always—both verbally and visually— encourage my subject. Once I've moved a chair into my desired window light and suggest a pose, then we begin to dance. To me, photography is not a static experience, so while I move and interact I notice and respond to what my subject does naturally, without my guidance. Every image is a collaboration between you, your camera, the light, your subject, and a moment that unfolds before your eyes. This is when the real magic happens—when the light is kind and flattering, when something natural happens, like a laugh or a gesture, and I have the desire to push my shutter.

Even if you are having difficulty capturing a particular pose, try to refrain from saying anything negative. It is your responsibility as both an artist and a professional to find your way out through a photo shoot that isn't flowing. Sometimes, for me, that means literally shooting my

way out of it. I'll keep taking photos, even if it isn't looking or feeling quite right, because the act of photographing often helps me get to a more beautiful place and helps relax my subjects. Other times I'll suggest a change of position, location, or outfit—this can help the shoot evolve.

One of the most important tips I can offer on posing and finding the perfect angle is that you need to move, too. You are part of the shot, so never rely solely on the position your subject is in. Be aware of your own body in the space and move a lot; move and continue to look through your lens. Sometimes a good image will become a great image if you move ever so slightly to the left or right, front or back. When I am photographing, you can find me all over the place—on the ground looking up, on a chair looking down, and everywhere in between. Light changes from all angles, so participate in finding the best light, the best angle, and the best pose.

If you are within earshot while I am photographing, chances are you'll hear me saying things like "Beautiful," "Oh, beautiful," over and over again. I even say that to men, which makes me laugh at myself sometimes. I might also give directives, such as "Don't move" or "Right there—perfect!" It all depends on the situation. Encouragement and positive words flow from me. What I do notice, though, is how affirmative comments affect whomever I am photographing in such a wonderful way. My enthusiasm is often met with equal enthusiasm from my subjects. Nothing is as powerful as genuine kindness—it will permeate your images.

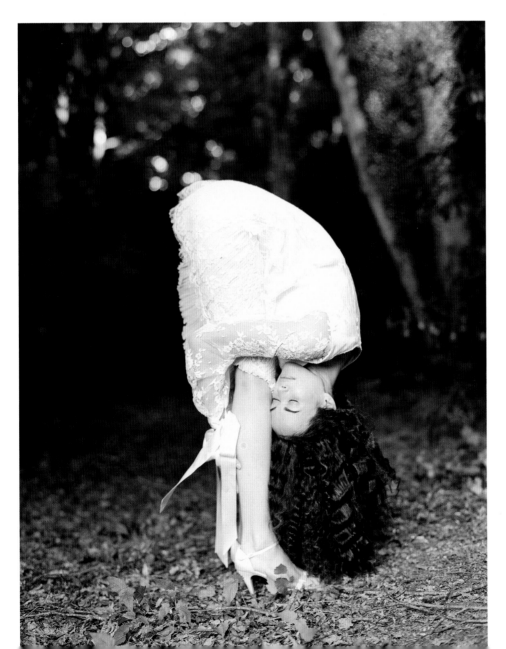

Getting to know your subjects is so important. After getting to know this lovely model, Gina, I learned that she loved yoga and was very flexible. And I just adore finding new ways of photographing people upside down. So when I asked her if she could rest her head on her knees, she happily complied. I highly recommend taking the time to talk with your subjects. Not only can you learn something personal about them that can help create a comfortable space while you are shooting but you just may find out something you'll want to incorporate into your photographs, as well.

Contax 645 with 80mm Zeiss lens, Ilford XP2 film (printed with sepia tones), f/2 for 1/60 sec.

75

Flare and Overexposure

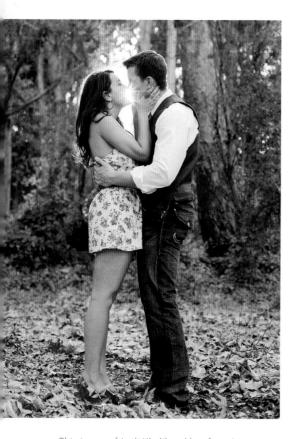

This image of Leili Khalil and her fiancé is an example of creative use of flare. I positioned them with the sun directly behind them, and instead of having them block the sunlight (as I often do), I asked them to pull back just a little from their kiss, so just a bit of the sun's rays came through between their lips. My exposure was for the shadow. If I had exposed for the brightest part of the sunlight, the image would have been much darker and would have looked more like a silhouette. Instead the image is bright and full of light.

Contax 645 with 80mm Zeiss lens, Fuji 400 NPH film, f/2 for 1/125 sec.

Lens flare occurs when light reflects inside the lens of the camera. The light bounces off the camera lens and components inside the lens and camera to create a starburst effect. Most photographers try to avoid lens flare, but I love it for the artistic and dramatic effects it can create when used correctly.

There are many ways to incorporate flare into your images. To experiment, try taking an image with the lens pointed near the sun (try this at dawn or dusk, so the sun is closer to the horizon than at midday). The light produced by the sun will bounce around the inside of your lens and create a natural flare effect. If you want to minimize flare, use a lens hood or have an assistant nearby to shade your lens from the sun's direct rays.

Another approach is to position your subject in front of the light, but not completely obscuring it. This is one of my favorite ways to incorporate flare within a photograph. This will create a silhouette and allow the sun's rays to obscure part of your subject. It also creates a "washed-out" effect, where the rays of light reduce the contrast and vibrancy of objects in the foreground. Again, this is one more artistic approach you can employ to create your own unique style.

Be sure not to overuse any one type of look or style, however. The decision of when to use lens flare or any other distinctive "look" must be made on a case-by-case basis. Sometimes you'll make this decision while shooting; other times you'll decide in the editing process. For instance, if I happen to be photographing a dozen different couples on a dozen different afternoons, some of my decisions will be made for me by the type of day it is. If half of those days are overcast, a "flare" image isn't an option, but for the six other couples, I might be shooting on a sunny afternoon, in which case I might use some flare. One shot I love capturing is a couple kissing (or rather, just about to kiss), so the sunlight comes between their almost-touching lips. This shot, when it works, is just beautiful. You get a lovely flare where a kiss should be—sweet and evocative, visually capturing the sparks between them. It isn't the easiest shot to get, and doesn't always work because often the sun will flood my lens too much or the image will have too much

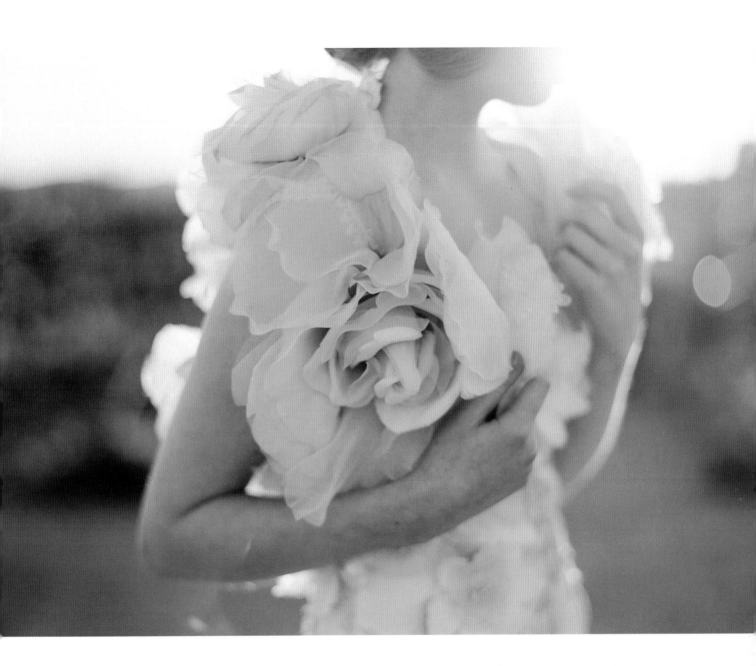

Learning how and when to overexpose and shoot into the sun is important for any photographer. It is often most successful early in the morning or late in the day, while the sun is low on the horizon. I exposed for the darkest part of the image and let the sun fill my frame on the upper right-hand side. You may have to experiment with your exposure to get this effect.

Contax 645 with 80mm Zeiss lens, Ilford XP film, f/2 for 1/125 sec.

light. It's also hard to focus when shooting straight into the sun, resulting in images in which the flare works well but the couple is slightly out of focus. The shot can also look overposed, since this kind of image requires a fair amount of setup and direction. Even if I photograph all six couples with flare between them, no two images will look the same, and perhaps only one will turn out successfully. Editing becomes essential here: You must be able to look at your images after the shoot and get rid of those that just didn't work. Never be so attached to an idea for an image that you can't assess the actual image afterward. This is another reason to shoot a lot, varying your posing, your exposure, and your lighting choices.

Evoking Emotion

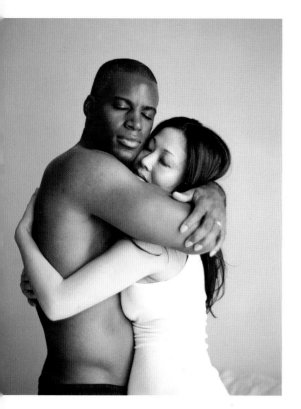

Capturing emotion in an image occurs when you achieve a beautiful balance between framing, lighting, and the nuanced expression of your subject. The magic happens when you, as the photographer, tap into the human experience that we can all relate to, whether it is a mother cradling a child, lovers embracing, or a couple kissing. We all have mothers, we've all been kissed (hopefully)—tap into that shared human experience and the emotion will follow. This is where you once again must rely on your inner feelings of when to push the shutter. No one can tell you the precise moment to make an image; only you can decide when the moment is right.

We already discussed one creative way to do this: using lens or sun flare between the lips of couples kissing, especially newlyweds. Another way to evoke emotion is through environmental portraiture. When you place your subjects in a location that has meaning for them, you instantly convey more about them. Seeing their surroundings can tell more of a story than a tight close-up can (which also tells a story, but in a different way). When I work, I like to do both very close-up images and some that incorporate my subject's surroundings.

A simple embrace of a couple who'd just had twin boys. I was there to do the boys' first portraits, but I was so moved by the sweetness of their mom and dad that I took several images of the parents alone as the newborns lay on the bed next to us. Two windows provided the light source for this portrait.

Contax 645 with 80mm Zeiss lens, Ilford 400 XP2 film, f/2 for 1/60 sec.

Opposite: Less is often more when making compositional choices. This image is so still and quiet that it allows the viewer to experience a variety of emotions. The light is balanced around the girl; the window and the light hold her gently within the frame. Play with light and framing within your image, and see how your results vary as you move and change your exposure.

Contax 645 with 80mm Zeiss lens, Fuji 400 NPH film, f/2 for 1/60 sec.

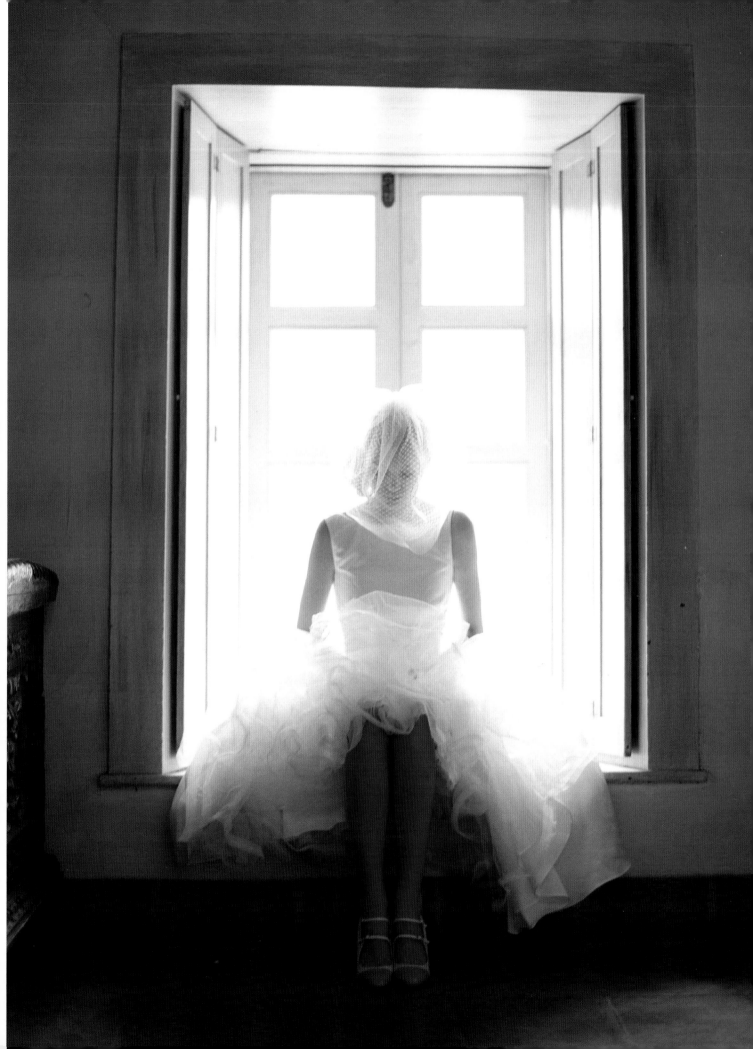

Trust Your Instincts and Let Go

Insight

I try to create something unique in each moment I am in, and resist the desire to re-create an image I've already done in the past (even if I know it works). Even when I use similar lighting situations, I always try to be authentic and in that moment. Allow yourself to experiment and evolve, to be inspired and to inspire. Let the environment, your subject, and the light awaken the artist within you.

Remember that old adage, "A picture is worth a thousand words"? Well, it's true, even with just a snapshot. As photographers, we are storytellers, and while a series of images together can tell a story about a person, telling a story with a single image is a truly special feat. To do this, you must ask yourself what you are trying to convey. Is it love, laughter, desire, joy, movement, stillness? As an artist, I am in search of beauty. I want my photographs to be artfully crafted and evocative. Of course, I am not always successful, but that is what drives me. My love for photography is constant. There are moments during any shoot when I really feel something in my gut, something that tells me I am documenting a special moment, and I trust that feeling. The more you overplan and overcompose ahead of time, the more you risk missing the magic in front of you. Be prepared, of course, but then release everything you think you know and allow yourself the freedom to respond and capture what's in front of you. Art happens where preparation and opportunity unexpectedly collide. A photograph that shares more than information, but also emotion, begins to truly tell a story.

There is an image I once took of a woman peering out of a car window just before she was about to walk down the aisle at her wedding. Only half of her face is visible, and you can't even see that she has on a wedding dress, yet it speaks volumes about anticipation and love. This photograph tells a story. It's an image that makes you pause and wonder what's going on. What is she thinking? What is she looking at? It raises questions and creates a narrative. In another image, one of a couple snuggling beneath a heart, there is simple sweetness in this visual representation of love. The gesture of their bodies, the gentle light, the heart above them—all of these intertwine to create a compelling scenario and a timeless feel. These images capture the stories of our lives.

These models embraced while I photographed them for *San Francisco Bride* magazine. On an impulse, I drew a heart above their heads. I am always following little impulses like that. Sometimes they don't work at all; other times they add a little sweetness that works. The important thing is to always be open to new ideas.

Contax 645 with 80mm Zeiss lens, Fuji 400 film, f/4 for 1/60 sec.

Moments before her wedding to NBA star Elton Brand, the very beautiful Shahara peered out the window of this vintage Rolls-Royce. This is one of my all-time favorite images. The soft light of the overcast day catches the serene look on her face.

Contax 645 with 80mm Zeiss lens, Ilford 3200 film, f/2 for 1/250 sec.

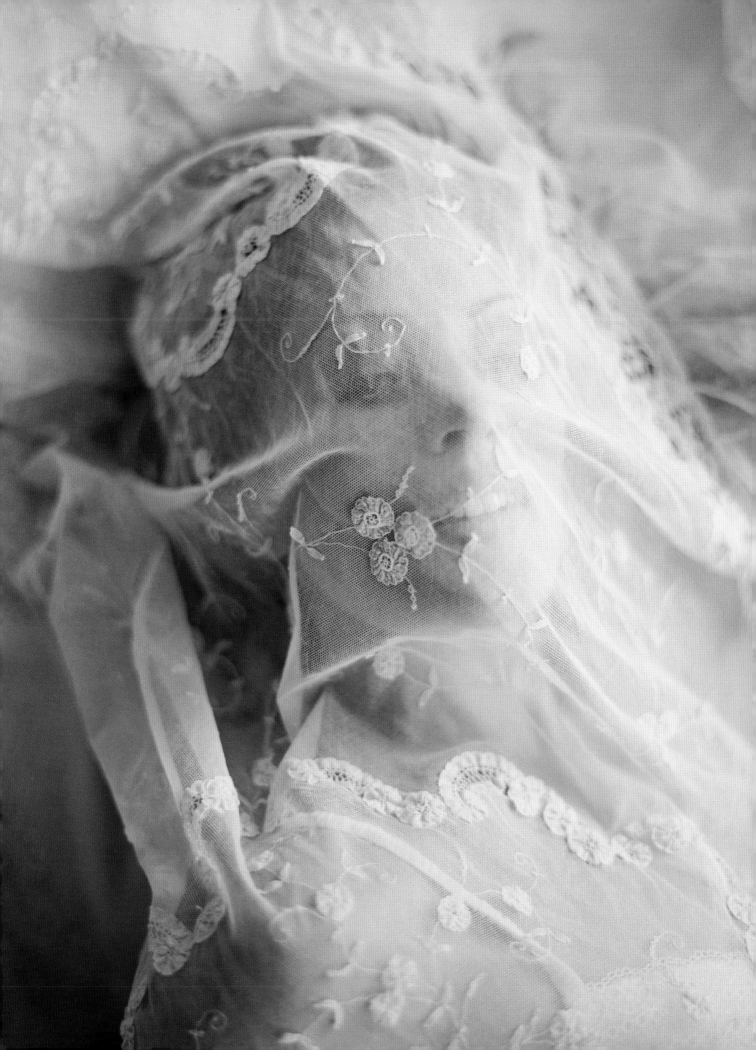

The *Sweet Underneath*

Boudoir & Maternity Portraits

This image perfectly conveys the power and softness of boudoir. Notice how the vintage lace simultaneously obscures and reveals the subject's face, while catching diffused window light. Although we see no nudity, the light suggests a private moment. I have exposed for the shadows on the left side of her face. The other side is so bright that you lose most of the detail, yet there is enough balance and information within the frame that the image still holds up. This would be a perfect situation in which to experiment with exposure. I prefer the lightness within this shot, but you may prefer a slightly darker image that isn't as blown out.

Contax 645 with 80mm Zeiss lens, Fuji 400 NPH film, f/2 for 1/60 sec.

Boudoir photography is the art of creating suggestive, sensual photographs, including maternity portraits. It's an art form that is as old as the earliest photographic processes, distinct from overtly sexual photography in its emphasis on the aesthetic qualities of the subject and the craftsmanship of the photographic process. As an artist, I adore the subtleties of boudoir: that combination of beautiful light and the exquisite female form. Some of my first boudoir images were of a woman on her wedding day, half-dressed and full of anticipation. Over time my boudoir photographs have evolved to include all types of women, capturing various times in their lives. The one thing that has remained constant is my use of natural light. For me, that is the most important element of boudoir.

Boudoir photography has the power to tell sweet stories of desire through artistic, alluring imagery. Successful boudoir is often more about what you *don't* see than what you do. It hints of things to come, of intimacy and affection, of longing and love. The most successful boudoir images capture that "in-between" space—in between anticipation and desire, love and intimacy, expectation and longing. It is a dance between light and vulnerability. I attempt to capture what I call "the sweet underneath," the beauty just beneath the surface of each woman.

Many women, of course, feel vulnerable when they disrobe, and as a photographer, you must be extra sensitive to your subjects' comfort level (both physically and emotionally). This is especially true in the case of maternity shots. Photographing a pregnant woman in this exposed state is something that can be challenging but also beautiful when you have chosen flattering, natural light.

The Art of Boudoir

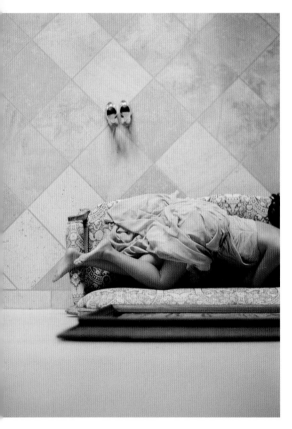

Some boudoir images are not revealing at all yet still convey a feeling of intimacy. I photographed this image from a balcony looking down on the girl as she lay across the coach. Light from French doors across the room is even throughout the fame. Her tousled dress and shoes cast to the side suggest a private moment. This is the power and beauty of boudoir.

Contax 645 with 80mm Zeiss lens, Fuji 800 NPZ film, f/2 for 1/60 sec.

Typically, boudoir images are done for women who want them as personal gifts for their husbands, partners, or themselves. There are times when I photograph couples during these sessions, but that is infrequent; for the most part I'm working with women. Whenever possible, I prefer to be in my subject's own environment, where she can feel as relaxed and comfortable as possible.

There are many ways to incorporate boudoir photography into your repertoire, such as capturing a bride getting dressed on her wedding day (there is something so beautiful about an unbuttoned wedding gown, or showing a pregnant woman with a full, supple belly). While for some pregnancy may seem like the most unlikely kind of boudoir imagery, there is something very sensual about the inner glow and full curves of an expectant mother.

Natural light is one of the most important elements of boudoir photographs, and your knowledge and use of it are critical in this type of intimate photography. I prefer soft, warm light, preferably window light. The light levels can sometimes be low when you are indoors (where most of my sessions take place), so fast lenses and high-ISO-capable cameras (or film) can be helpful. I always use at least ISO 400 speed film, and often will employ 800 and even 3200. (If you are shooting with a digital camera, you'll have even more options to vary your ISO settings and exposures.) At a minimum, my lenses will have an f-stop of 2, which will allow not only more light into my frame but also a greater depth of field to enhance the softness of my photographs.

I've noticed over time that I tend to shoot more black-and-white and sepia film during my boudoir shoots. Black-and-white images have a timeless feel and can be very flattering. Color can also be beautiful if it's exposed softly. I used to use Kodak Portra CN black-and-white film for my black-and-white and sepia images, but sadly, it is no longer being produced. Now I use mostly Ilford XP2, which is basically black-and-white film processed in color chemicals (C-41 process). It gradates

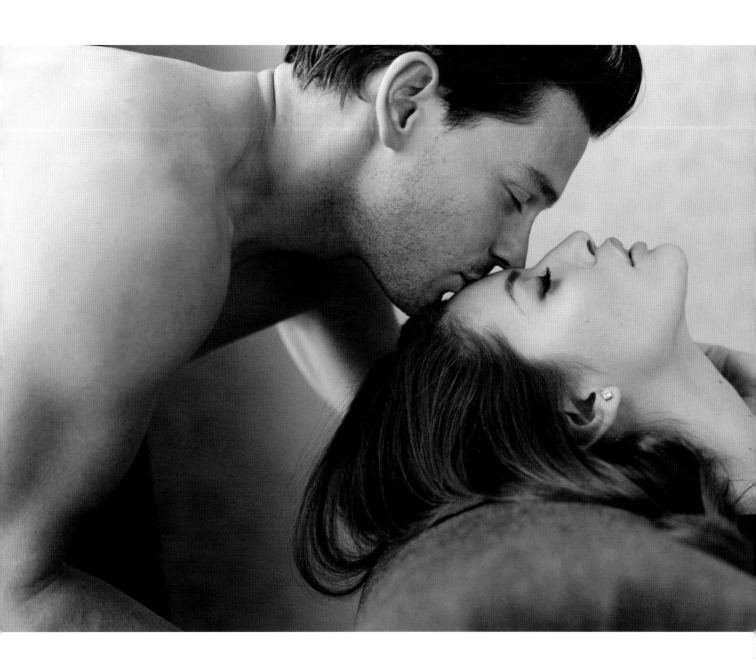

Boudoir that shows nothing at all can be so moving. Here it feels almost as though we are intruding on a private moment. There was a window behind me that cast a soft, even light on this couple, and I cropped the frame so that there is no hint of clothing, enhancing the feeling of intimacy. I posed the couple, as I often do, upside down from each other, which added to the composition. The image feels so real to me, I sometimes forget these were models cast for a boudoir shoot. Lighting, nuanced gestures, and composition can add depth and meaning even to a posed image.

Contax 645 with 80mm Zeiss lens, Kodak Portra 400CN film (printed sepia), f/4 for 1/60 sec.

to lovely black-and-white tones as well as the warm brown tones that I love so much.

Ultimately, successful boudoir photography depends on several key elements: finding soft light to work with that flatters your subject and enhances the mood and feel of the image; respecting your subject's comfort level; and using composition, direction, and certain types of clothing or material to highlight a woman's best features without being overtly sexual or inappropriate.

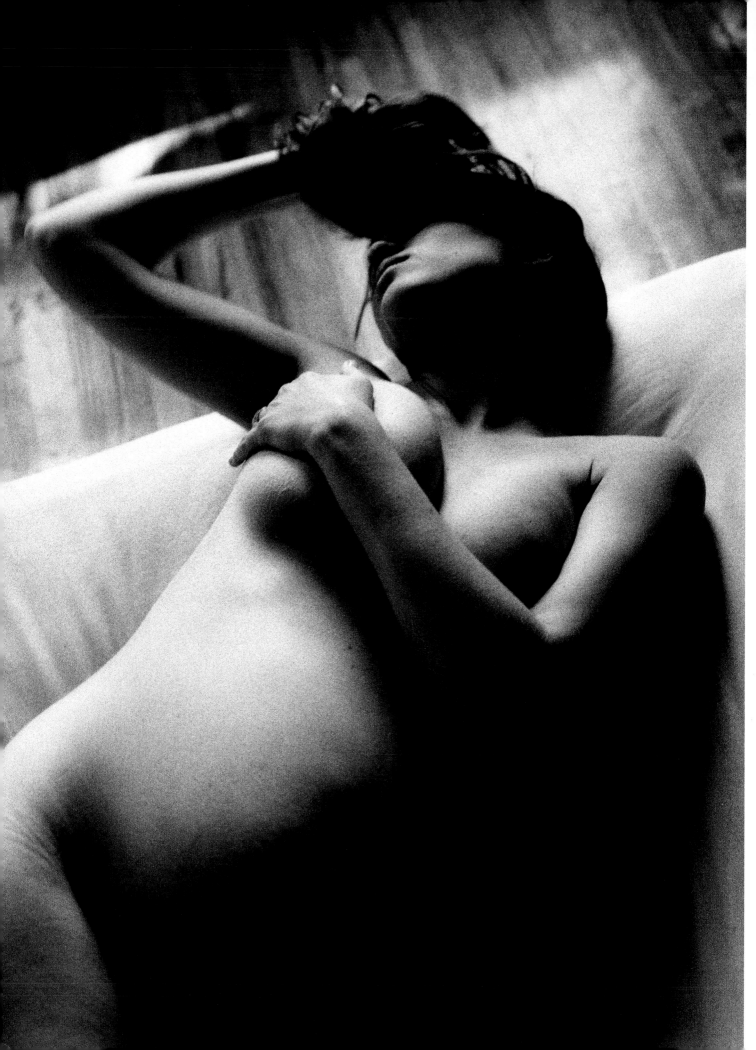

Finding the Most Flattering Light

It is here, in "the sweet underneath," where lighting—even at its most subdued—might be more important than in any other type of photography. This is not to say that you need complicated setups or additional lighting to achieve a beautiful image. In fact, for me the opposite holds true.

My lighting during boudoir sessions is simple and pure. I go out of my way to avoid harsh, bright light, especially here, where a woman may already be feeling vulnerable and wanting to minimize as many "flaws" as possible, real or imagined.

Window light is especially flattering for boudoir portraiture, because it often provides more diffused light and is therefore a gentler way to light the curves of a female form. Look for soft, even light rather than very bright, direct sunlight. Again, as in almost all the situations I describe, it's crucial to expose for the shadows. After you place your subject near window light, your exposure should be for the darkest part of your composition: Set your camera's aperture to f/2 for 1/60 sec. Digital shooters can try different ISOs, from 100 on up, and over time you'll begin to learn which combination of light, pose, and camera setting works best for you.

Light is probably the most important element to be aware of when photographing a pregnant woman. This is a vulnerable time for most women, as they are often full of new curves. This portrait of Jo Gartin of Love, Luck & Angels was taken just days before the birth of her son. The light from her bedroom window is minimal, and the shadows almost work as a blanket. She is both exposed and protected.

Contax 645 with 80mm Zeiss lens, Ilford 3200 film, f/4 for 1/60 sec.

It is important to be aware of where the light is hitting your subject. Notice how, in the image opposite, light from a nearby window caresses the woman's cheek, breast, and side. See how the light shows us part of her face? If her head were turned the other way, you wouldn't see that lovely shape of her jawline. The interesting part of this image is that the woman is nine months' pregnant, but since her belly is in shadow, you don't see how full her curves are. Compare that to the bottom image on page 89, for example, where the room is full of light and we can see everything. Light and composition are tools to draw the viewer's gaze to certain areas within a frame, and your choices impact the feel and look of the final image. Lighting is essential, and the more you recognize how it changes from situation to situation, the better you can utilize it for images with dramatic impact.

I love to overexpose a little whenever possible in my boudoir images. Occasionally, but only if my client is really comfortable and I feel I need it, I might have my assistant come in with a reflector for use by the window. This helps bounce a little light back toward my subject. More often than not, though, I don't use a reflector. Instead, I try to work with what is in front of me. I also seek out clean, white fabrics and window light.

There are some situations in which a woman will go outdoors and be comfortable enough partially undressed, which I love. During those times I seek out open shade, because it possesses that same soft quality, or backlight on occasion to accentuate the curve on an expectant mother's full belly. The light you choose works best if it reflects the mood of the image.

The Vulnerable Subject:
Soft Light and
Gentle Guidance

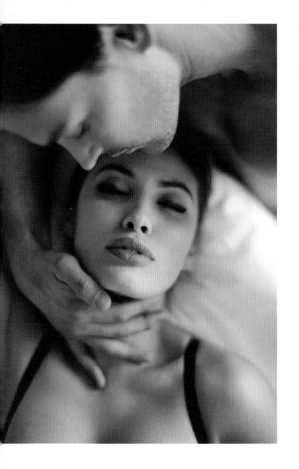

The very first step in any boudoir or maternity session is to create a safe space for your subject. The more you are aware of her feelings, the more you can create a truly beautiful image. She must trust you enough to relax in front of you, even when in various states of undress. Sometimes I'll put my camera down and simply have a conversation first. Good communication leads to more successful images. As a woman, I can understand my subject's sense of vulnerability. It is in these moments that we relate to each other personally and thus create an authentic connection. We may, for instance, share stories about our fist kiss or perhaps our favorite shoes. Being tuned in to your subject's feelings also means being extrasensitive to the most flattering light, composition, and exposure. I'm constantly considering professional photography details like these, even while having a more personal conversation. This balance—between forming an authentic connection with your subject while simultaneously assessing and evaluating the light—works to create memorable boudoir images.

Desire is hard to put into words, let alone photographs. Here there is so much emotion filling a rather small frame, and the gesture of his hand on her neck creates tension in the image. It is so gentle, and yet she is so vulnerable. Every couple has a private language, the way they speak to each other and touch each other when no one else is around. I love to be present and so close to my subjects and still capture such an intimate moment. To get this frame, I shot a lot—so much, in fact, that I think they were able to almost forget I was there. There was a window to the right of them, but it didn't provide a lot of light.

Contax 645 with 80mm Zeiss lens, Kodak Portra 400CN film, f/2 for 1/60 sec.

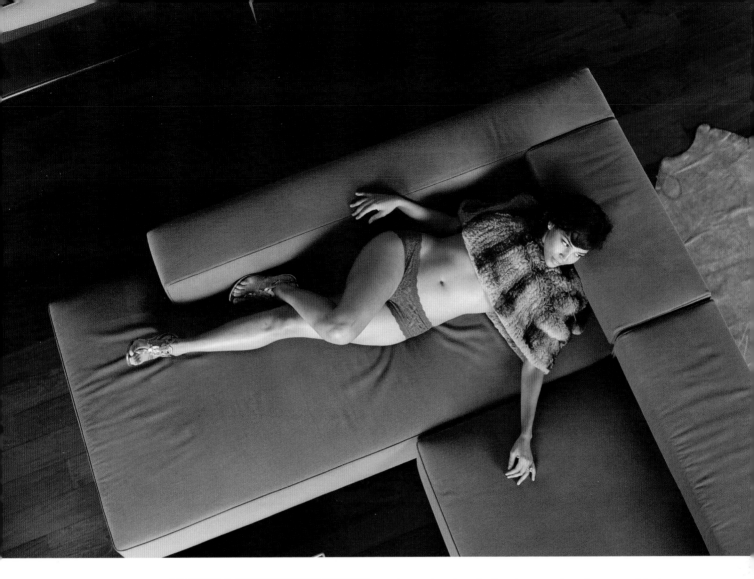

Above: I love how this boudoir image from far away still feels intimate. The window light falls on her face and form, so we can clearly see her beauty. Natural light does this so well. Since I was a bit farther away, I stopped down to f/4 to ensure that the expression on her face would be clear and easily read (at my usual f-stop of f/2, the image would have been too soft if my focus was off by even just a little bit). I am seeing her clearly, but I'm not allowing too much detail to be in focus, because I still want to maintain a soft feeling overall.

Contax 645 with 80mm Zeiss lens, Fuji 800 NPZ film, f/4 for 1/60 sec.

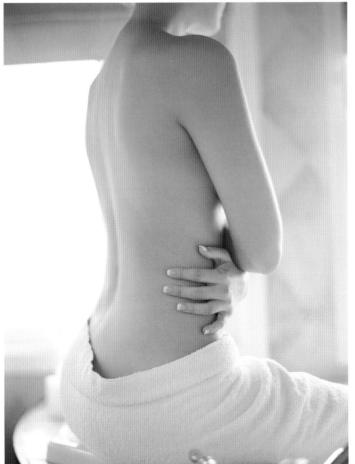

I created this intimate image while photographing promotional shots for the Kenwood Spa. The model sat on the edge of a Jacuzzi in windowed room filled with natural light. I focused on the model's manicured hand. She is undressed and yet not fully exposed to the camera. The resulting image is clean and very bright, while also mildly suggestive.

Contax 645 with 80mm Zeiss lens, Fuji 400 NPH film, f/2 for 1/60 sec.

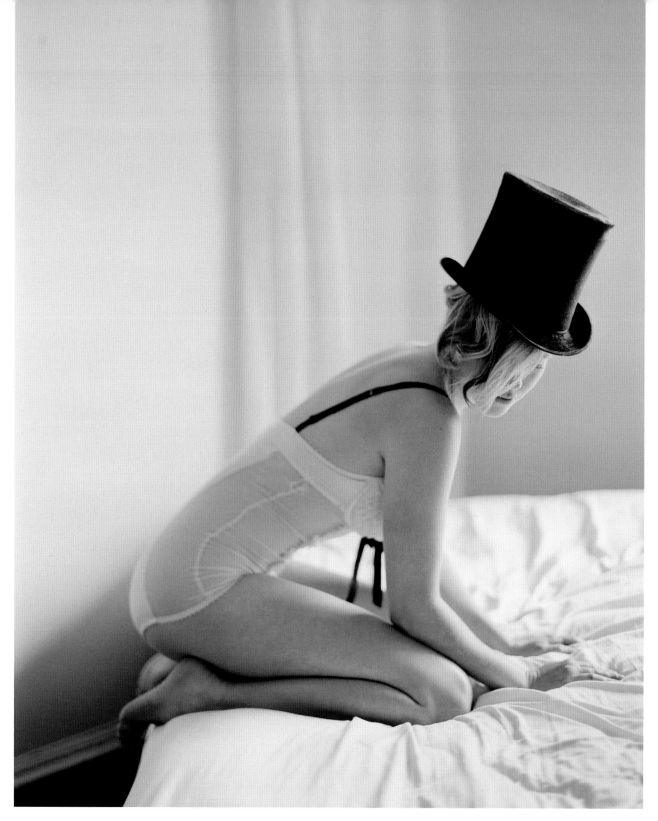

I love the balance in this image. The simple tonal quality of the background and my subject's lingerie perfectly balances the dark tones of the vintage top hat and bra straps. There is also balance in her gesture, the way she is bending forward, relaxed yet strong. She even feels a little shy to me, as if the hat gives her a little protection. Always pay attention to where the light falls on your subject—here, the light is coming from a single window and perfectly captures the side of her face.

Contax 645 with 80mm Zeiss lens, Ilford 400 XP film, f/4 for 1/60 sec.

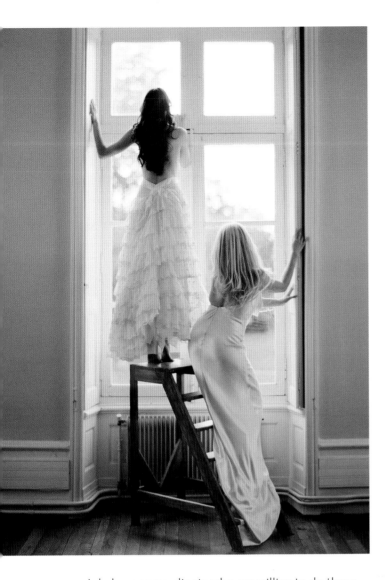

This image was taken during a bridal fashion shoot in France, and it may be one of my favorite images ever. Having two women in the frame feels unexpected and raises questions: Who are they? Where are they? What are they doing? I love that you do not know exactly what is going on, yet at the same time, I am so drawn to the beauty and to the light that bathes them in softness. The girls are facing the window, looking directly into the late-afternoon sunlight.

Contax 645 with 80mm Zeiss lens, Ilford 400 XP film, f/4 for 1/60 sec.

I do have some clients who are willing to do these sessions outdoors, but in those instances, I make sure we are in an area where we won't be easily seen and where the subject won't feel exposed. I cannot emphasize enough how important the physical and mental comfort of your subject is.

Keep in mind that it's not necessary to be up close to compose powerful boudoir images. Sometimes, pulling back can create images with stronger impact. I sometimes prefer to shoot from overhead or several feet away to create a more voyeuristic feel. In the image of a woman on a couch shown on page 89, I'm on a balcony about fifteen feet above my subject, and although she is partially clothed, the mood of the image still feels sensual and relaxed, as light from several large windows cascades across her body and accentuates her curves.

Once your subject is comfortable and you have made some choices about light and location, gently guide her into the most flattering poses. Often, I ask my subject to lie down and perhaps tilt her hips a little to the side, because the more curvy she is, the softer the feel of the image. I might focus on her fingertips or the curve of her waist. Again, soft light is absolutely essential in creating an intimate and flattering look. With my aperture at f/2, my shutter is wide open and much of the frame will be out of focus, with only the precise area I focus on being clear. I prefer not to see too much background detail in these kinds of shots; the shallow depth of field enhances a feeling of softness.

I am very thoughtful and aware of posing during a boudoir session because, to me, angles and curves are often more flattering to the natural shape of a woman's body. Having your subject lie flat on her back is not a good idea. What is helpful is to offer gentle direction. Guide your subject to bend her knee or turn toward the window. Any gesture that accentuates the natural angles of a female body is often more flattering in an image—just try not to "overpose" or overthink it.

91

Less Is More

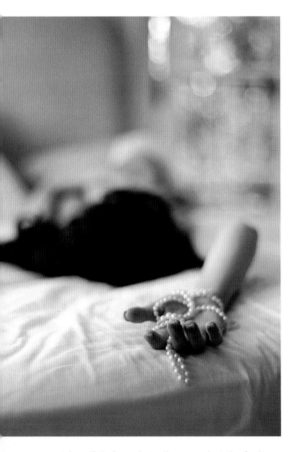

A handful of pearls is all we see, but the feeling of boudoir is still present. This is an intimate, suggestive image, full of soft, flattering window light. I like that we do not see much of the woman at all.

Contax 645 with 80mm Zeiss lens, Kodak Portra 400CN film (printed sepia), f/2 for 1/60 sec.

Every woman possesses an innate sensuality that is utterly unique, like a fingerprint. The beauty of shooting boudoir lies in capturing something just beneath the surface of what the viewer can see. When you are talking about someone showing more skin, and you are photographing her in a sensual way, your light and focus need to be soft. That way, your images will be much more flattering and powerful (in terms of the suggestion of intimacy). Just showing the peek of a curve or the lacy edging on a piece of lingerie can be much more suggestive than putting it all right out there. The same goes for focusing on more private areas, like capturing the curve of a breast. I prefer not to show the whole breast but rather a partially covered or obscured view of the bosom. I also like photographing the curve of a woman's shoulder, the hollow of her neck, the look on her face—there are so many possibilities.

One example of how less can be more is conveyed in the image shown on page 95, which I shot in the bathroom of a hotel while working on an editorial shoot. A window was directly behind the girl, and I exposed for the shadows on her face using an f-stop of 2.0 for 1/60 sec. Because I exposed for the darkest part of the image (so you can see it clearly and it feels pleasing to the eye), the lighter parts, like the backlit area behind her, are even brighter, contributing to the overall luminous quality.

In addition to loving the light in this image, I am struck by the gesture of the woman's body and the way she is pressed up against the shower door, as though it were her lover. The mood is one of mystery and longing. There's even a cinematic quality to this shot, as if you are seeing a glimpse into the middle of an emotional story that is unfolding. The woman's body is not fully revealed or undressed, yet the image is brimming with desire and sensuality. With boudoir, there is so much you can say with lighting and composition. You can create a dialogue between image and viewer without saying a word. If you show too much, you lose the power of having your viewer want to see more.

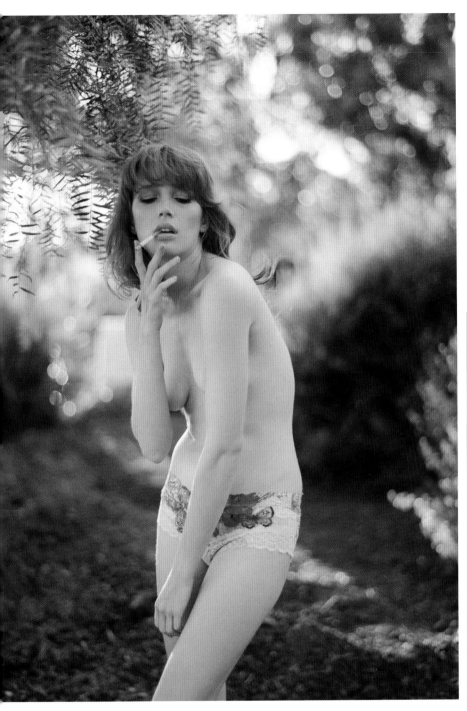

This shot was taken on a break during a shoot for Claire Pettibone's butterfly lingerie line. It was a warm, windy day in Malibu, and as the model stood unself-conscious in the backyard, I took a few frames of her. Notice how the light in the tree behind her almost glistens—I achieved this by shooting toward the sun but with the tree slightly diffusing the direct light from my lens. We clearly see that she is topless, and yet her arms gracefully cover her breasts. This, to me, is a good illustration of how the concept of "less is more" can work beautifully in boudoir.

Contax 645 with 80mm Zeiss lens, Fuji 400 NPH film, f/2 for 1/60 sec.

Although most of my boudoir images are of women, sometimes I do photograph couples together. I love the suggestion of intimacy here, how her hands are pulling at his buttons and yet we hardly see any skin at all.

Contax 645 with 80mm Zeiss lens, Fuji 400 NPH film, f/2 for 1/60 sec.

93

Opposite: I love to create a voyeuristic feel in my boudoir images. Here, the shower door created tension in the composition while accentuating the glow of the window light behind her.

Contax 645 with 80mm Zeiss lens, Kodak Portra 400CN film (printed sepia), f/2 for 1/60 sec.

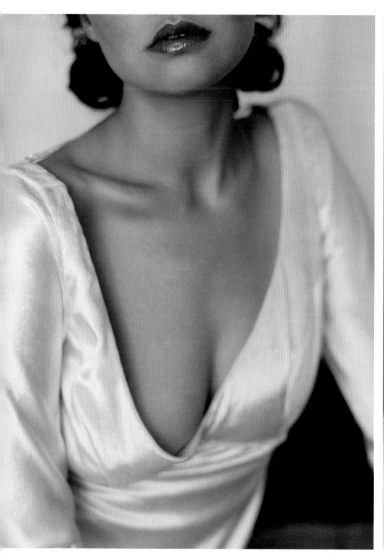

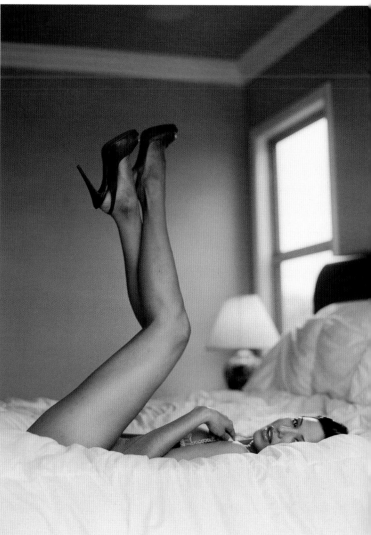

This image of a woman in a wedding gown is so sensual to me. The shapes of her mouth and breasts are so soft, and the light is soft and even, too. She is near a window in a bridal boutique.

Contax 645 with 80mm Zeiss lens, Kodak Portra 400CN film (printed sepia), f/2 for 1/60 sec.

The folds of the blankets obscure the view of her body and this, along with her sideways glance, adds to the voyeuristic feeling of this image. Behind me were floor-to-ceiling sliding glass doors, which illuminated her from the front while a window in the background provided additional natural light. I love the demure gesture of her hand near her heart, balanced by the bold beauty of her Louboutin shoes above her.

Contax 645 with 80mm Zeiss lens, Kodak Portra 400CN film (printed sepia), f/4 for 1/60 sec.

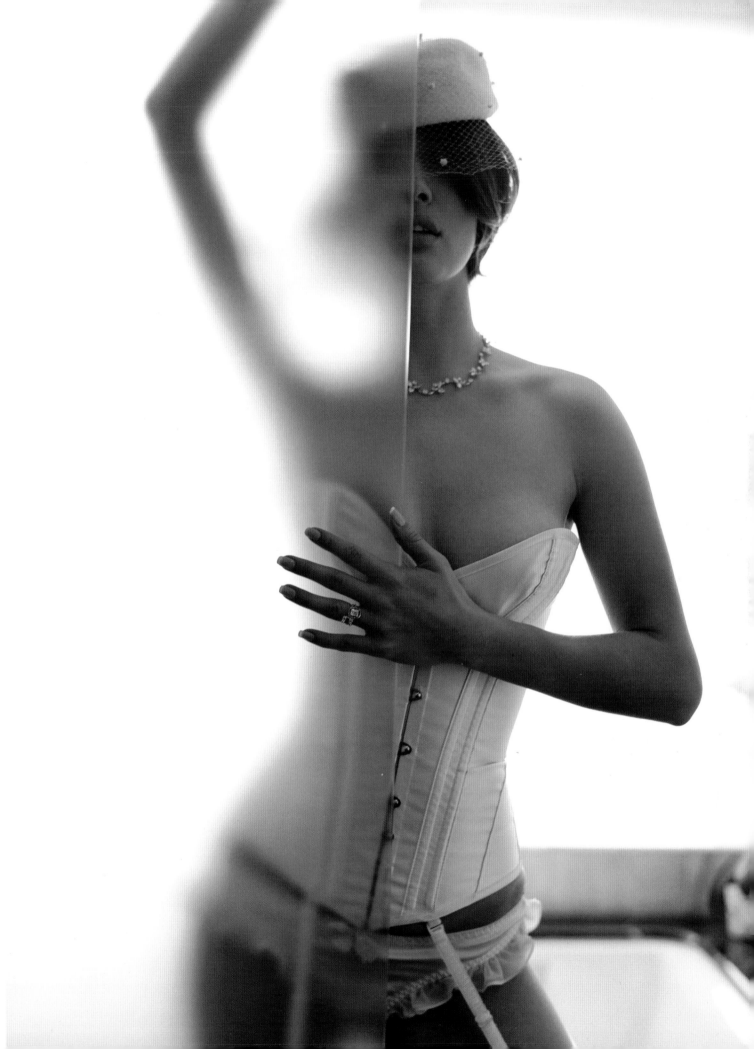

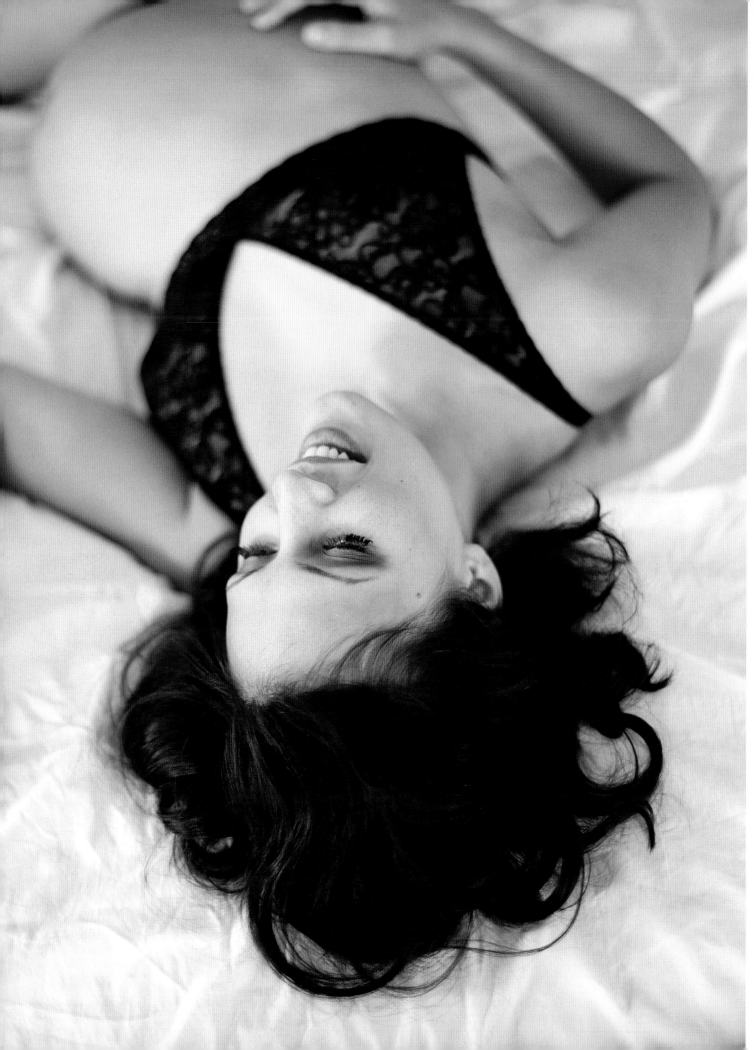

The Expectant Mother

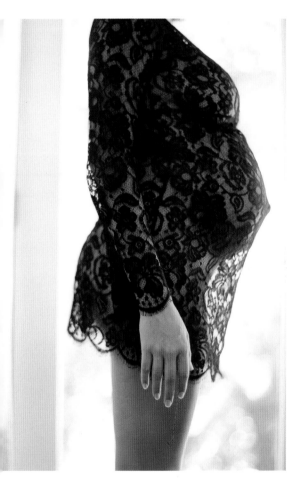

My pregnancy work is a natural extension of my boudoir imagery. It's all about celebrating a woman's femininity, so it's just as crucial to have soft, flattering light here as in my regular boudoir photos.

Most pregnant and semiclothed women are more comfortable being photographed indoors, so windows become your best friend during these types of portraits. The softer and more beautiful the light, the happier your client will be. I just love letting window light whisper over the curves of an expectant mother. I also love taking portraits of a pregnant woman's face. I think of these images as secrets: Someone looking at the image may not know that the subject is nine months' pregnant, but the woman will always know, and there is an inherent sweetness in the eyes of an expectant mother that is just lovely to capture. That, along with details of her belly, tells the story of anticipation and love. The softness of light that comes through a window is perfect for capturing the softness of impending motherhood: Focus on her hand resting on her belly, set your camera at f/2 for 1/60 sec., and the result will be simply breathtaking.

Left: For some, pregnancy may seem like the most unlikely kind of boudoir image, but I think there is something so sensual about the full belly of an expectant mother. The lace here accentuates both the swell of the baby inside her and the feminine beauty of motherhood. A nightgown or robe can also provide a pregnant woman with a bit of security, so she can pose more freely in her bountiful curves. This beautiful mother stood in front of sliding glass doors while my assistant was beside me with the reflector to add a little bounce light. The dappled light is coming from the sunlight outside the window. It looks so bright and luminous because I have exposed for the black lace, which made the brightest part of my frame overexposed.

Contax 645 with 80mm Zeiss lens, Fuji 800 NPZ film, f/2 for 1/60 sec.

Opposite: Oh, to be pregnant and so lovely! Please break out the lace—the sexier your subject feels, the more likely you'll be able to capture the sweet underneath and the sensuality that makes boudoir imagery so alluring.

Contax 645 with 80mm Zeiss lens, Fuji 400 NPH film, f/2 for 1/60 sec.

I relate easily to expectant mothers because I am a mother myself, but you, as a photographer, can always find some personal connection to your subject. Maybe you haven't had children but want to one day, in which case you can connect on that issue. Always try to relate to the person in front of you and what she is experiencing. For instance, being pregnant can be quite difficult, especially as a woman nears the end of her term—it's hard to sleep, you feel huge, you don't recognize your body, and so on. But it's also the most beautiful time, as a woman becomes ripe and full of life, her body soft and curvaceous. I encourage my pregnant clients to trust that the images will be more flattering than the way they feel. It is this acknowledgment that is often the catalyst for them to relax and let me begin to photograph.

Whenever possible, I like to shoot in a subject's home, because being in her own space will help her feel at ease and relaxed. It also is more authentic, a representation of where she is at that moment in her life. I try to remove any obvious visual distractions, like piles of paper or stacks of dishes, so that the resulting space is clean and uncluttered. I also make sure I have a glass of water in the room for the woman. Pregnant women get very thirsty, and being aware of that little fact can be so thoughtful. It may sound obvious, but attention to details can really enhance the quality of your images.

I am always involved in the styling of a shoot, whether I am using something from my subject's collection or from my own. I often bring my personal collection of see-through robes, nightgowns, and lace cloth to a shoot, whether the subject is pregnant or not. I will also make myself quite at home in a woman's

Insight

It can be nice during a pregnancy shoot to include the husband or other children. I start with the woman by herself, and then as she is feeling more comfortable and relaxed, I bring in the rest of the family.

dresser drawers (with her permission, of course). Often, a woman will tell me she has nothing that fits right, but I always disagree. Almost every woman owns a special bra-and-underwear set or nightgown that she might not want to wear, but they actually look beautiful and frame a woman's body well, especially a pregnant belly, without the woman having to be totally nude.

If you are shooting a woman who is curvy, a see-through robe or nightgown can be a fantastic tool, because it catches the light and acts like a bounce around the body. If you ask your subject to stand in front of a window, the robe will capture that light and you will see—and feel—the swell of her belly in a soft, flattering way. Remember, a pregnant woman wants to see the photographs and feel that she looks beautiful at a time when she feels anything but.

When it comes to positioning a pregnant subject, I tell her that if I ever ask her to get into a position or situation that is uncomfortable, she should let me know. I like to suggest poses that capture the woman's likeness in a flattering way but that are still comfortable. For instance, if a pregnant woman is on her side or standing, it's flattering to have her bend her leg to accentuate her curves, as in the image shown opposite, top. When I photograph a pregnant belly, I want to see its swell and fullness and curvature. Curves are like window light—the more you have, the better the mood and feel in your final image. I also try to minimize overt nudity by having the subject strategically cover her breasts with her hand or perhaps some fabric. Once a pregnant woman is feeling relaxed and comfortable with me, I often ask her husband to participate. The gesture of tenderness between a couple expecting a baby is beautiful to capture. A successful boudoir image of a pregnant woman (whether alone or with her mate) is about honoring this moment in her life, not about the nudity itself.

The use of natural light to illuminate the fundamentally beautiful female form will help you create wonderful boudoir photographs, whether maternity or otherwise. The key is to keep a dialogue open and gently guide your subjects into helping you create unique, original, and breathtaking keepsakes. Do this, and at the end of the day, both you and your clients will walk away fulfilled and content.

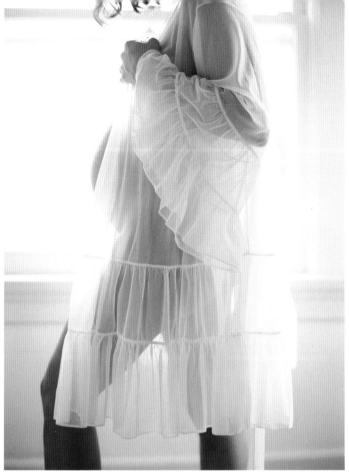

This mother-to-be is absolutely beautiful and very pregnant. The light that frames her is flattering and luminous. Notice how the bend in her knee adds to the overall composition of the image. It's flattering to her curves and grounds the image at the same time.

Contax 645 with 80mm Zeiss lens, Fuji 800 NPZ film, f/2 for 1/60 sec.

This photograph of Kristine and Paul Korver (founder of 50 Foot Films) was taken when they were expecting their first child. I began the session by doing boudoir maternity portraits of Kristine alone; once she seemed relaxed and comfortable, I invited Paul to lay with her. There were two windows in the room: one directly to the right of the frame, the other a little farther away and to the left. I used a fast film and exposed for the shadows on Paul's face.

Contax 645 with 80mm Zeiss lens, Ilford 3200 film, f/4 for 1/125 sec.

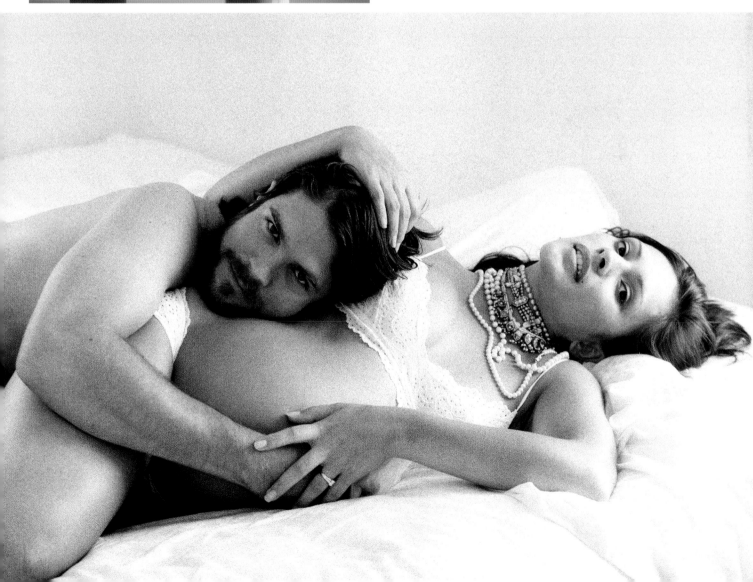

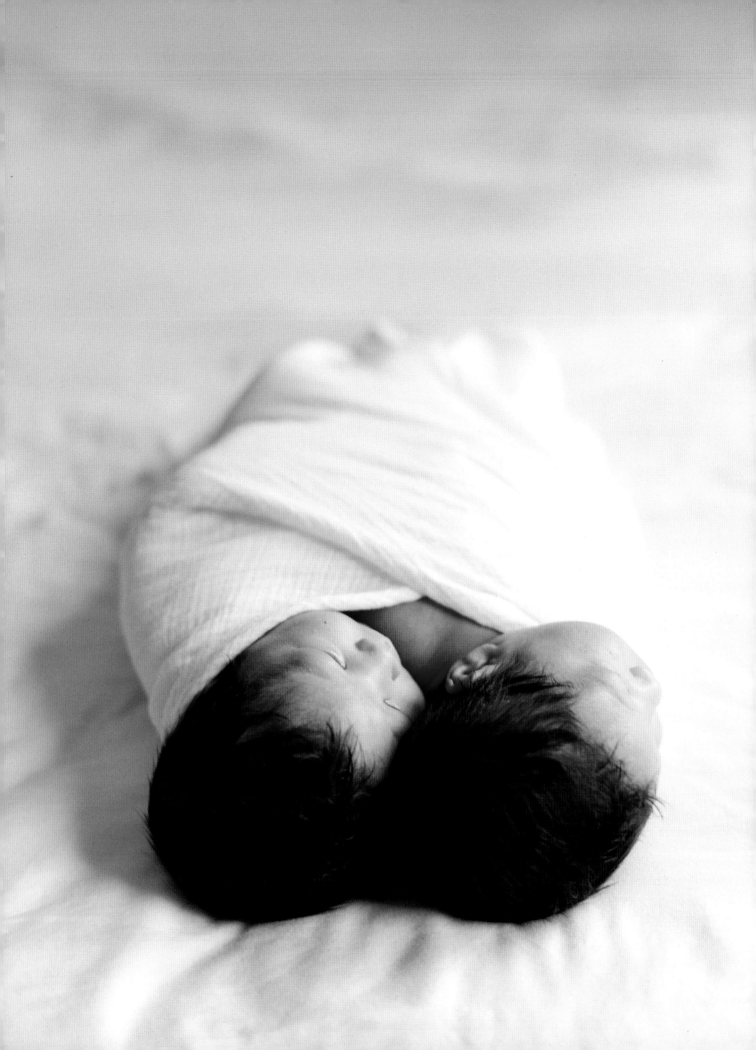

Little Ones

These brand-new, identical twin boys were swaddled together on a clean white sheet, illuminated by window light.

Contax 645 with 80mm Zeiss lens, Fuji 400 NPH film, f/2 for 1/60 sec.

Children and babies make amazing subjects: They are full of innocence and vulnerability; they are pure and unguarded in their expressions; and they possess an innate joy and exuberance that illuminates any image, often just by smiling or being themselves. That being said, children's photography presents a host of challenges. For one thing, children are so full of life and energy that you are often dealing with moving targets and therefore have to be quicker as well as more responsive and creative in how you connect with them. On the opposite end of that spectrum are babies, particularly newborns, who, for the most part, are completely immobile and are usually doing only one of three things at any given time: sleeping, eating, or crying. Ultimately, you need to adapt to your subject's movements, or lack thereof, and keep the shoot fun and engaging without having it become the equivalent of an out-of-control playdate.

Successful portrait photographers have a way of coaxing, relaxing, and playing with children. The more you are able to interact directly with kids and let them be the way they naturally are, the more fabulous the portraits will be. Another key skill is being able to communicate well with their parents. The worst thing that can happen during this kind of shoot is to have parents unintentionally interrupt and try to direct their child. Gently asking a parent to step back can help you make an image they will be thrilled with.

The Art of Capturing Children

Kids are trained to sit and smile at the camera, but if you really want them to break out of those stiff poses, you need to relate to them on their level. Once you find a location where the light is great, the next challenge is to bring the child you are photographing into the process and make sure he is having fun or at least feeling comfortable and relaxed. This is especially important while trying to get your perhaps-unwilling toddler into the best light. Try to make children feel important and knowledgeable by including them into the fold and making them feel like an integral part of the shoot. After all, to have captured the fleeting essence of that little person in any given moment is truly a gift and should be approached as such.

If I'm photographing ten- to twelve-year-olds, I'll sit on the ground next to them and ask about school or their favorite sports, or something that is going to matter to them. The more comfortable you get kids to be and the more you get them to talk about themselves, the more they will trust you and open up, and the more real they will be in your photographs. Being a good photographer begins long before (and long after) you are holding your camera and assessing the light. Good communication leads to great portraits.

For children ages three to seven, I might sit in the very spot where I want to photograph, take out my camera, and act like I need help with it. This helps draw out a child's natural curiosity. They can help load the film, even press the shutter. I'll even sometimes strike a bargain with them, saying something like, "Your mom wants a nice photo of you, so why don't we make a deal? You let me take a few photos so your mom is happy and then you decide what you want to shoot and I'll let you use my camera to take a picture." Nine times out of ten, they are onboard.

One thing that is really wonderful about photographing children is that even when they are not looking at the camera or smiling, or looking right at me, so much of what they do reflects their personalities. I may do a few posed and styled portraits, but in general I prefer to capture their essence while they're playing or not looking at me or hiding their head, or whatever they are doing naturally. Because of this, I tend to need a little more space when shooting children so that I can move around them myself rather than moving them into better light. I'm constantly moving and trying to find the best shot through the viewfinder. It's hard to direct children, so you are better off directing yourself.

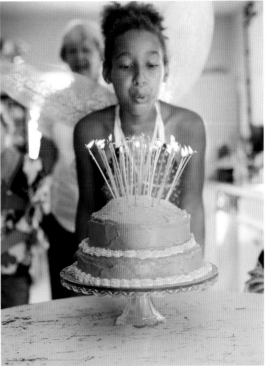

Far left: This little girl was an amazing dancer, and she was thrilled to put on her ballet costume for our portraits. As she stood on an old tree stump playing with her dress in the afternoon sunlight, I took many photographs without uttering a single word.

Contax 645 with 80mm Zeiss lens, Fuji 800 NPZ film, f/2 for 1/125 sec.

Left: Birthday sweetness in a window-filled kitchen.

Contax 645 with 80mm Zeiss lens, Fuji 800 NPZ film, f/2 for 1/125 sec.

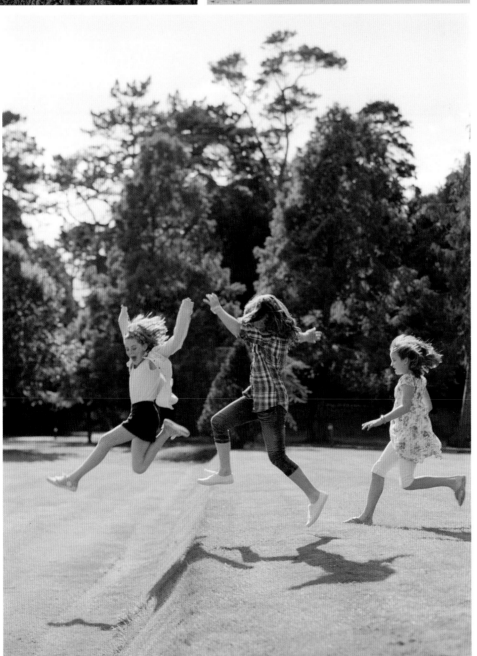

Sometimes, to capture a portrait of children together, you have to get creative. These girls were playing around on the grounds of Ashford Castle in Ireland on a warm, sunny day. They were having so much fun that I took photos of them doing exactly what they were already doing. I set my shutter to a faster speed (1/500 sec.) to catch them in midair. The sunlight was a bit to the right and behind them, creating a beautiful backlit scene.

Contax 645 with 80mm Zeiss lens, Fuji 400 NPH film, f/4 for 1/500 sec.

103

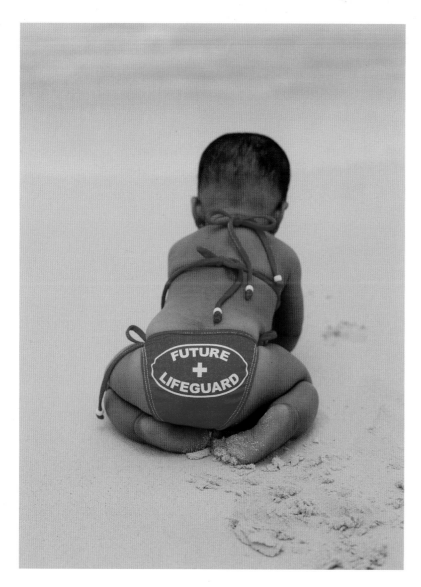

Opposite: Another fun way to capture children is to let them dress up. The more fun a shoot is for children, the more likely they will be willing participants. I also encourage parents to let us break the rules while we shoot. Here we let her dance on the bed, which is usually not allowed. This big bedroom had several windows that provided abundant light.

Contax 645 with 80mm Zeiss lens, Ilford 400 XP2 film, f/2 for 1/60 sec.

Left: This is one of my favorite shots, taken on location in Cancun. In order to get this image, I probably shot three or four rolls of film. Every time I was ready to take the image, the little girl started to crawl or look back at me. When shooting babies and children, you may have to take a lot of images to get one that really works.

Contax 645 with 80mm Zeiss lens, Fuji 800 NPZ film, f/4 for 1/125 sec.

Time constraints with children are a little different than on other shoots. Anticipate having downtime, and avoid rushing them or forcing them to do things. The worst thing you can do is cause a child to cry because you want her to do a certain thing when she clearly doesn't want to. Instead, I tend to be really low-key and am much looser with time because I want the children to feel comfortable.

On a technical level, my exposures tend to be a little faster for these portraits because it's harder to get the same kind of quiet, setup moment as for a regular portrait, unless the child has fallen asleep. You are likely to be dealing with a moving target, so your response and exposure need to be faster. While I may have a low-key demeanor, I am paying very close attention to the light.

With older, more rambunctious kids, I'll usually shoot outside so that they can run and play and be themselves. In that case, I'm most likely shooting at 1/125 or 1/250 sec. so that I can capture their movement and not have it be too blurry as they jump around.

Another option is to use props to slow your subjects down. A strategy I employ with fidgety little ones is to suggest we play dress-up. On one shoot, I put my daughter Jasmine in a white fluffy ballet outfit. She danced on the bed in ample window light, preoccupied with the pretty dress, while I photographed a whole roll of film. The prop was the dress—a simple, beautiful, fun addition to the photograph. Thinking about your young subjects' experience is important, even while you are placing them in the lighting situation you want.

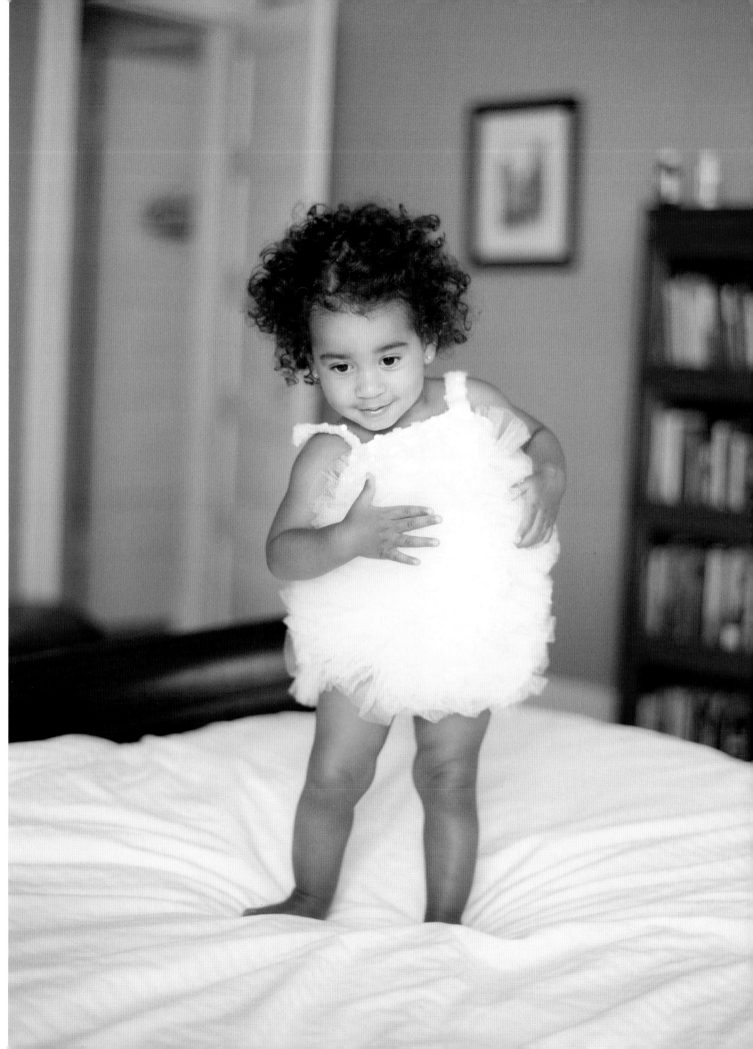

The Dynamic of Parents

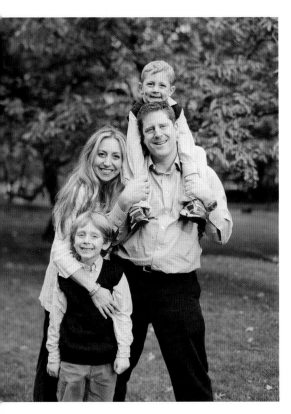

With family portraits, it can sometimes be helpful to pick a little one up. Kids don't often have a lot of patience, so doing something fun like sitting on his dad's shoulders can keep a child engaged. This image of amazing sweets designer Amy Atlas, her husband, and their sweet boys was taken in New York's Central Park on an autumn day.

Contax 645 with 80mm Zeiss lens, Fuji 800 NPZ film, f/4 for 1/125 sec.

Unfortunately, many parents have preconceived ideas of what they want their child to be doing or looking like in the image. The more I can connect with the parents, the more comfortable they are entrusting me to capture their child naturally—rather than directing and overposing their children, who usually resist—and the happier and more successful the shoot will be. I have kids myself, so I can relate to parents on that level; that's a good start. Often, if I am able to interact with the child directly without the parent getting involved or hovering around, I can get a lot more from the shoot. The least effective situation is when the parents keep hanging around, saying things to their kids like, "Look at me," "Let me clean your face," "Stop fidgeting," and so on. That kind of interaction can be challenging, and not beneficial to the shoot. When this happens, I politely encourage the parents to allow me to spend time with the child by myself and do my thing.

When I do include a parent in the shot, the same philosophy applies. Parents' natural inclination is to make sure their child is okay and doing the "right" thing; I encourage parents not to worry about what their child is doing or not doing and to allow the shoot to unfold naturally. For instance, with rambunctious children, I won't try to subdue them but rather let them express themselves. Young children would usually rather play than be photographed. At one shoot (with Amy Atlas and her family), I asked the father to put his youngest son on his shoulders. This made the experience much more fun and gave me a few moments to capture the entire family, spirited children included. Another way to include a parent seamlessly is to have them do what their children are doing. At another shoot, two little girls were lying on the grass for a portrait. When it was time to include their mother, instead of having them get up for a proper portrait, I asked her to lie down next to them. Again, I asked the mother to look directly at me, without giving the girls any direction. The soft, even light of the open shade in their backyard added to the gentle look of this image.

Sometimes parents will have a specific place in mind where they want me to shoot, but when I get there the light in their desired area is no good. Part of my job as a professional is encouraging them to let me shoot where the light is most flattering. I may be polite and take a couple of images where they suggested, but then I quickly get back to guiding and gently directing both the child and the parents toward what will make the most well-lit images.

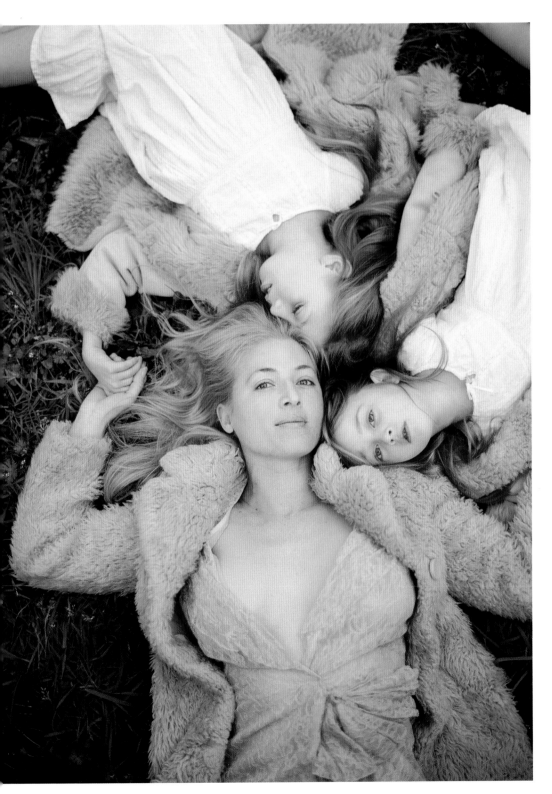

There is something so inexplicably beautiful about a mother and her children, and this image of designer Eden and her two daughters is no exception. I was on a makeshift platform (created from a couple of sawhorses and a piece of wood), about eight feet above. Eden's gaze is still and calm, while the girls are a bit more restless. There is even light from a cloud-filled sky.

Contax 645 with 80mm Zeiss lens, Fuji 800 NPZ film, f/4 for 1/125 sec.

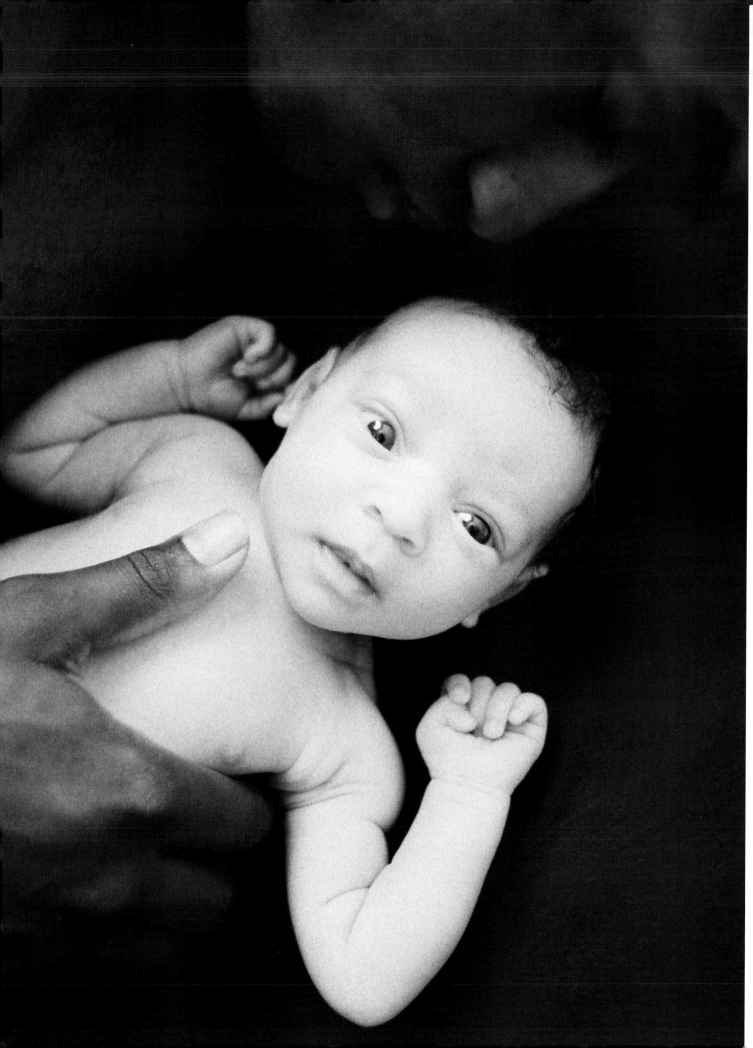

Luminous Light and the Newborn

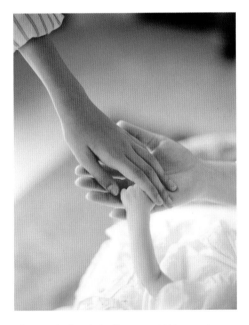

Above: Window light illuminated this sweet gesture between a mother and her two children.

Contax 645 with 80mm Zeiss lens, Fuji 800 NPZ film, f/2 for 1/60 sec.

Opposite: The tones in this image are so compelling to me. I wanted to see detail in the darkness of the father's skin in comparison to the newborn baby. There was very low light coming from a single window in the room.

Contax 645 with 80mm Zeiss lens, Kodak Tri-X 400 film, f/2 for 1/30 sec.

I tend to shoot newborns almost exclusively indoors, by window light, for the warmth and glow it exudes. There's nothing as beautiful as a sleeping baby on a clean, white sheet next to window light; it's one of the most timeless moments you can capture. If a newborn has gone to sleep, I do the type of shooting I would do with anyone: f/2 for 1/60 sec., and I'll try to create that depth of field, that openness with the light, to get a luminous feel.

On a newborn shoot, you want the baby to be comfortable and warm—and for the mother and father to feel calm. Of course, if a mom or dad is comfortable going outside for the photo shoot, then I will, but I don't push that. The most important elements to bring to a shoot with a newborn are respect and kindness.

Encourage the mother to feed her baby and do whatever they naturally do, whatever is on their timetable; this further helps the baby and mother feel at ease and comfortable. The more comfortable my subjects are, the better my images are. Comfort leads to trust, and if a newborn's parents trust me, they will more likely respond to my requests, like, "Let's go over by the window near the beautiful light."

If I'm photographing a baby and the mother is cooing in the background, the baby is going to look at the mom instead of me, so I try to gently get the mother to move out of eye range and let me be the focal point. I'll coo and take shots at the same time. Trust me, babies will more likely look at you if the parents are out of their sight line.

Another thing to keep in mind is that a newborn portrait needs to show scale. When you see the shape of a father's hand around a newborn's head or a baby's hand in his father's hand, clients can see how fragile and little their babies are. Capturing that vulnerability documents a truly fleeting, and beautiful, moment in time.

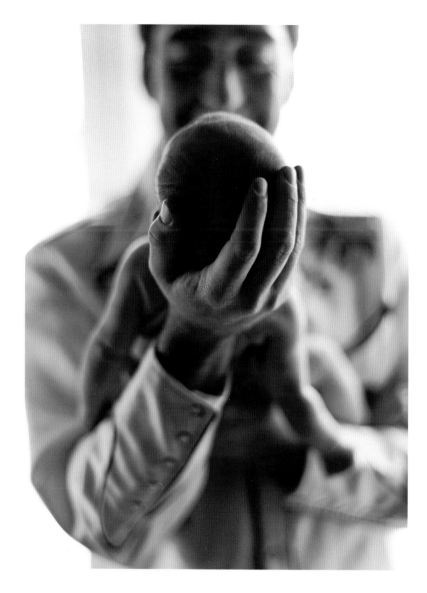

When posing a newborn, here are some simple strategies to keep in mind. As I said earlier, scale is extremely important. Children grow and change so fast that sometimes it is hard to remember just how small they were when they were first born. I try to capture this by including one or both parents with the baby for context. I also find the simplest of poses to be most successful, such as a baby on a bed wrapped in a blanket. It is also good to take close-up images of tiny feet and hands. The vulnerability and newness of a tiny baby is just beautiful, so I try to emphasize that whenever possible.

One last thing to keep in mind: I'm interested in capturing and honoring that little delicate space babies are in, so I never try to force them to give me an expression. Certainly I'll shoot details of the face, but a newborn isn't going to give you a whole lot of variation in expression. If I'm working with a slightly older baby, then, by all means, I'll encourage the mom or dad to bring the baby up closer, maybe cheek to cheek. Not only will you get a variety of expressions from the baby but also from the parent, who feels so delighted and in love with the baby and will often give you a more expressive look that is beautiful to capture. For a shot like that, in which the mother is holding the baby up near her face, I'll be sensitive to rotating my position so that I get even light on both their faces.

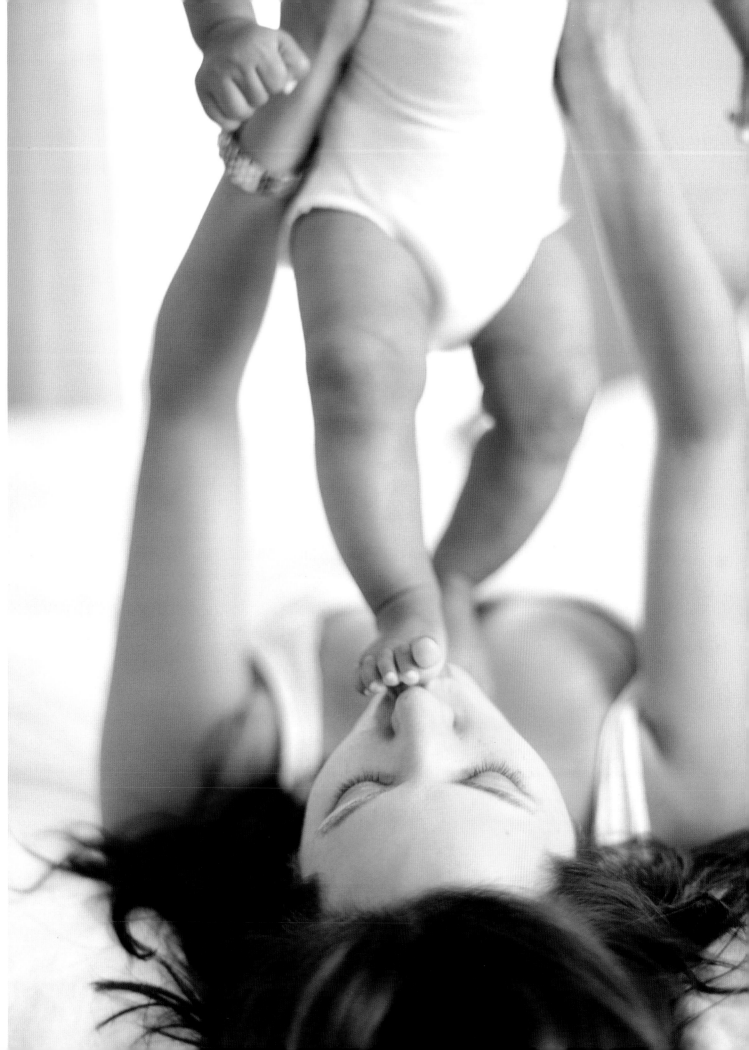

Including Meaningful Props

Many photographers like to bring props to a kids' shoot. I have some lovely vintage props, like an old scale, that I will bring upon request. Older children, especially, might feel more comfortable holding one of their own toys or even a leaf or a cool rock or a pinecone that we find wherever we are shooting. With a child, the experience should be authentic; that way you elicit authentic responses. Certainly, incorporating something from their life, like a special toy they care about, can help relax them. Maybe I'll shoot them for a little while with that special toy, and then, once I've done it their way, I'll encourage them to let me do it my way. We'll take turns—"I do one, you do one."

One extra challenge with younger kids is when they want to suck a pacifier—that can be very hard to shoot around and requires creative thinking. I might hold the pacifier in my hand, right next to where I'm focusing my shot, so they are seeing it and paying attention to me, or maybe I will let them suck the pacifier for a little while and then get them a toy or a piece of fruit. There's nothing like capturing a kid biting into a big, ripe peach in the summertime. It's a fabulous photo op, because they become so uninhibited. This is a time when you want to capture what it feels like to be young, and something special about a child in that moment.

I like to encourage children to participate in portrait shoots. The more they are involved in the photographic process, the more meaningful the experience will be. Here, I handed designer Kirstie Kelly's son a plastic camera from my bag so that we could take pictures of each other. He was both the photographer and an adorable subject.

Contax 645 with 80mm Zeiss lens, Fuji NPH film, f/2 for 1/125 sec.

Opposite: Sometimes giving a child something to do can slow her down a little. In this shot, the peach provided both a slight distraction for the little girl and a beautiful element within the shot.

Contax 645 with 80mm Zeiss lens, Fuji 800 NPZ film, f/2 for 1/60 sec.

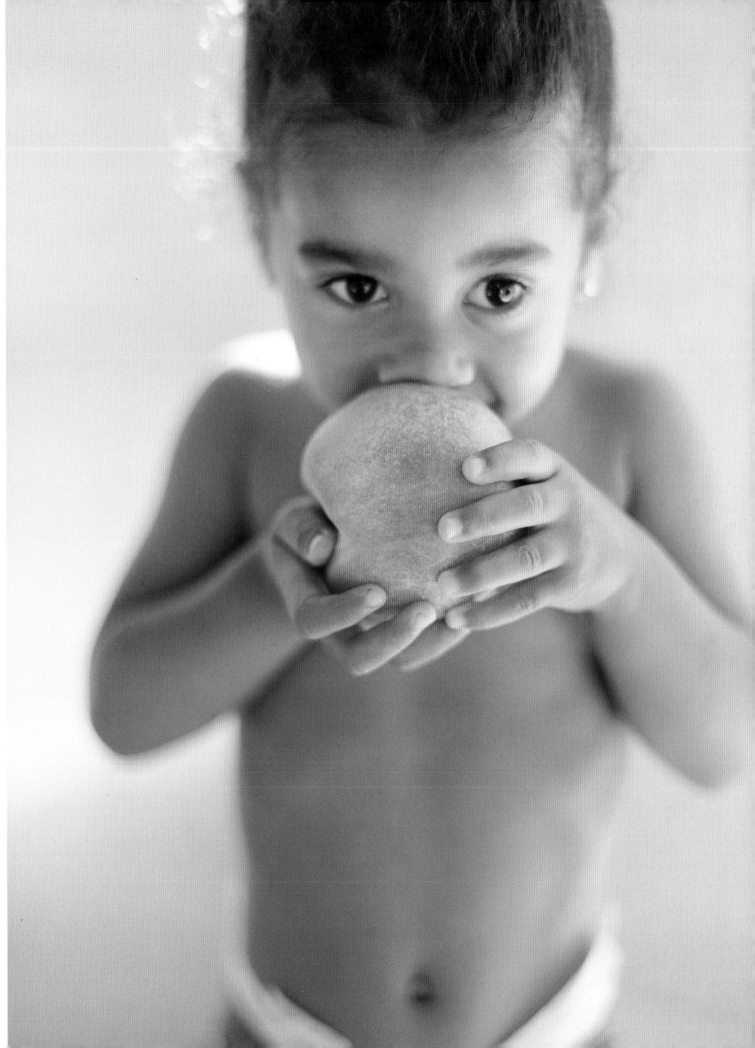

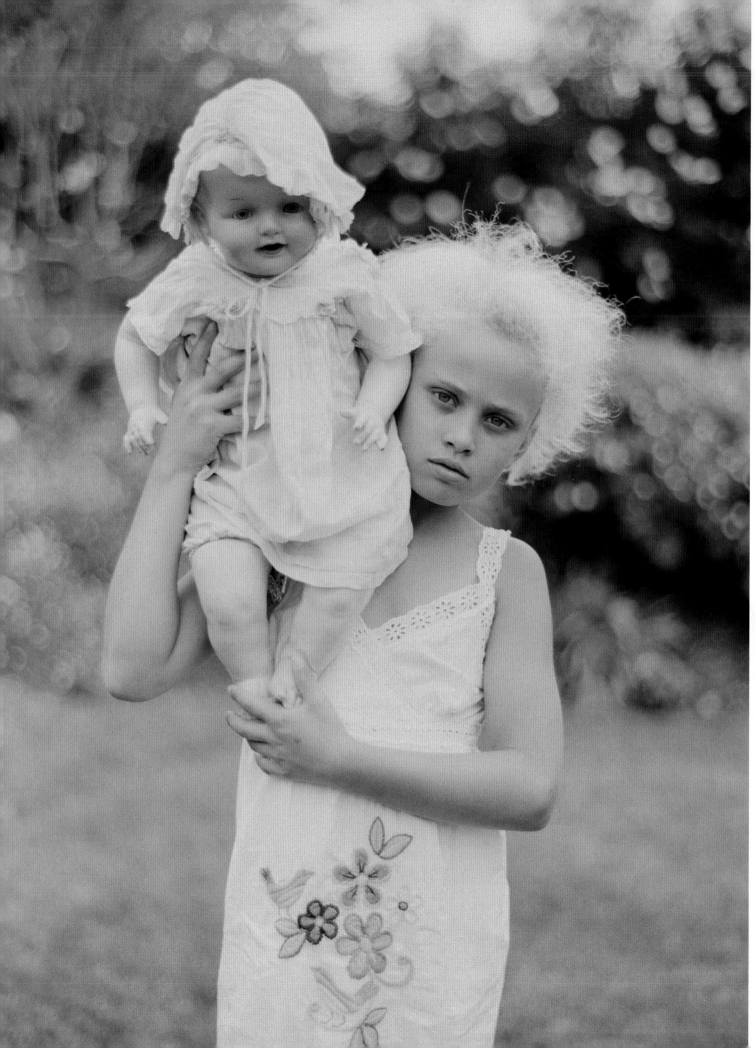

Opposite: During a portrait shoot, this lovely girl held up her great-grandmother's doll. We stood in her backyard with the sun behind her, and I exposed for the tones and shadows in her face.

Contax 645 with 80mm Zeiss lens, Kodak Portra 400CN film (printed sepia), f/2 for 1/60 sec.

Right: A vintage bathtub was the perfect place to photograph this rambunctious two-year-old. She enjoyed the bubbles, which gave me an opportunity to compose the image. And even though the day was cool and overcast (with perfect, even light), the water was warm enough to keep my little subject cozy.

Contax 645 with 80mm Zeiss lens, Fuji 800 NPZ film, f/2 for 1/125 sec.

Left: Can you measure the weight of love? If you could, it would probably look something like this. I love this vintage scale and the sweet little baby toes.

Contax 645 with 80mm Zeiss lens, Ilford XP2 film, f/2 for 1/60 sec.

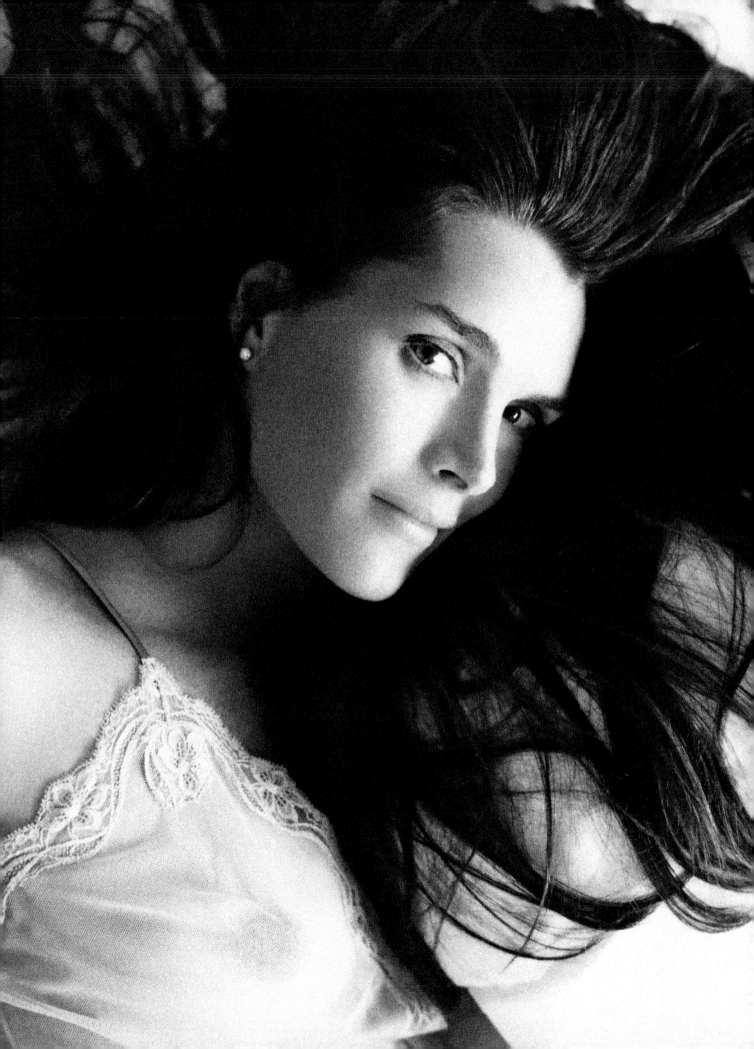

The Celebrity Portrait

This image of Brooke Shields was taken the day before she gave birth to her second daughter, Grier. Brooke is already a natural beauty, and the window light accentuated her innate glow even more.

Contax 645 with 80mm Zeiss lens, Ilford 3200 film, f/4 for 1/125 sec.

The single most important element to remember about photographing celebrities is that they are human beings, just like us. Therefore, it is essential to approach the celebrity shoot just as you would any other. Most of my shoots of this nature are wedding-, maternity-, or newborn-based, so the purpose of the shoot is usually an emotional occurrence or real-life moment that transcends their celebrity. Celebrities cry and laugh and celebrate just like us, and the beauty and light I seek is the same as in all my shoots. The only elements that may differ are the amount of time I have to shoot a celebrity and the fact that there are often more people on set, such as an art director or photo editor, an agent, and/or a publicist.

Another factor here is that you are most likely being hired by a magazine or high-profile client, and the photo editor or art director usually has a specific shot list in mind. Before you can even begin to experiment or think outside the box, you must first fulfill what the client wants. Only after that, if time allows, should you explore other creative options. When treated with kindness and professionalism, most clients acquiesce to your way of approaching an image if you first give them what they want. I always do more than a shot list requires because I feel that I am being hired for my vision and style.

I feel fortunate to have been hired to photograph several celebrities. I have never targeted a particular client but rather strive to make my images and portfolios strong and representative of my best work. For me, that means showing images that convey my consistent use of natural light. If you want to pursue this kind of work, the most critical thing is to create a strong and consistent body of work, and show it to people who can help you get hired: photo editors at entertainment magazines, successful wedding planners, friends (or friends of friends) who may be able to share your images with a celebrity. Success inevitably comes from the quality of your work and how well you promote yourself. It is all about lighting, timing, and opportunity.

How to Execute
and Fulfill a Shot List

Most magazine editors have a specific agenda or type of shot they want from a shoot, and we'll often discuss the agenda and come up with a printed shot list. I think of a shot list in much the same way I think of a pose: It is merely a beginning, a starting point. True beauty in an image is a blend of beautiful lighting and a natural, real moment. If you only stick to your shot list, you may miss something wonderful right in front of your eyes. My approach is to take all the images on the shot list first, and then respond and create photographs from a more organic point of view. As my style is so intrinsically connected to natural light, even while I am fulfilling a shot list, I communicate about where I think the image should be composed.

There are certain steps I like to run through before I even begin shooting. I check out the location and immediately look around for the best natural light; I communicate ahead of time with the creative team (if I am on assignment with a magazine) to establish what they are looking for (i.e., Is it a cover story or an editorial piece about something in particular, such as a celebrity couple who just had a baby?); and finally, I find out if I need to do any research pertinent to the story they are trying to tell in the magazine. It is critical that I have enough time and opportunity to be more creative and do some of the things I want to do after I have fulfilled their shot list. I find that if you communicate about that ahead of time, everyone is on the same page. They know that I am thoughtful about what they need, but they are also hiring me because of what I do and trusting me to give input on the spot, as well.

One thing that may differ from my other shoots is that I might have two or three assistants present, I've printed out a shot list, and I

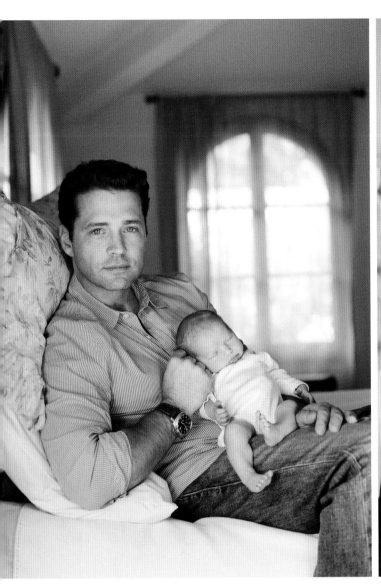

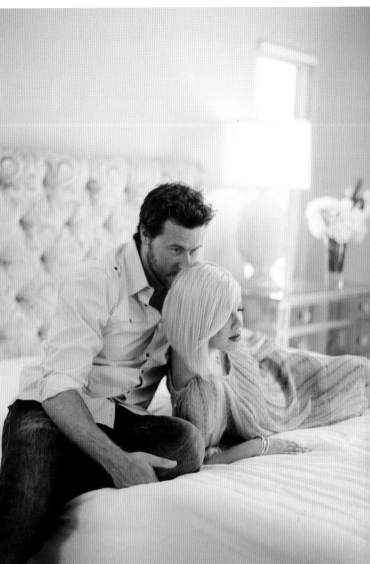

Above, left: During an assignment for *US Weekly* magazine, I photographed former *Beverly Hills 90210* star Jason Priestly with his newborn daughter, Ava.

Contax 645 with 80mm Zeiss lens, Fuji 800 NPZ film, f/4 for 1/60 sec.

Above, right: I have been photographing the intimate lives of Tori Spelling and her husband, Dean McDermott, for many years, from their wedding reception to the evolution of their growing family.

Contax 645 with 80mm Zeiss lens, Fuji 800 NPZ film, f/2 for 1/60 sec.

will have another assistant carefully communicating with me throughout the day to make sure we are getting each shot on the list. There is also always a representative from the magazine on set, making sure I am honoring what they've asked me to do. Only later do I get into the space where I am being my more creative, inspired self, doing what happens naturally.

One example is when I photographed former *Beverly Hills 90210* actor and director Jason Priestly with his newborn daughter for *US Weekly*. I knew *US Weekly* wanted a nice portrait of him holding his daughter, as well as variations with Jason and his wife, Naomi, so first I did several of those kinds of shots. Then I went on and took some more photojournalistic images in which Jason was holding the baby, feeding the baby, laughing, and emanating joy over the baby. Certainly Jason knew I was there, but these were not posed portraits; rather, they were candid lifestyle shots, and they were quite sweet. The room in his home where we were photographing had several windows, which was great; the more light sources the better.

119

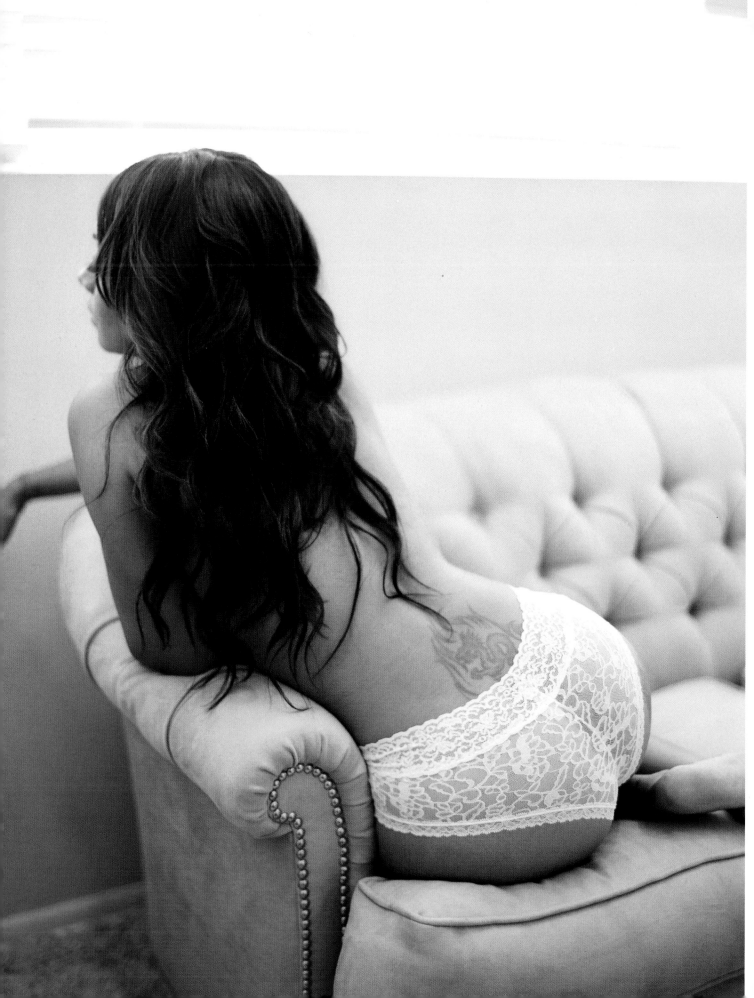

Opposite: Actress La La Vasquez (Anthony) hired me to take some boudoir images for her wedding anniversary with her husband, NBA star Carmelo Anthony. We only had one hour, and our shoot was in a friend's office. Working quickly, I moved all the books and clutter out of our way and had her sit on a couch underneath the windows, where her beautiful figure was well lit by the window light.

Contax 645 with 80mm Zeiss lens, Ilford 400 XP2 film, f/2 for 1/60 sec.

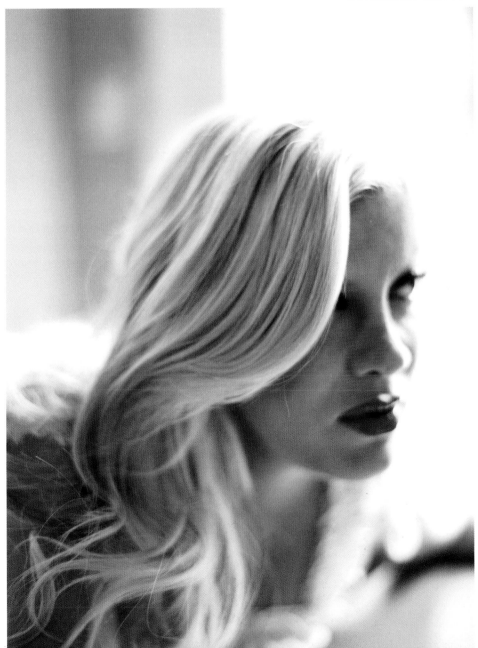

These two images were taken during actress Tori Spelling's first pregnancy with son Liam. I love the intimate, documentary feel of these photographs.

Both images: Contax 645 with 80mm Zeiss lens, Kodak Portra 400CN film, f/2 for 1/60 sec.

121

I had only a precious few moments to capture this portrait of actress Kate Walsh (of *Grey's Anatomy* and *Private Practice*). She was just going to sit down at a dinner party, which was beautifully but very dimly lit. I asked her to come sit on the porch for a moment, and she graciously complied. The ambient light on the open porch beautifully lit her face. You often have to make quick decisions on a shoot. If you know where the light is good, do not be shy about suggesting shooting in a flattering spot.

Contax 645 with 80mm Zeiss lens, Fuji 800 NPZ film, f/4 for 1/125 sec.

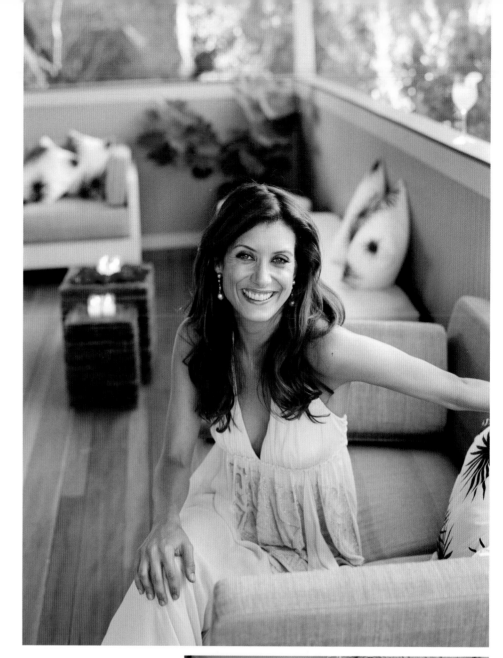

Mary Lynn Rajskub, best know for her role as Chloe on the hit show *24*, is seen here enjoying her newborn son. I stood above them as they lay on a daybed near a window. Mary Lynn smiles as she comforts her fussy baby, while the window light caresses them both.

Contax 645 with 80mm Zeiss lens, Fuji 800 NPZ film, f/4 for 1/125 sec.

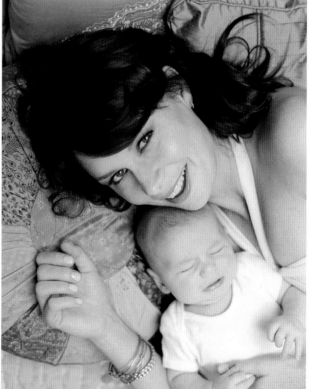

How to Find Good Light
in a Limited Time Frame

No matter what the call time is, always get to a job early so that you have time to assess the light, the options in different rooms, and what locations will work for the type of light you want in your image. Arriving early is one of my biggest secrets, and it takes so little effort. It is better to be on set half an hour early rather than even one minute after you are expected. Preparation is the most important thing, even if you are in a time crunch. I've had as little as half an hour to compose and create a shot.

Being efficient with time is another important tip. For me, that means having at least three cameras loaded with film and ready to go before I get to the location. That way I am ready to shoot the moment I walk in the door. I can then devote all my energy to identifying the best place to shoot, with the most flattering light, and thus make the most of my time.

Many of my clients invite me in to photograph intimate moments in their lives, but that doesn't mean I always have enough time, or the right light, to work in, so I improvise. For example, when I do a celebrity newborn shoot, there are often crew members present from whichever magazine I am photographing for.

My priority is always to make the baby and parents feel comfortable. I usually have the best success by clearing the room, so only my subjects and I are present. I'll shut the door and work with the window light coming into the room, so I can utilize whatever limited time I have without distractions. Creating a quiet space is important, especially when a newborn is present. If clearing the room from unnecessary distractions seems daunting, simply suggest that your subject come with you to another spot (one that you chose previously, upon arrival, while assessing the light). Make the most out of your time and light, whether you have several hours or a precious few minutes to create a shot.

It is always my preference to shoot in a natural-light situation with available sunlight or shade, but it is important to shoot in whatever situation you find yourself. When I photographed the birth of Tori Spelling and Dean McDermott's daughter, Stella, it would have been totally inappropriate for me to use flash in the hospital room, and quite frankly, the bright surgery light worked well in helping me capture the essence of Stella as a newborn.

Engaging Your Subject

How do you engage a celebrity subject? It's not much different than engaging any subject. I do it as naturally and unobtrusively as possible. When I'm at a celebrity shoot, I'm often relating to a new mother who just happens to be an actress. I'm not thinking about her celebrity status at all. I'm still as personable as possible and make sure my subject feels comfortable, no matter who she is. I'm thoughtful about light, making sure I guide her to places in or around her home where the light is most flattering, which we all know is by a window or outside with the sun behind her.

Let's say, for example, I go into a house and there is a dog there. I'm going to sit down and pet the dog and be sociable. I don't come in shooting aimlessly, so to speak. When you can combine human interaction with good use of natural light and composition, you'll have more opportunities to capture the images you want. Before you can direct your subjects to sit near the best light, you must first relate to them in a social, relaxed way. Making a human connection is the simplest way to begin the collaboration that resides within every photograph.

This image of entertainment broadcasting personality Samantha Harris was part of an editorial shoot for *People* magazine. After choosing the perfect spot that utilized available window light, mother and daughter played while I took pictures.

Contax 645 with 80mm Zeiss lens, Fuji 800 NPZ film, f/2 for 1/60 sec.

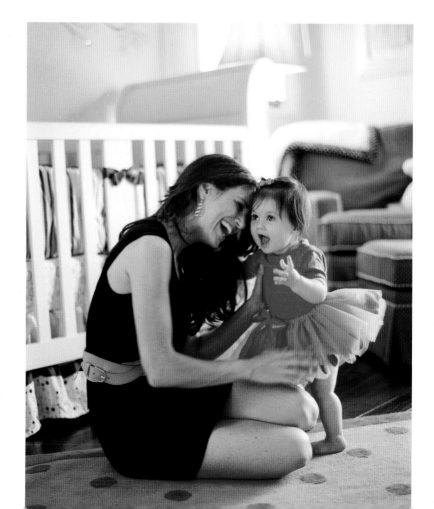

Actress Constance Marie plays with her lovely little girl, Luna. Natural light paired with the natural joy of motherhood is always a beautiful combination.

Both images: Contax 645 with 80mm Zeiss lens, Fuji 800 NPZ film, f/2 for 1/60 sec.

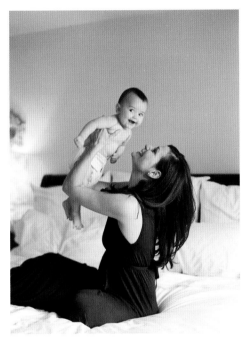

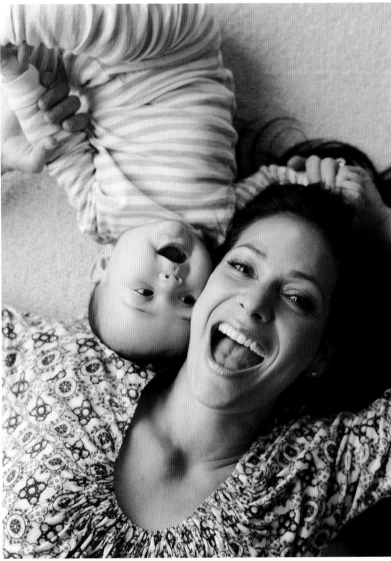

When I first walk into a celebrity job, usually an assistant or magazine representative answers the door and introduces me to my subject. I'll be photographing her eventually, but that doesn't mean I just sit in the other room and wait for her to get her makeup and hair done. Instead, I might go into the room where she is and just chat with her. The more natural your initial interaction with her feels, the more natural the final image will be. Find the relatable element that will add to the authenticity of your final image. For instance, if I am photographing a first-time mother, I may share something about my experiences when my eldest daughter was born. It is about being a person first, a photographer second. This may go against your impulse as a professional, as

f-stops and lighting options mill through your head, but a perfectly lit image has little impact if you do not also capture some tangible element of the person you are photographing. It is about balance between what you know as a photographer and what you feel as a person.

This may go without saying, but always treat your subject, in this case a celebrity, with human kindness. For instance, when I was shooting actress Constance Marie and her beautiful new baby, even though it was for a magazine assignment, I still printed photographs I took after fulfilling the shot list and sent them to her in a box with a sweet note attached, knowing she would appreciate having some as a keepsake for her family album.

The Nuances of Intimacy

Paying attention to the subtle moments is what it's all about. For instance, because I shoot film, there are natural pauses in the shoot where I have to stop and reload, or pass my camera to my assistant to reload—either way, there is a break in the repetition of clicking the shutter. I secretly think this is an advantage, that the necessity to stop actually adds to the dynamic and rhythm within a shoot. In those moments, when the subject stops feeling that he is posing for a portrait, there will be some incredibly natural, sweet moments that happen outside of the posed shot list. I always try to be prepared for those moments. During the Jason Priestly shoot mentioned before, for example, there was a moment after we'd done a shot when I put the camera down and he tended to his child. Right there is that moment of intimacy between father and daughter that I don't expect but can't pass up, which is why I have another camera nearby and ask my assistant to pass it over. I always try to capture those in-between, unplanned moments.

When I was photographing actress Jeri Ryan and her newborn baby daughter, Gisele, for a magazine, we did a series of portraits in Jeri's home. I'd already had the honor of photographing her wedding in France, as well as her pregnancy portraits, so we had an existing bond and a sense of comfort between us. We did a series of portraits of her on the couch, holding her daughter and looking at me, beaming like the new mother she was, and in between shots, I put the camera down to reload when her twelve-year-old son came into the room and they be-

gan discussing how delicate Gisele's tiny hands were. The son reached out to touch the baby's hands and it was such a beautiful moment that I said, "Oh, don't move!" I picked up my camera, came in close, and got a shot of just their hands together. It was such a wonderful, intimate shot that was within the context of this bigger shot on the magazine's list. The image ended up being one of Jeri's favorites because it beautifully, and emotionally, conveyed the scale and relationship of the siblings.

This all goes back to what I said earlier about arriving early and taking stock of the site (with your host's permission, of course). When you are on a photo shoot, you have to achieve a heightened sense of awareness for the entire day—that's part of your responsibility. Pay attention to light, to gestures between subjects, and to moments of realness (a real laugh, a real caress, and so on). Maybe the husband of your subject is standing in the doorway and says something to make the new mother laugh—you need to be aware of it, no matter what job you are on. Your brain has to be turned on at another level. There have been many times when I've been wrapping up a shoot, putting stuff away, when something beautiful happened that was unscheduled and unposed and I reach again for my camera. When people feel they are not being photographed, they often convey a more nuanced side of themselves, so you have to be paying attention even if the camera is not right in front of you. The more you are connected to the moments in front of you, the more you will be prepared to respond when something unexpected unfolds.

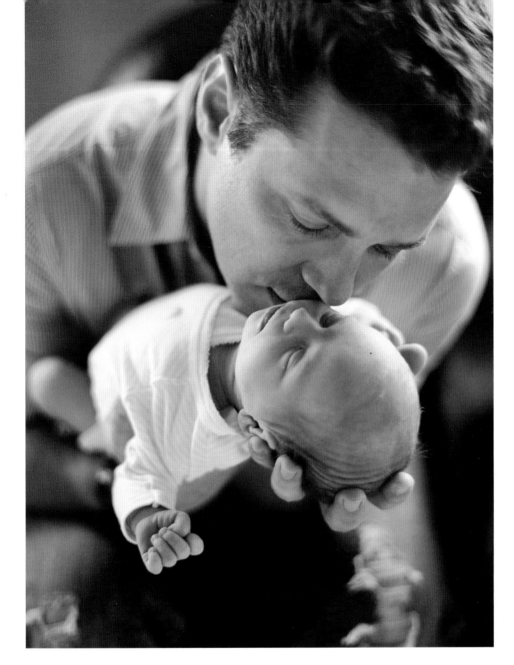

A candid image of Jason Priestly with his newborn daughter, Ava.

Contax 645 with 80mm Zeiss lens, Kodak Portra 400CN film (printed sepia), f/2 for 1/60 sec.

Actress Marissa Jaret Winokur won a Tony award for her Broadway role in *Hairspray*. Her infectious smile and love for her family were beautiful to document.

Contax 645 with 80mm Zeiss lens, Fuji 800 NPZ film, f/4 for 1/60 sec.

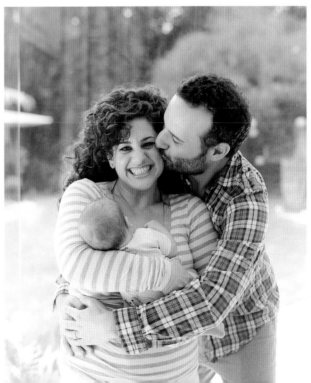

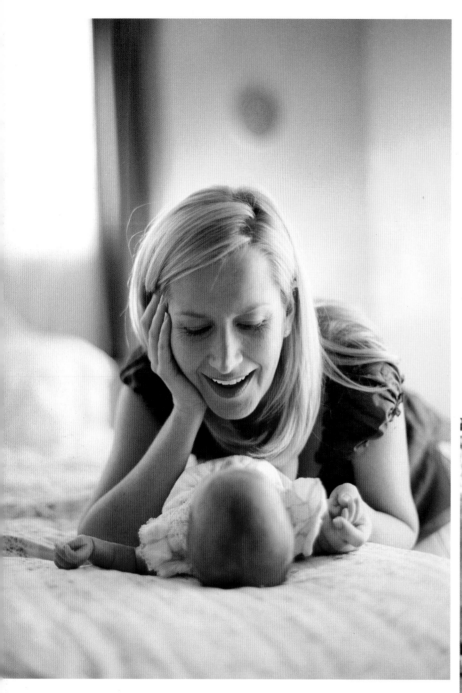

Angela Kinsey from the hit TV show *The Office* plays with her newborn in a bedroom with window light streaming in.

Contax 645 with 80mm Zeiss lens, Fuji 400 film, f/2 for 1/60 sec.

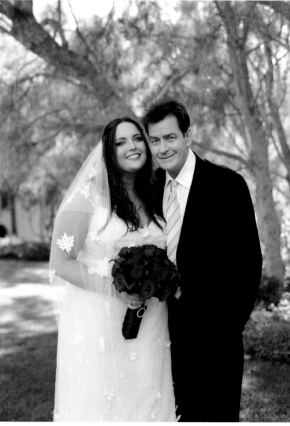

Proud father Charlie Sheen stands with his daughter Cassandra on her wedding day. I took all the family group shots in a little patch of shade protected from the harsh afternoon sun.

Contax 645 with 80mm Zeiss lens, Fuji 400 NPH film, f/4 for 1/60 sec.

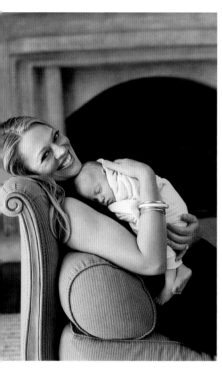

From wedding kiss to baby girl: I love documenting the evolution of love and happiness within a family. Actress Jeri Ryan married the love of her life, Christophe Eme, in France, and then later I had the pleasure of photographing their newborn daughter, Giselle.

Both images: Contax 645 with 80mm Zeiss lens, Fuji 800 NPZ film, f/2 for 1/60 sec.

The *Wedding Portrait*

This kiss took place on the roof of the Sunset Towers Hotel in Hollywood, California, as the sun was descending in the sky. There is just the right amount of flare coming between their parted lips to capture the impact of the moment, creating an emotional image full of light.

Contax 645 with 80mm Zeiss lens, Fuji 800 NPZ film, f/4 for 1/60 sec.

Weddings are the heart and soul of any couple's love story, and as such I like to approach photographing their special day from a very thoughtful place. I don't think of shooting wedding portraits as a job but rather an honor that's been bestowed upon me. What I love about the wedding day is that there are endless opportunities to capture the most wonderful memories for your client—portraits of the bride and groom, images of their family and friends, details (flowers, the wedding dress, shoes, and so on), the ceremony, the reception celebration. These are all moments within their love story that come together to tell something unique about the couple.

By nature, the wedding day is a whirlwind of emotions and moments all mingled together. To capture all of that both quickly and accurately, you need to communicate with your bride and groom beforehand to make sure you are all on the same page regarding the images they care most about, and how to meet their needs within the time line of the day as well as capture the moments that unfold naturally before you.

Of course, there will be times throughout the day when people are pulled by different emotions and practical constraints; how you decide to approach those moments is critical. The more you can be respectful and aware of the incredible journey the bride and groom are embarking on together, the better you can capture their unique love story. For me, doing this is completely and inexorably tied up in my lighting. Ninety percent of the images I create at a wedding are with natural light, not only because that is my lighting preference but also because a wedding is a very challenging place to set up lights and not be intrusive. Being a natural-light shooter is a real advantage at a wedding. I am constantly thinking about and assessing the light, and directing the couple into the most flattering and beautiful natural light I can find.

Light and Love: It's All about Communication and Timing

I was lucky to capture this moment of spontaneous joy. It is essential to be prepared for moments like this at a wedding. After the officiant pronounced the couple "husband and wife," I stood poised and looking through my camera as they walked toward me.

Contax 645 with 80mm Zeiss lens, Fuji 800 NPZ film, f/2 for 1/125 sec.

My work on wedding portraits starts long before the actual wedding day. Every photographer should be involved with the creation and execution of a time line for the wedding day by communicating both with the couple and the wedding planner, if there is one. If you just show up at the wedding and expect to get everything done without preparation, you may be in trouble. For instance, maybe the bride and groom have only scheduled fifteen minutes for group shots, but this is impossible if they have a large family. When I begin communicating with a bride, I make sure that, first, I can start photographing at least two hours before the ceremony—and that is if I'm not doing group shots ahead of time but only images and portraits of the bride getting ready, details, and portraits of the bridal party. If I need to shoot the bride and groom or do more organized, posed portraits ahead of time, I'll start as much as three or four hours before the wedding to ensure that I have enough time to execute the images in a way that will be successful.

Be sure to take into account the lighting at play during different times of the day. For instance, if a couple is planning a sunset ceremony and they don't want to see each other beforehand, this creates a challenge for a natural-light shooter because you can't make images in the dark and have them look the same way they do when there is available light. Certainly you can use flash, but it won't have the same look and feel. So I make sure I connect with my bride and groom about which shots are the most important. If the top priority is getting married at sunset, then we need to do portraits before the ceremony. If it is for them to not see each other before the ceremony, then I'll encourage

them to schedule an earlier ceremony time. The more involved you are with these options and how to best meet a couple's needs, the better able they will be to make informed decisions about their imagery.

In terms of finding moments of light and love during the wedding day, these present themselves from the time the bride starts getting ready to the first dance on the reception floor to the final embrace at the end of the evening. For instance, if a bride is getting ready in the corner of the room while trying to slip on her undergarments or dress, I will say something like, "Oh, you look so beautiful, come over here by the window and do exactly what you were doing." It is natural for a woman to hide in the corner while dressing, but it is incredibly beautiful to capture her putting her gown on for the first time with her bridesmaids or having her mother

helping her while they're near window light. It helps create and illuminate a moment in a way that being in a little corner does not. I make sure that while I am a documentary photographer trying to capture what is real and unfolding before me, I am also an artist and professional who has been hired to notice those nuances of light and guide the bride into the best situations.

One interesting example is when I photograph a couple seeing each other for the first time, which is something I'm doing more and more often at weddings (it's often referred to as the "first glance" or "first sight"). I like to help orchestrate the moment for a couple of reasons. One, so that I have a good position to frame both of them, and two, so it is in a lighting situation that is flattering to them, one that will emphasize the beauty of the moment. If I'm shooting inside, in a bride's hotel

The time right before a
ceremony is so full of emotion
and beauty. Here, the bride
looks toward a small window
as the sun sets. There was
very little light in the room,
so I used the fastest film I
could. I love how the painting
behind her becomes part of
the image.

Contax 645 with 80mm Zeiss
lens, Ilford 3200 film, f/2 for
1/60 sec.

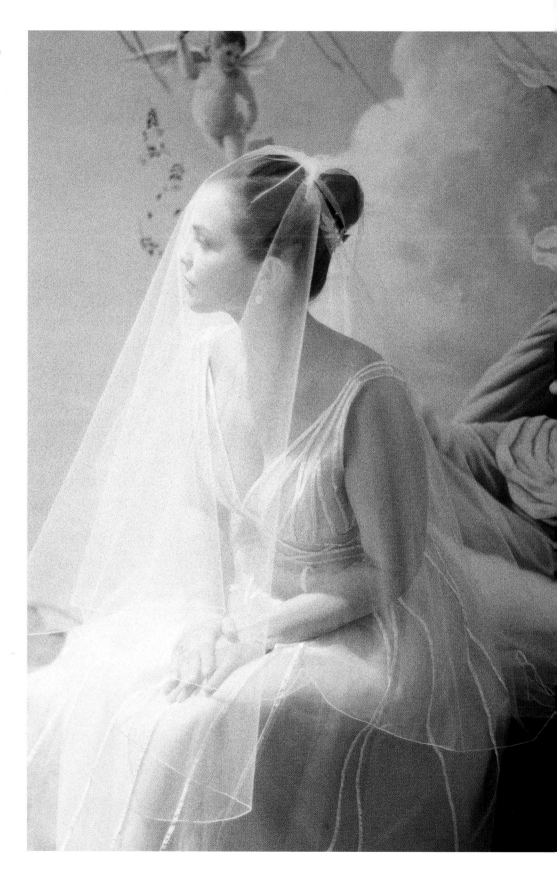

suite, I will politely ask everyone to leave so that the bride and groom can see each other by themselves, with no witnesses other than myself. It's a lovely moment to document as they take in the emotion of the day.

Sometimes I'll have the bride stand by a window and have the groom come in with his eyes covered until he is standing in front of her. This gives me a chance to pull back, focus on them, and then ask them to look at each other while he moves his hand from his face. This way I have chosen light that is going to look beautiful

for them and focused before the moment happens, to fully capture an experience they might not even fully remember because it is so full of emotion. If am shooting them outside, the same thing applies: I compose the image ahead of time and also prepare for the natural expressions unfolding as they set eyes on each other. That's the situation you can't plan for, the way they are going to hug or cry or embrace or laugh. It's an incredibly private moment, and being the only witness to it is very moving.

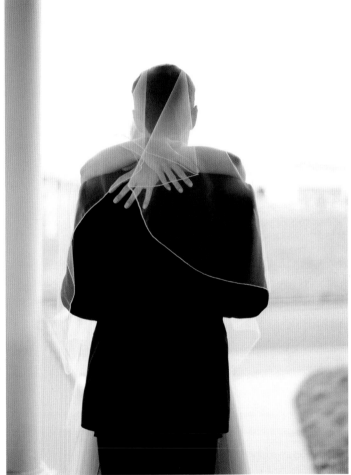

The mother-of-the-bride laughs as she cradles a baby. This is my favorite type of group shot, a moment within a moment. I had organized them in a line to do a proper group shot, and then something else happened—an unplanned moment of joy. It was a very bright day so I made sure to set up the shot in a shady spot.

Contax 645 with 80mm Zeiss lens, Fuji 800 NPZ film, f/4 for 1/60 sec.

This image was taken right after the bride and groom saw each other for the first time. The moment was intimate, so sweet.

Contax 645 with 80mm Zeiss lens, Fuji 400 NPH film, f/2 for 1/60 sec.

The Subtleties of Beauty: Adding the Details

Every element a couple chooses for their special day is part of their personal love story—the flowers, the ring, the dress, the photos, the cake, and so on. To me, the subtleties of beauty are about tying in the human element, like the portraits and the "getting ready" images, along with some of the details and specific things they've chosen to be part of their wedding day. Capturing everything from the tilt of a bride's head as she puts on her shoes to the color of the sky on the day a couple gets married, to the bouquet the bride carries down the aisle—these are all subtleties of the day that carry meaning for the couple and are important to document. They are all part of their love story.

In turn, items like the dress, rings, and shoes deserve their own portraits because they reveal so much about the day. In the end, it's about creating images the couple can share with their children and grandchildren in years to come, images that will allow people who couldn't be there to still experience what it felt like to be part of the wedding.

One thing to note: If I am photographing something close up, like a bouquet, I don't usually backlight it the way I would a portrait of a person. I tend to place an object on the ground or on a chair, in some spot where I can get above it and frame it well with even light. With a wedding dress, I like to get creative with where I hang it and how I shoot it. I will always ask permission to take the dress on a walk, maybe borrow a ladder and hang the dress from a tree (I've also been known to hang dresses from chandeliers or from a window in the room where the bride is getting ready). I prefer to use backlight or ambient window light, just as I would with a portrait of a person. The portraits of these inanimate objects should be timeless, iconic images that help tell the couple's love story.

Opposite, bottom: It's the little things that can say so much. After the ceremony of this couple, I photographed them at their altar. Lavender had been strewn on the ground, and it was the perfect backdrop for a portrait of their feet. The details of a wedding can be effective visual components of the photographs. The late-afternoon sun cast a gentle light on the vignette.

Contax 645 with 80mm Zeiss lens, Fuji 800 NPZ film, f/2 for 1/60 sec.

Far left: I recommend creating "portraits" of a bride's bouquet. The flowers may only last during the wedding, but the photo will last a lifetime.

Contax 645 with 80mm Zeiss lens, Fuji 400 NPH film, f/2 for 1/60 sec.

Left: Pretty much everything at a wedding needs a "portrait." I love to take a clean, simple image of the cake before it gets too dark. I photographed this cake as it sat on a table near a big window before the ceremony took place.

Contax 645 with 80mm Zeiss lens, Fuji 400 NPH film, f/4 for 1/60 sec.

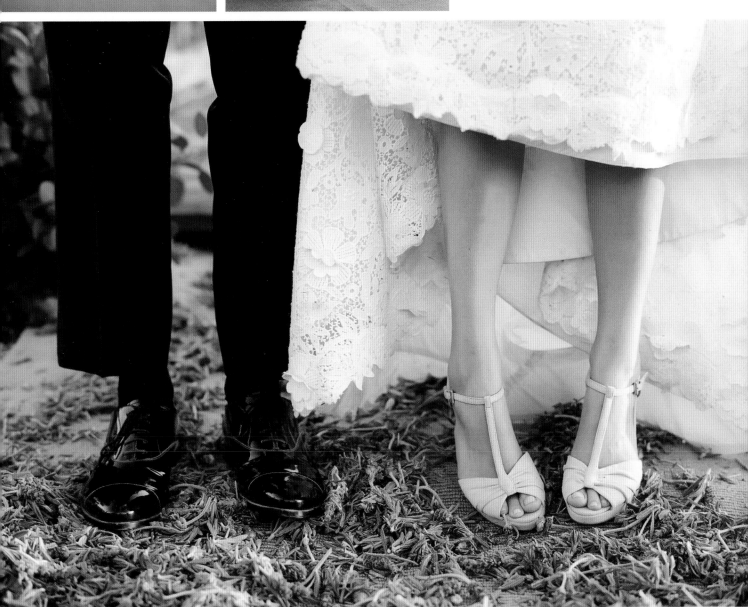

As the sunlight poured in behind them during a sunny day at the beach, this groom picked up his bride and gave her a sweet kiss.

Contax 645 with 80mm Zeiss lens, Fuji 800 NPZ film, f/2 for 1/60 sec.

Sometimes you just have to let go. After a ceremony in Mexico, this sweet couple took off their shoes and started running down the beach. It was an unbuttoned moment on a gloriously sunny day.

Contax 645 with 80mm Zeiss lens, Fuji 800 NPZ film, f/4 for 1/250 sec.

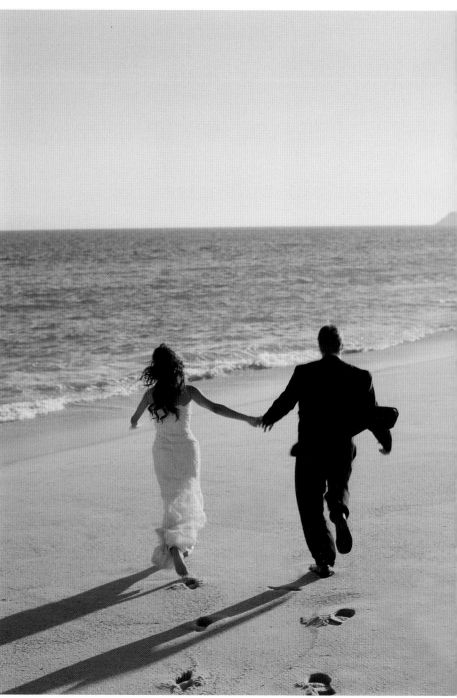

Bride-and-Groom Portraits: Think Outside the Box

I like to get very creative when I am doing portraits, especially those of the bride and groom. First, I like to do a traditional, "proper portrait"—something they can give their parents—with the couple standing next to each other looking right into my lens. Then I will often lie down underneath them and shoot up, with the sun coming between them. Some couples are willing to lie on the ground and kiss their partners upside down and do all kinds of creative posing, while I shoot from above. I always try to think outside the box and experiment.

I've also photographed couples who have taken off their shoes and run along the beach, or posed under or behind a parasol. Of course, any creative posing works best with the couple's enthusiastic participation. If they are interested in props or playful shots, I am more than willing to go along with that. If they want something more photojournalistic, then I don't offer any posing at all and just photograph them as they interact naturally throughout the day. Either way, it's important for me to capture something real to them—and something that I know ahead of time matters to them so that I can execute it as best as possible.

The intimate dynamic between a bride and groom during their vows can also result in some amazing portraits. During the ceremony, I tend to move around a lot—I want to get a wide view of everything that is happening as well as capture close-up expressions on their faces. One thing you never want to do, though, is stand in front of a particular person or group of guests and block their view. (Likewise, there is often a videographer or filmmaker present whom you also have to be thoughtful and respectful of.)

The ceremony portraits tend to be much more photojournalistic in nature, because again, you can't interact with, interrupt, or distract the couple from what is happening. Instead, you must capture what you see and what is unfolding in front of you as gracefully and unobtrusively as possible.

While a couple is exchanging vows, it's better to focus on the person who isn't speaking—that way, you can capture the expression while hearing the vows. When you are photographing someone speaking, it's very challenging to get a good portrait—you either get them midword or with their mouth contorted. If the groom is reciting his vows, I will sneak up behind him and focus on the bride over his shoulder. That way I can see her emotional response. The tendency is to focus on the person speaking, but if you flip it and go against that urge, you can get really beautiful, emotional portraits during the ceremony.

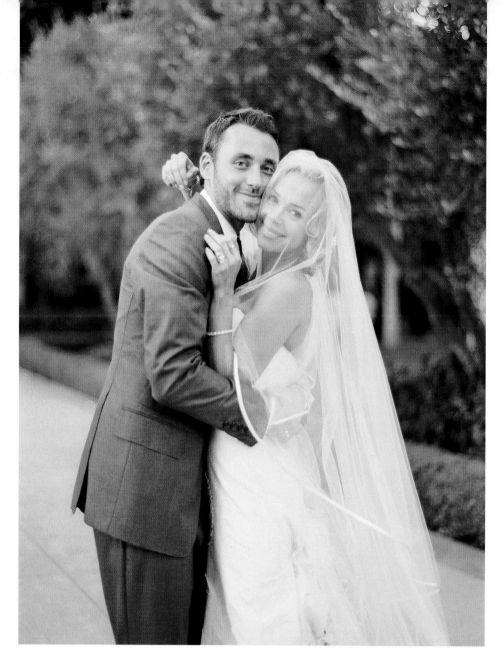

Opposite: Atop a mountain in the Santa Ynez Valley, I knelt between Jill and Josh Schwartz as the last bit of light lingered in the sky. I love to change my perspective from time to time. This angle created a graphically simple image, with nothing but the sky and a little bit of light framing them.

Contax 645 with 80mm Zeiss lens, Fuji 800 NPZ film, f/2 for 1/60 sec.

Left: Stylist Simone embraces her new husband Marc beneath the netting of her veil. Notice how the veil catches the light and frames her face. The cloud-filled sky created the most lovely, even light.

Contax 645 with 80mm Zeiss lens, Ilford 400 XP2 film (printed sepia), f/2 for 1/60 sec.

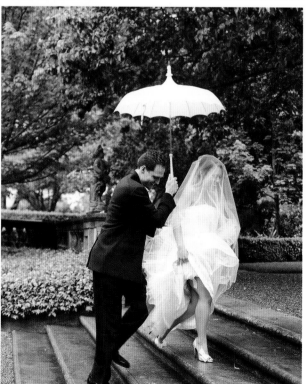

As the rain starts to fall, a groom shelters his new bride from the raindrops. Although most would admit that rain is not ideal for a wedding day, it certainly can add to the beauty of the images.

Contax 645 with 80mm Zeiss lens, Kodak Portra 400CN film (printed sepia), f/2 for 1/125 sec.

140

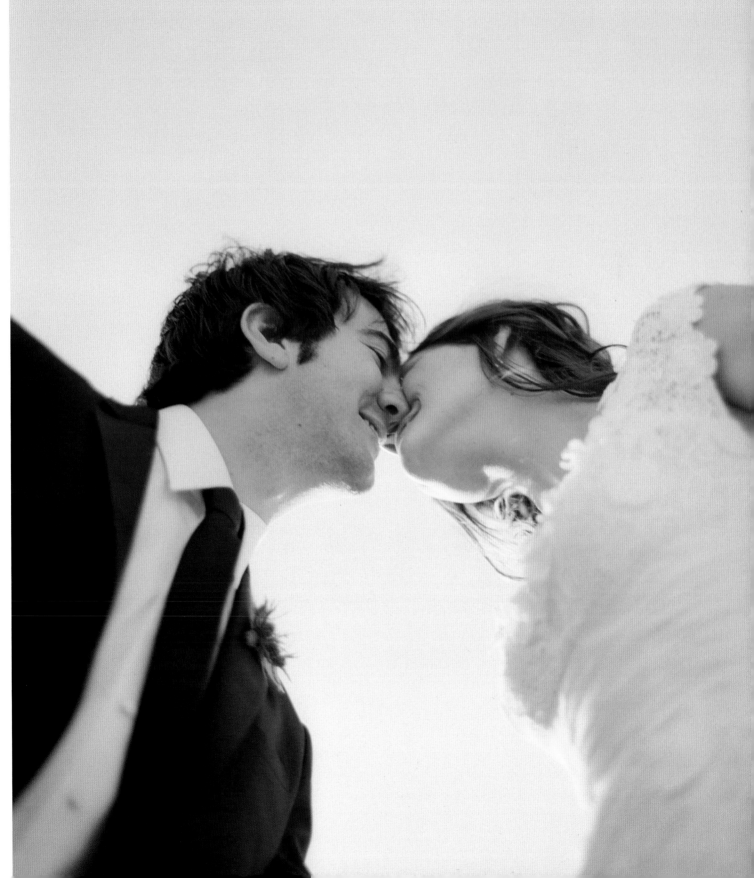

The Luminous Group Shot

I approach group shots a little differently than I do most of my other portrait work. I want things to be clearer and more in focus than usual, and I do not want a shallow depth of field. When I shoot groups at a wedding, I like to focus on one or two faces, usually the bride and groom, and I'll stop down to at least f/5.6 so that if everyone is in a line, they will all be mostly in focus.

When it comes to composing a group shot, I never yell, raise my voice, or tell people where to put themselves in any sort of overly structured way. However, I will put my camera down and arrange people a bit—because sometimes when you are doing group shots, the natural tendency is for people to line up behind one another. They don't realize that I have more room in my frame, so I will encourage them to position themselves in a straight line. I generally pose them to a certain degree, but then allow something natural and real to happen. These people are celebrating an incredible day, and sometimes, when I'm changing film or after they believe I'm finished, people in the group will start laughing, hugging, or having a moment between them. These are the moments you want to capture, and getting them is partly about being prepared, partly about paying attention even when people think the shoot is over. Always keep an eye out for that moment "in between" the moments.

Many group shots are done outside, and if it is a really bright day, I'll stop down to f/5.6 (exposed for 1/60 sec.). As with most of my portraits, they are still backlit (with the sun behind them), and I still overexpose for the shadow. Other times, when I am in open shade and have a smaller group of people, I might shoot at f/4 but still usually at 1/60 sec. As a film shooter, I can let a lot of light into my frame (digital shooters may have less flexibility).

Due to scheduling conflicts or the bride and groom's preferences, there will inevitably be times when you are shooting group portraits at high noon, which on a sunny day can result in very harsh, contrasty lighting. In those situations, I make sure that I have either scouted the location ahead of time, or if that is not possible, I'll take a quick look around while the bride is in her final moments of preparation and pick a place that will work both for the best lighting and the number of people I'll have in the group shot. For instance, if we are going to be outside in a large space and have a large number of people to shoot, I'll make sure that I am placing the entire group with the sun behind them so that there won't be a lot of people squinting and feeling uncomfortable. The best group shots are a result of preparation, anticipation, and implementation of everything you've learned about light.

Right: This group shot was taken on a sunny Santa Barbara afternoon. There is no "perfect" way to organize children. I love how not everyone is looking at me. The portrait feels real and relaxed. I stopped my lens down to f/5.6 so that I could get a clear shot of the whole group. With the sunlight behind them, I exposed for the shadow.

Contax 645 with 80mm Zeiss lens, Fuji 800 NPZ film, f/5.6 for 1/60 sec.

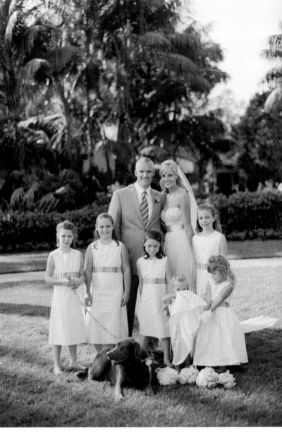

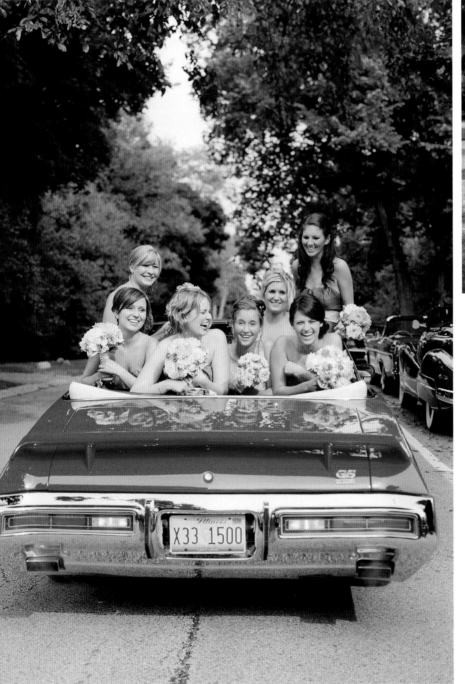

Left: All the bridesmaids in this wedding party piled into a bright red car to head to a reception outside Chicago. The partly cloudy day created a great lighting situation, and I ran into the street behind them to capture this image. I love how playful this photo is; it feels like the beginning of a celebration.

Contax 645 with 80mm Zeiss lens, Fuji 800 NPZ film, f/4 for 1/60 sec.

143

The Creative Edge

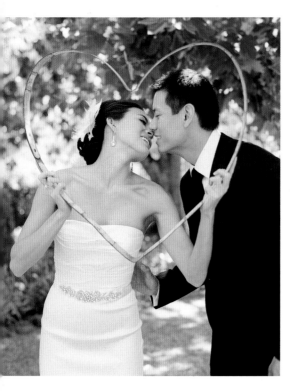

This image was taken on a bright, sunny day in a Napa Valley vineyard. I took the newlyweds to a shaded nook with the sun behind them. The metal heart was made from a piece of an old wine barrel. I exposed for the shadows and pressed my shutter just before they kissed. The heart acts as a frame within the frame and accentuates the light on their faces.

Contax 645 with 80mm Zeiss lens, Fuji 400 NPH film, f/4 for 1/60 sec.

Keeping it fresh is one of the most difficult aspects of wedding photography. You need to establish a recognizable, cohesive style and yet, within that consistency, keep producing fresh images. There are always going to be trends and certain types of images that are popular and that your client may request. My number one priority is giving clients what they want, so if they want a cute, trendy image, you'd better believe I'm going to shoot it for them. Certainly there are images that I repeat from wedding to wedding, out of either practical necessity or personal preference. Yet I struggle not only to create new and unusual images but also not to imitate an image I've previously done. It can be easy to fall back on certain types of images that work well, but I also like to challenge myself as a professional and as a photographer, and remain connected with the moment unfolding in front of me. The advantage here is that a wedding is full of emotions and moments, and it's the best place to be if you want to capture something unique.

I put a lot of effort into the final presentation of a couple's wedding images, so postproduction is as important as what I do before and during the wedding. I separate all of their photographs into little bundles, securing each with ribbon, before delivering to a bride and groom. I also love to create special albums or make encaustic wax pieces of a particularly lovely image, and I also offer oversized montages of the day that can be hung on a wall in someone's home. I present all these elements to the couple as art—the art of their life. When you have the honor of capturing a couple on their wedding day, you are documenting moments that will become family heirlooms, passed on for generations to come.

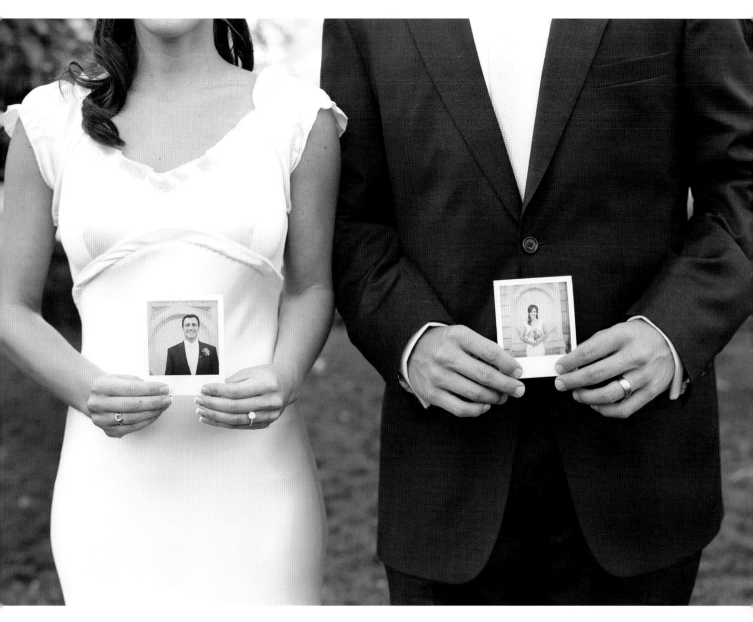

Photographer Nicole Hill and her husband, Adam Gerulat, took turns taking portraits with a Polaroid camera. I thought it would be cute to take a portrait of them holding each other's images. The overcast day in Utah gave me even light, perfect for this shot.

Contax 645 with 80mm Zeiss lens, Kodak Portra 400CN film (printed sepia), f/4 for 1/60 sec.

145

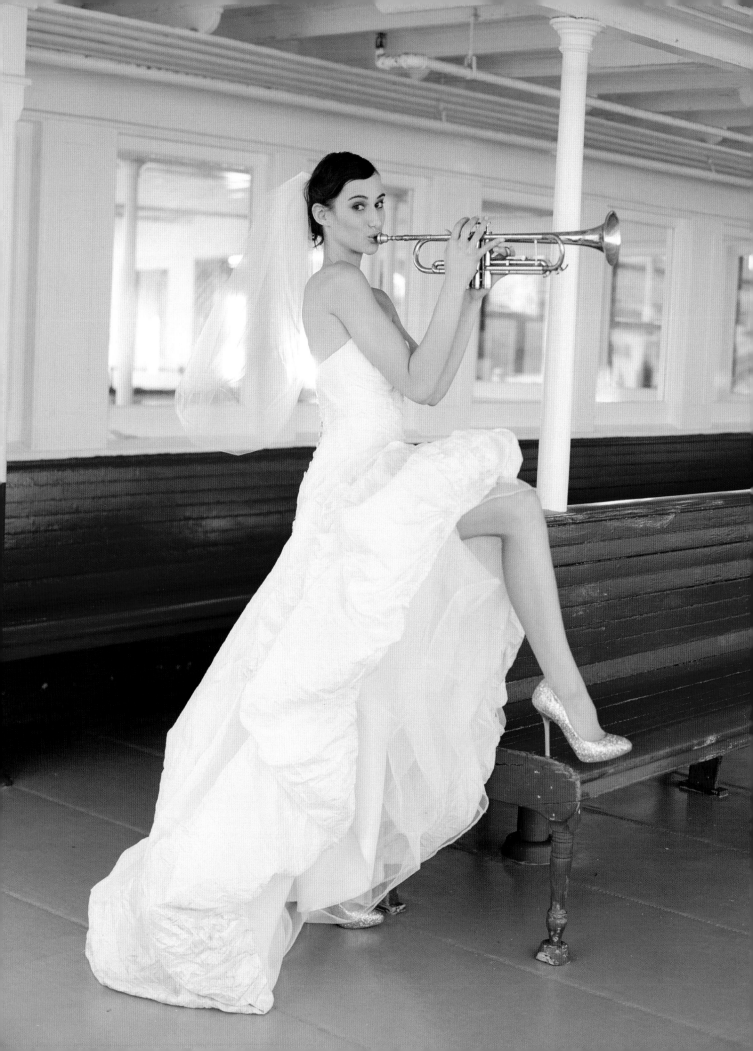

Styling & Props

Props make me happy. Perhaps this is because beautiful vintage objects remind me of exploring antique stores with my mother. It is important to incorporate props as naturally as possible. For this image, I asked the model to pretend to play, creating a better fit within the frame. The horn also adds a playful element to the image. The warm light of the San Francisco bay lit the scene well.

Contax 645 with 80mm Zeiss lens, Fuji 400 NHP film, f/4 for 1/60 sec.

As we draw toward the close of this book, you should be well-versed in the most important elements in your portraits: the light, your camera settings, your composition, and the comfort level of your subject. These components should be present before you even think of introducing something new into your repertoire. As you become more comfortable with your personal shooting style, however, and more familiar with what does and doesn't work, you may want to broaden your scope by incorporating styling and props to enhance the mood and feeling of an image, help tell a story, even provide background information that relates to your subject.

Props have been a part of my life ever since I was a young girl and my mom would take me to antiques stores. Those outings were a special treat, and I was completely enamored of the incredibly old things I saw. For me, certain objects hold a lot of meaning, and I'm always curious about the stories behind them. My own essential props include fabrics, vintage cameras, signs, and crowns. Whenever I travel, my first stop is a flea market or bazaar, and I've found amazing props all over the world, including a vintage bed in Miami and an old flour sack in France. Incorporating props into my work was a natural evolution for me.

But simply because you have a prop and love it doesn't mean you should use it in every shoot. A key aspect of using props is to know when to use them and how to use them. Pay attention to your location, and take note of what is available around you to use if it makes sense within the context of your image. It can be anything from a chair on a patio or a flower from a garden to a textured wall or a piece of antique furniture. The options are endless if you are in touch with your own creativity. Of course, there are many photographers who are not into using props, and that's totally fine. Just skip over this chapter if you prefer. However, if you are drawn to the idea of incorporating props, keep in mind that an object should not overpower your subject but enhance your images and options within a shoot.

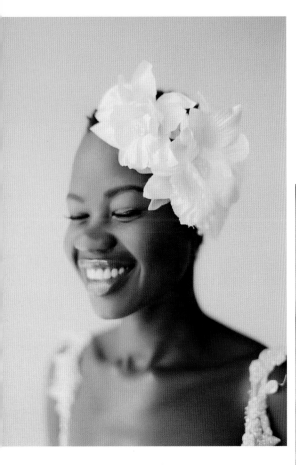

Left: Sometimes using a prop doesn't require adding anything to the shoot but rather simply focusing on a detail. Here, my main focus is the flowers in her hair. The detail of flowers catches the light and complements her smile.

Contax 645 with 80mm Zeiss lens, Fuji 400 NPH film, f/2 for 1/60 sec.

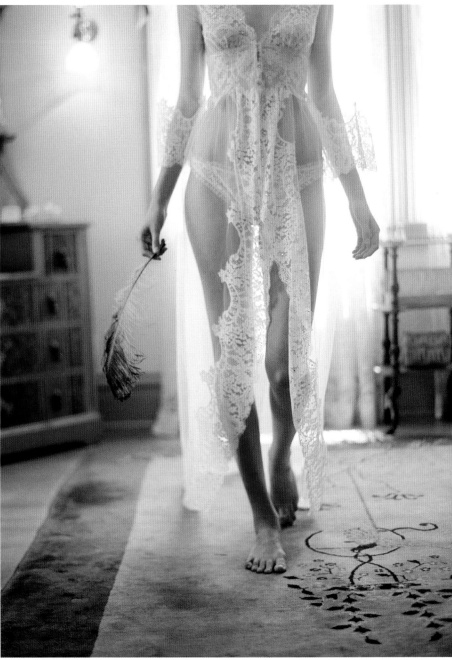

Right: In this image, a feather adds an element of interest without dominating the frame. Backlight from a window illuminates both the model and the feather with a gentle, warm light.

Contax 645 with 80mm Zeiss lens, Fuji 400 NPH film, f/2 for 1/30 sec.

Incorporating Essential Props

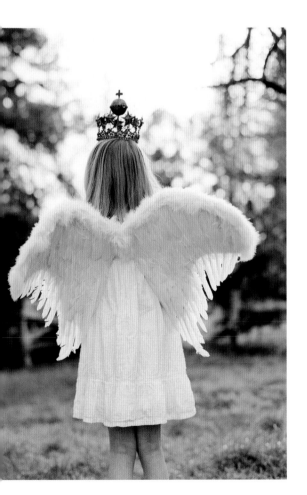

I often bring a bag of props to a shoot, but that doesn't mean I'll necessarily use them. So how do you decide which props are essential and which might be considered frivolous or unrelated to the image?

One rule of thumb is that props can be used to help you tell a story or add another dimension to an image. While at a shoot for lingerie designer Claire Pettibone at an amazing Victorian house, I incorporated elements from the historic property. A vintage writing plume on a desk felt like an authentic addition to the style of the lingerie; light from the window behind the model illuminated both the robe and the feather with gentle backlight. On another shoot, a simple flower headpiece framed the model's face without taking over the image. When making choices about props and styling, it is usually best not to include too much. A prop should be a subtle addition to the overall feeling of a shoot. And no matter what props you include, the most important element is always the light.

This image is from a personal series on crowns. The little girl faced the sun as it descended in the sky. I exposed for the shadow, creating a luminous light around her wings.

Contax 645 with 80mm Zeiss lens, Kodak Portra 400CN film (printed sepia), f/4 for 1/60 sec.

Even better is to use something already at the location or something your subject already possesses that is meaningful to her. For instance, while photographing a friend's birthday party in France, the cake and candles were perfect props. I moved the cake into the middle of the courtyard so that it would be well lit on the overcast day. Even though it was still daylight, I lit the candles. This image to me captured the sweetness of the birthday celebration in a flattering light. The cake, the candles, the light, the kiss—together they tell a story.

Although a prop can feel essential in the moment, always be willing to get rid of it if it isn't working. In order to create meaningful images, you as a photographer must adapt as your shoot unfolds. If you look through your lens and the light seems too harsh, move to another spot until you find flattering light. If you found an amazing prop, like a vintage camera, but your subject looks uncomfortable with it, get rid of the camera. Only if the prop feels and looks natural while you are shooting will the resulting image look natural. Styling a shoot is as much about what you *don't* include as what you do. Let your instincts and eyes guide you.

Props can also be "essential" because they are special to you, as the photographer. Let's say you love hats (as I do). Go ahead and use them in your shoots, and make hats one of your essential props. In addition to using vintage props, I also love supporting up-and-coming designers. One of my favorite headpiece designers is Myra Callan of Twigs & Honey. I often incorporate her pieces, which are true works of art, into my shoots, and by doing so, I am offering patronage to another artist. Look within your own community; you may find creative options right under your nose.

One caveat: When incorporating objects into your photos, do not force them. As a professional, it's your responsibility to consider ideas that your clients may

not think of themselves, but you need to remain unbiased. You may have fallen in love with a vintage camera and wanted to use it, but if it doesn't work or looks out of context, you have to be willing to edit that image out. That's an important part of being a good photographer, no matter what type of images you are shooting. Props or no props, always strive to see and evaluate your work separately from the experience of creating it.

Ultimately, use props whenever it feels right to you. If you have some things you think will work well, bring them with you. If a subject has something around his house, something that is part of his life that might work well, then I will encourage him to bring it to the shoot so that we can play with it and make the image more dynamic. It's just a matter of testing the waters and experimenting. If something catches your eye while you are on location, or you have an object at home you are most identified with, try using it in an image. It may not work, but that's okay. Then move on to something else. Just as I've encouraged you to experiment with light and exposure, you should also try variations with props. You'll only know what works after trial and error.

While photographing this friend, I decided to come in close and crop out part of her face to draw attention to the beautiful Twigs & Honey hair adornment. Experiment with framing, especially when incorporating props. The window light cast a soft, diffused light on my subject.

Contax 645 with 80mm Zeiss lens, Fuji 800 NPZ film, f/2 for 1/60 sec.

This sweet husband shares a kiss with his wife after lighting her birthday candles. Incorporating objects into your shoots always works better when they are real. It was her birthday, and the cake was a perfect prop for this photo. The day was a bit cloudy, and I took this image as the sun hid behind a cloud, giving me a soft, even light.

Contax 645 with 80mm Zeiss lens, Fuji 400 NPH film, f/4 for 1/60 sec.

While shooting a wedding, I noticed a woman wearing the most beautiful emerald green shoes, which just happened to be the same color as a vase in the hallway. I asked her to remove her shoes for this photograph. The hall was filled with windows, bathing the shot in even, soft light.

Contax 645 with 80mm Zeiss lens, Fuji 800 NPZ film, f/2 for 1/60 sec.

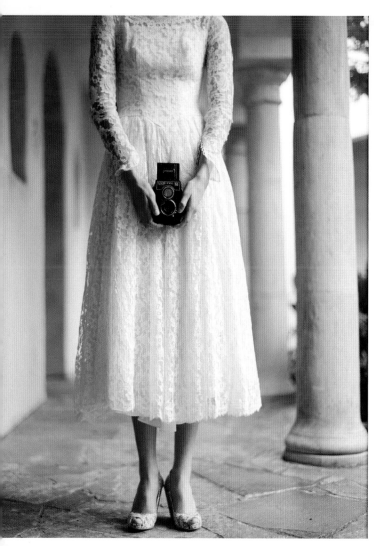

Above, left: This stylized image is one of my favorites. I love how the vintage lace dress frames the woman's arms as she gently holds a vintage Russian camera. The overcast day emitted a perfectly even light.

Contax 645 with 80mm Zeiss lens, Fuji 800 NPZ film, f/2 for 1/60 sec.

Right: I adore details. This stack of vintage books, paired with a handmade crown and sparkly shoes, was part of a fashion shoot for designer Ivy & Aster. Several large windows filled the room with diffused light.

Contax 645 with 80mm Zeiss lens, Fuji 400 NPH film, f/2 for 1/60 sec.

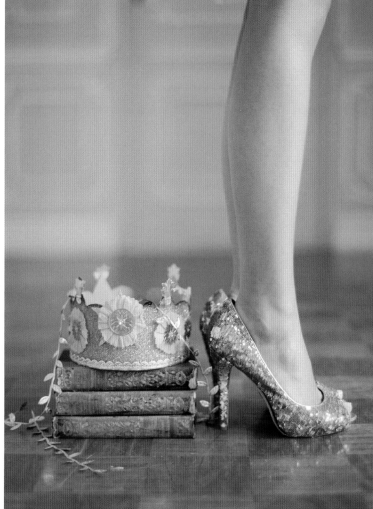

Opposite, top right: A young couple wearing Venetian masks hold their son in their arms. The three stood in a field on a bright day with the sun behind them. What I love about this image is how the masks are captivating yet don't detract from the visual allure of the beautiful baby boy. The pose and gesture between the couple and the baby are natural and relaxed, so the masks do not take away from the focus of the overall image.

Contax 645 with 80mm Zeiss lens, Fuji 800 NPZ film, f/4 for 1/60 sec.

This fairy-inspired shoot was styled by Tricia Fountaine. The owl was the most amazing element; I love how the bird is spreading her wings, almost as if on cue. This moment was captured in a wooded area outside of Santa Barbara. The trees above helped diffuse the bright light of the sunny day.

Contax 645 with 80mm Zeiss lens, Kodak Portra 400CN film (printed sepia), f/2 for 1/60 sec.

Sometimes the most effective prop is something very simple. This sweet "xoxo" spoon was made by Monkeys Always Look. As model Faye Dinsmore rested the spoon against her lips, I asked her to close her eyes. The result is an image that feels like a wish, as though she were wishing for a kiss.

Contax 645 with 80mm Zeiss lens, Ilford 400 XP2 film, f/2 for 1/60 sec.

The Sweetness OF SIGNS

When it comes to best utilizing props, try to be aware of your strengths and weaknesses. I love signs but I'm not a calligrapher. Instead, I have them made for me by Modern Press in New York City. One that crops up a lot in my images is a "Kiss" sign (I also have signs that say "Lovely," "Sweet," "Love," and so on). *Kiss* is one of my favorite words, and what I love about including it in an image of two people kissing, such as the one shown here, is the visual and literal repetition. The viewer is hit with the concept on multiple levels. Signs can bring the image back to just one word, succinctly and directly.

The other image shown here, of a girl holding a *Vogue* book, offers a play on styling and words. Look at the repetition in the photo—the girls on both the book cover and in the image are wearing black and have black hats on. They are all "in vogue."

Here, the book is a natural addition to the portrait. The woman holding the book is wearing a black hat and dress that mimic those worn by the women on the book's cover. The visual repetition is both graphically pleasing and playful. The window light caresses her cheek and bounces off the white pages of the open book back onto her face.

Contax 645 with 80mm Zeiss lens, Fuji 800 NPZ film, f/2 for 1/60 sec.

I placed a series of Polaroid prints I had taken on a bed, and then lay a spoon bearing the name of my workshop on top and photographed the little montage. The spoon-sign was a great graphic addition to my sign collection.

Contax 645 with 80mm Zeiss lens, Fuji 400 NPH film, f/2 for 1/60 sec.

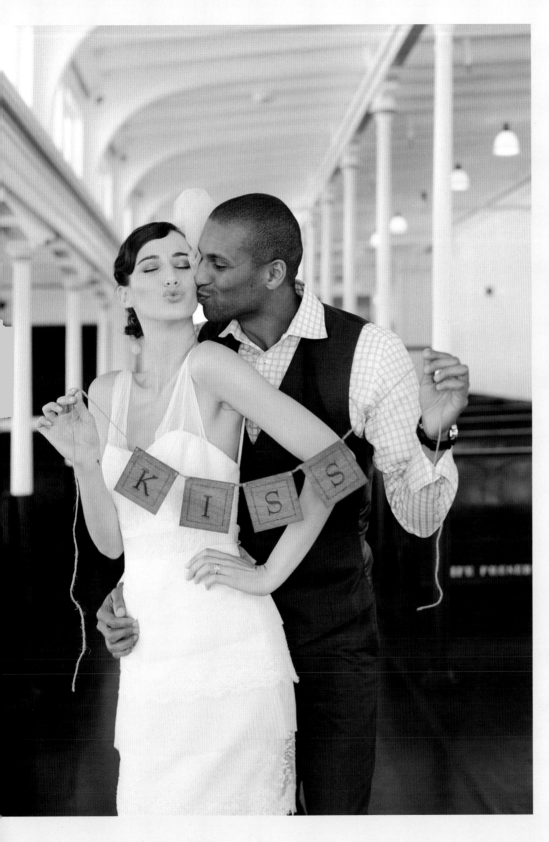

They say an image is worth a thousand words. I like how incorporating a sign can focus the image on just a *single* word.

Contax 645 with 80mm Zeiss lens, Fuji 400 NPH film, f/2 for 1/60 sec.

155

Authentic Styling

Whenever I am working on a styled shoot, I strive to create authentic-feeling images. This is often more challenging than you'd expect. I find window light to be the best first step toward making a natural-feeling image.

Contax 645 with 80mm Zeiss lens, Ilford 400 XP film, f/2 for 1/60 sec.

Styling a photo shoot is, simply put, making artistic choices about how you are going to approach a shoot. It is being thoughtful about composition, framing, posing, and props. In its most basic form, styling is more about what you are *not* shooting than what you are including. A more stylized editorial image is one that is uncluttered, unencumbered by unnecessary elements within your frame. Other times, you are adding elements to enhance your image. The point is, you as the photographer, as the artist, are making stylistic decisions before and during your shoot. You are part of the images you create rather than just observing and capturing.

A successful stylized shoot achieves a natural ambience. This may seem contradictory, but I promise, it's not. This first element is, as you may expect, beautiful, flattering, natural light. Then, as you interact with your subject, be thoughtful about all the elements you see when you look through your camera. Finally, encourage the subject to move or hold still, depending on what you think works best. Be aware of posing and your subject's relationship to the light at all times, and yet still strive to capture something that looks utterly natural.

I have been lucky enough to work on many shoots with professional stylists. I am always grateful to have another creative person to help influence the style of the shoot. More often than not, however, I am styling on my own. Any photographer can style her own shoot with a few guidelines. First, styling starts before you get on location. For me, it starts the moment I book a job. I talk at length with my client about our shoot and make suggestions about location, clothing, time of day—everything. I have a vast collection of pretty things—blankets, crowns, props of all kinds—and I will gladly bring any of them to a shoot upon request. Preparation is not only a photographer's best friend but also a stylist's. Once at the shoot, I use whatever feels most natural to the setting and my subject.

This gray dress blends so well with the gray walls. Although it was an extremely bright day, a covered patio outside provided the perfect open shade to capture the subtleties and tones within the dress.

Contax 645 with 80mm Zeiss lens, Fuji 400 NPH film, f/4 for 1/60 sec.

Bottom, right: The sky, although one of the unlikeliest props, is one of my favorites to use in an image. I love to pause during a photo shoot and look up directly at the sky and take a photo. This can be an especially nice addition to a wedding day, to give the couple a visual record of what the sky looked like on the day they exchanged vows.

Contax 645 with 80mm Zeiss lens, Fuji 400 NPH film, f/4 for 1/125 sec.

Bottom, left: This sweet couple, Jillian and Rick, brought a cozy blanket to their engagement shoot that took place on a slightly chilly, overcast day. I loved the quality of the light, and the blanket worked as a perfect prop for the two of them to snuggle under. This is my favorite image from their engagement shoot. I love the way he is kissing her cheek under the blanket and the adorable way she is peeking out at me. It is almost as if their bodies are forming a heart together.

Contax 645 with 80mm Zeiss lens, Fuji 400 NPH film, f/4 for 1/60 sec.

Sometimes the prop within an image is not necessarily what somebody is holding. One time, while I was on an editorial shoot for a magazine, for example, I noticed how the design and tone of the wallpaper on the wall in the room we were shooting in was reminiscent of the design and theme of the dress my model was wearing. I decided to have her stand right next to the wall, and it was almost as if she became part of the design. It was one more element that was already there—I didn't bring something in, and I just happened to notice and respond to it while we were shooting. That wall became a great design and styling element just by placing her near it. The tones really complemented what she was wearing.

Another time, I photographed an engaged couple who brought some personal belongings, one of which I adapted as a prop to use in their photographs. On the previous page, they are shown standing together while peeking out from under a blanket that the woman's fiancé is holding above them. It was a cold, overcast day, but the woman had her heart set on wearing the blue dress you see in the picture, which was really meant for warmer weather. They brought this blanket from home, and we found a way to incorporate it into the shoot so that, one, they could be warm and cuddly and, two, she could still wear the dress she wanted to wear. And this was a way to incorporate something that belonged to them while creating this really sweet image where we get a sense of them as a couple. The blanket tied all the elements in the image together.

One thing I like to do at most jobs is take pictures of the sky, which I sometimes consider another important visual element. I always photograph the sky at a wedding or a portrait shoot because I think it's one of those sweet little details people don't necessarily remember. You may remember that your day was warm and sunny or overcast, but not what the sky looked like on the day that we took photos. I think it's a great detail to use sometimes because it can really anchor an image in terms of time and place.

The same thing goes for using styling within an image, which can mean anything from hair, makeup, and wardrobe to how you are placing your subjects and framing them within your image. In one shot of a girl getting ready, I noticed how beautifully the light was hitting her face in that moment and captured it, which ended up being one of my favorite images of the shoot. It may be tempting to wait while your subject is getting ready to be photographed, but if you remember to pay attention and be prepared for anything at any time, it opens up the range of photo opportunities available to you within a shoot tremendously.

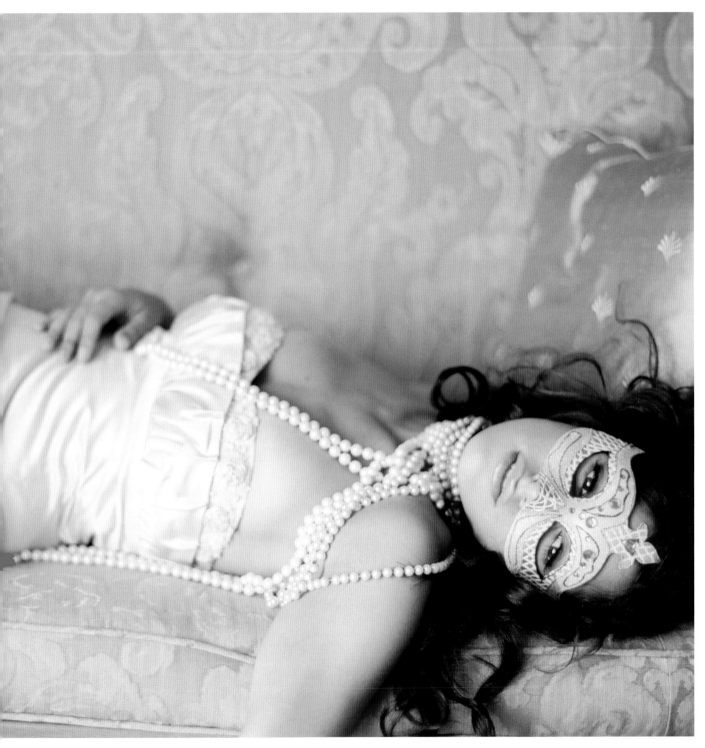

The simple addition of a mask creates a little mystery in this photo. Because the prop is the same tone as the chaise, it is not overpowering. I love props that enhance, rather than dominate, an image.

Contax 645 with 80mm Zeiss lens, Fuji 800 NPZ film, f/4 for 1/60 sec.

159

modèle *weddings*

THE SECRET CHARM OF
Villa Lago

**DESTINATION
SANTA BARBARA**
What to do the
week before
your wedding

ETERNAL LOVE
At the Acacia Mansion

A French Seduction
by Elizabeth Messina

Santa Barbara
MAGAZINE

AU
NATUREL
ALL THINGS GREEN

ECH UTOPIA
ILICON BEACH SWELL
VON CHOUINARD'S
PIC ADVENTURE

PLUS
WEDDINGS
YOUR 2010 GUIDE TO
THE WHO'S WHO OF I DO'S

PROFE IONAL
photo a he
SEPTEMBER 2008 | WWW.PPMAG.COM | $4.95

Enchanted
The wedding industry is driven by love and emotion.
*"As a photographer and a woman,
I'm connected to that."*

ALSO IN THIS IS
» HOLIDAY CARD IDEAS
» 5 THINGS SENIORS WILL B
» BOUDOIR-STYLE PORTRAIT

YWD
YOUR WEDDING DAY

The Perfect Pair
shoes and lingerie

Paper & Ink
stylish invitations

*An Evening
of*
Classics

Fall 2005 $4.95

Private Paradise
island-style weddings

PROFESSIONAL
photographer

MediaKit09
YOUR ADVERTISING PLANNING GUIDE

свадебный журнал-каталог
**МЕДОВЫЙ
МЕСЯЦ**
октябрь | ноябрь 2008

2 РЕТРО-СИЛУЭТА
АНТИЧНОСТЬ И ШАНЕА

4 НАПРАВЛЕНИЯ
ВАШЕГО СЧАСТЬЯ

24 СКИДКИ
ОТ 5 ДО 20% – ВНУТРИ!

**Первый
номер**

Chumash!
LIVE IT UP AT THE CHUMASH CASINO RESORT SUMMER 2005

keeping cool
this summer!

amazing hot stone massage
slot strategies for you
*the willows welcomes
a five-star chef*
*the art of cooking talent
for the samala stage*
*what goes into a
four-diamond resort*

Ines del mar
Wedding
The art of weddings

ECO FRIENDLY FIN

REAL LOVI
INSPIRING DESIG
AND DEC

AFTER DA
BOUDOIR PHOTOGRAPHY A
LING

FEATURED DESTINATI
PHOTOGRAPH

EVENT COLOR PALETTE
WITH DESTINATION EV
DESIG

DAVID TUT
SOUTH BEACH WEDD

ELEMENTAL INSTINCT
FLORALS, DECOR VENUES,
INVITATIONS: LETTING NATURE'S
ELEMENTS INSPIRE

RAINY DAY WOMAN

BEAUTY AND THE BEACH
GORGEOUS GOWNS

FALL/WINTER 2008
$6.99 US $7.99CAN

www.inesdelmar.com

YWD
YOUR WEDDING DAY

*Dusk
til
Dawn*
Sensual Gowns

Your Total Look

Event Environments
Modern, Romantic and Enchanting

Boutique Perfumeries

Stunning Weddings Culture from around the world

Sweet Surr
Behind closed do ses of a bou

Winter 2007

The Art of Business

A big part of running a photography business is sharing your images. In addition to having my website and blog (kissthegroom.com), I work with many magazines, and being published has been wonderful for my career. When approaching magazines and websites with your work, don't get discouraged if you do not get the response you are hoping for. For every cover I have been lucky enough to be featured on, there are countless others that passed on my work.

You may have wanted to be a photographer since you were a child and are as creative as can be, but it's important to remember that this is still a business, and the business side of your art deserves as much attention as the creative side, if not more. You must not only be a photographer but also an entrepreneur, managing emails and phone calls, making deadlines, keeping on top of photo submissions, and constantly tending to stacks of paperwork, all the while maintaining your creative spirit and sense of self.

To find success in photography, as in any creative business, the key is to be tenacious. Photographers starting out today have so many outlets and venues for getting their work seen—magazines, websites, newspapers, blogs, gallery shows—all creating opportunities to get work before an audience and quickly build up a clientele. After all, if you don't know how to promote your work, no one is going to know who you are or what you do, no matter how talented you are.

Most important, recognize that success is a long, winding road and will be different for different people. No one will know about the jobs you didn't get or the magazines that rejected your work, but they will notice the ones you do get. Stay humble and remain committed to your work throughout any trials and tribulations that you encounter along the way.

Establishing Your Niche

You only get one chance to make a first impression, so be thoughtful about how you want to represent yourself. Here are two examples of my business cards. Instead of simply making a two-sided card, I created a trifold, which allowed me to show more images and create a visual story. This card presents some of my wedding, still life, and editorial photography, and although the images are from different jobs, they are all similar in tone and feel, which I believe is paramount. I want to convey both the variety of work I do as well as the consistency in the look of my images.

Becoming a photographer starts the moment you pick up your camera. Every image you shoot is an investment in yourself and brings you one step closer to establishing yourself. If you want to brand or market yourself in a specific genre or style—as, say, a "natural-light shooter"—then put your energy and effort into learning how to shoot in all different natural-light situations, whether window light, open shade, backlight, and so on. Consistency in your images is the first step to successfully branding your photography business.

When you are looking at your images after a shoot and notice some that are really working for you, make a folder of favorites to represent your best work. You must develop the ability to edit down your work. Getting the kind of clients you want begins with shooting and putting out the type of images you ultimately want to get hired for. The selection you show potential clients is critical. Any photographs you disseminate must be well lit and properly exposed as well as reflect your best work.

Once you've compiled a collection of images that reflect your style, the next step is printing a business card with your contact information and the type of work you offer (like "boudoir photographer" or "specializing in natural-light portraiture"). If you include an image on your business card, make sure it represents your style.

Along with business cards, another crucial marketing tool is your own website. You may want to hire a designer to help develop a logo to represent your business and design your collateral material, which should all be congruent with the look and feel of your website and images. You may even want to consider investing in a custom-designed

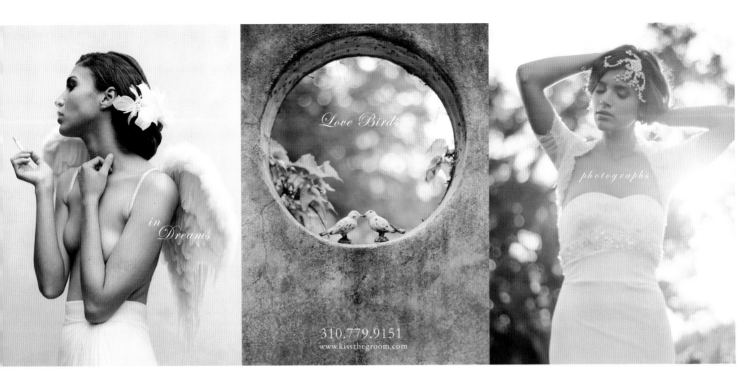

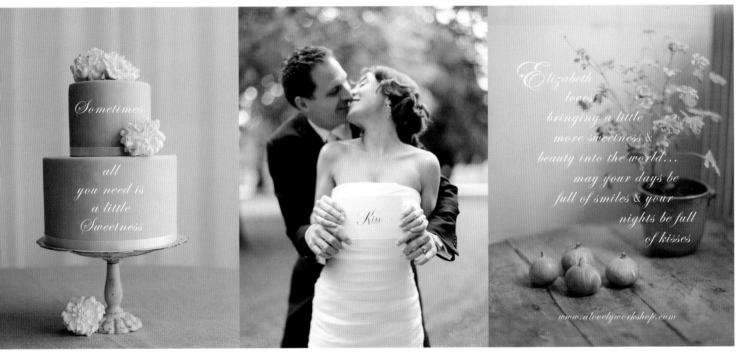

website, though this can be cost-prohibitive. Luckily, there are some wonderful template website companies on the Internet that offer reasonably priced services and look very professional (my favorite is BIG Folio). Successful branding will help you differentiate yourself from other photography businesses.

After I had a business card I was proud of and a website that represented my work successfully, I began to pursue other outlets for sharing my images. (Before you approach any outside websites, blogs, or magazines, be sure your personal website is well thought out and accurately represents your talent.)

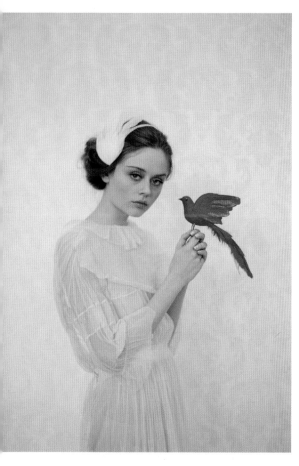

These two images were done for a campaign for headpiece designer Myra Callan of Twigs & Honey. Everything I know about natural light and composition has helped me take on projects like this one with confidence. These images were shot in a huge window-filled warehouse just as the sun was heading below the horizon and I asked the model to climb into the window. She was beautifully lit from behind, but we just had a moment before the light was gone. The other image was created earlier in the day. I used a backdrop from drop it MODERN, and the clean, simple background helped keep the focus on the designer's lovely headpieces; plus the white backdrop acted a little like a reflector and helped keep the light bouncing around the beautiful model.

Both images: Contax 645 with 80mm Zeiss lens, Fuji 400 NPH film, f/2 for 1/60 sec.

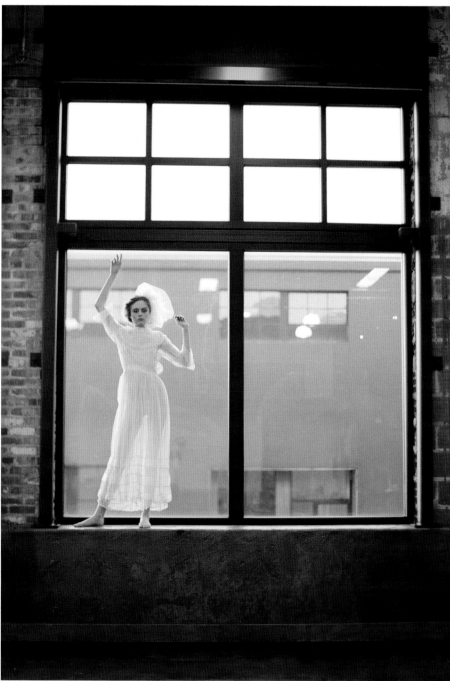

One Step at a Time

Another valuable thing to do when establishing your photography business is to set specific goals. I write my goals down, both short- and long-term aspirations. For instance, one of my short-term goals may be as simple as responding to all the e-mails in my inbox by the end of the week. My long-terms goals may be more ambitious. I actually wrote down two years ago that I wanted a book of my work published. I believe the simple act of writing things down brings them into your consciousness and makes it more possible to actualize your dreams. If your goal is to shoot for a certain magazine or be known for your stylized portraits, write that down. If a year from now you want to be published in *Martha Stewart* magazine, write that down and work backward from that point. What would your work look like six months before your goal? What would it look like two months before your goal? What do you need to do one month before your goal to get closer to it? Break it down all the way through, and do one thing every day that invests in yourself or adds to your business, whether making a list of shoots you always wanted to do, scouting locations, printing a new business card, or making a phone call to someone you'd like to connect with but haven't had the courage to call. Every day is a new opportunity to move one step closer to your goals.

Everything I've done has happened by taking one step after another. One of the first celebrity weddings I ever shot, for example, came in response to one image—an ad I'd placed in a local magazine that the bride-to-be saw; that ad prompted her to call me up. That one wedding paid for the ad—and then some. Although I rarely advertise now, it was a worthwhile investment earlier in my career. You never know who might see your work. Once you've done all the homework on your craft—experimenting with bracketing, exposure, and different lighting situations—and are confident and competent shooting in a certain way and putting your work out there, success will find you. I believe the effort and investment you put into yourself and your business will come back to you.

There are so many amazing blogs on the Internet and they are always in need of content. Getting your work published online is a wonderful way to get established as a photographer. There are a couple of important things to remember when submitting images to a blog. Blogs that feature your images will often link back to your website, so be sure your website is a good reflection on your work prior to sending images to outside websites. It is critical to know the style and audience of the blog that interests you and send images that are relevant. Each blog may have different guidelines for submission; respect and follow their instructions. It is also important to avoid sending too many images. I suggest keeping your submission to twenty of your favorite images. If a blog editor wants more, she will let you know. Finally, do not send the same work to several different blogs. Blogs are similar to magazines and do not want content that has been published elsewhere.

Defining Success

Remember to celebrate little victories. If I see my photo on the cover of a magazine at the grocery store, I will dance around in the aisle. When my children accomplish something special, we celebrate at home. My daughter (shown here) celebrated a special day with a sparkler. We were in our kitchen standing near a window-filled door, and the natural light was beautiful. Try to appreciate every moment along your photography path, wherever it may lead you.

Contax 645 with 80mm Zeiss lens, Fuji 800 NPZ film, f/2 for 1/60 sec.

What does success mean to you? The definition of *success* changes from photographer to photographer. You need to define and redefine success for yourself as your career evolves. For some people, success means making a certain amount of money per job. For others, it means landing destination jobs and traveling all over the world. And for still others, it means just taking a truly beautiful image that you are proud of. Continue to define *success* for yourself and celebrate each one, then move on to the next one, always pushing yourself along the way to do better. Just be careful not to let someone else's notion of success define or limit you.

I have had many pivotal moments in my career: the first time I booked a job for which someone actually paid me money; the first time I was published in a national magazine; the first time I was asked to write a book. Each success helped me continue to the next level. I think of my career as a journey—every twist and turn along the way is valuable and important. I've lost many more jobs than I've booked, but no one knows me for the images I did *not* create. You will inevitably suffer disappointments along your path, but let go of the setbacks and always relish your successes, no matter how small.

It's really, really crucial to love what you do, because being a successful photographer is about so much more than just taking pretty pictures. There's a tremendous amount of work—a tremendous amount of paperwork, and a tremendous amount of post- and pre-production—that has nothing to do with shooting. It can be overwhelming and daunting. So if you don't have a true, inherent love for it, you might have a hard time moving forward. Make sure you are 100 percent committed to your craft!

Getting Published and Gaining Exposure

When I first had a desire to have my photographs published, I educated myself. I had photographed several weddings and made several portraits, and thought my work was worthy of being in a magazine. I bought a stack of magazines and pored through them page by page. Then I chose the ones I thought my images were a good fit for. Whatever you do, do not change your work to fit someone else's vision; find outlets that are most in sync with the images you want to create. After finding five magazines I wanted to be published in, I selected ten of my favorite images and made five 5-by-7-inch prints of each one. I packaged them up and sent them to the five magazines, along with a handwritten note addressed to the photo editor of each publication. (Always send correspondence to a specific person, not to a magazine or company as a whole.) Most of the editors responded, and it led to my work being published in several of the magazines I'd approached.

When you're selecting images to send to a magazine for consideration, always edit your work, just as you would for a blog submission. Twenty fabulous images will have more impact than two hundred. Your body of work is only as strong as your weakest image, so choose thoughtfully. Also, be sure to follow the submission guidelines of the magazine or site you are hoping to be featured in or on (each one may have slightly different criteria).

In all your correspondence, be personable and respectful. If someone does not respond to your submission (whether magazine or blog), do not call or e-mail over and over again; let it go. Photography is a marathon, not a sprint, and if one editor doesn't respond to your work, another one will. Flash-forward to the current day, and not only have I been published in far too many magazines to name here, my work is also featured on blogs all the time. I still submit work to them, but they also come to me now because I've been able to establish myself and get my name out there over time. (With blog submissions, I simply write a couple of sentences like, "Hi, I love your site. I would be honored if you would consider using my work at some point. Please let me know if you are interested." Always e-mail something that invites the blogger to contact you.)

The most important tips I can give for submitting work to either a blog or a magazine are these: Avoid overwhelming the person to whom you are sending your work: Make sure your work is consistent and that you feel proud of every image you submit, and make sure to edit your selection before you send out that package or e-mail. Send ten images—twenty at most—and you will have more impact, with potential clients coming to you to ask for more.

Even if clients aren't coming to you initially, the power of the Internet and social networking means that

Right: If you have taken the time to work on your craft and have a body of work you are proud of, the next step is sharing your photos in a way that will resonate with viewers. The most powerful way to establish a public presence is by having a beautiful and easy-to-navigate website. When choosing a design for your site, be sure it reflects your work and your style. Try not to look too much at other photographers' sites when coming up with ideas for your own. Instead, look in less obvious places: your home, design magazines, your photographs. You don't want to replicate other photographers' ideas but rather represent your own. There is only one you.

Contax 645 with 80mm Zeiss lens, Fuji 400 NPH film, f/4 for 1/125 sec.

Above: Always remember the details, both in your images and in your business. This man, a guest at a wedding in North Carolina, picked a flower for the bride on a beautiful Southern summer's day. In business I always include handwritten notes to clients and other business peers. For me, being both personal and personable has been a cornerstone of building solid relationships with those I work with.

Contax 645 with 80mm Zeiss lens, Fuji 400 NPH film, f/2 for 1/125 sec.

you still have opportunities to market and establish yourself at minimal expense. For instance, the power of blogs is truly incredible. Over the past couple of years, I have reached a whole new audience with my self-created blog, kissthegroom.com. I wanted something in addition to my website to promote my wedding, portrait, and lifestyle images—a more interactive venue that could be updated easily and daily, and one that could accommodate comments and feedback from visitors. I show images I like that perhaps an editor passed over, quote poems and song lyrics that relate to my images. It's a very personal site, and although my goal when I started it was not business-oriented, it has enriched my business incredibly.

The Power of a BEAUTIFUL IMAGE

Life can be hard and intense, but I seek natural beauty in everything—a very powerful and moving premise of my work. Part of my approach and aesthetic stems from when I was in art school and everyone was questioning the meaning of life; part is because I want to bring more beauty into the world. In my work, beauty equals natural light, pure emotion, and an in-between moment that you can capture with a camera.

The art of self-promotion relates to how you define what's beautiful, feeling confident about your style and aesthetic, and then consistently creating photos based on those principles.

Consistency is everything. Clearly, nobody wants to put out an unsuccessful image, but the more you show work that you feel is beautiful, the more the kind of person who is going to watch you is going to want to hire you. If you do something outside your natural inclination, you might quickly steer off course. The more you are yourself and are consistent in your work, the more you will attract the kind of clients who get you and your work. People who find and hire me want film and natural light. They respond to the images I show them.

No matter how busy I am, I always have a personal project going on the side to help me stay creative and engaged in taking interesting photographs. It also allows me to explore ideas and concepts without being limited by another person's needs. This image of my son took one year and forty minutes to create. Our family was very moved during the 2008 presidential election, and I started collecting magazines that featured Barack Obama on the cover. I wanted to create something visual to capture this historic time in our country, but I also wanted to save a piece of history for my children. I made the shot on an overcast day near a wall outside our home. The flat, even light helped accentuate the similarities between Obama on the magazine cover and my son.

Contax 645 with 80mm Zeiss lens, f/4 for 1/60 sec.

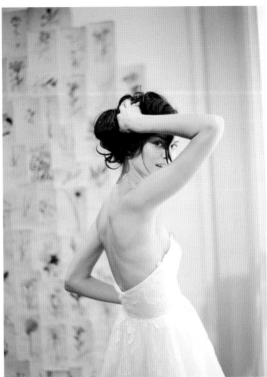

Left: On an editorial shoot for *Brides Magazine* in New York City, I got to work with the big, beautiful windows at the Lovely Bride boutique. Even when I am shooting a commercial job, I stay true to the core of my style. Although I had lights on hand in case I needed them, I executed the entire shoot with natural light. The resulting seven-page spread was featured in seventeen markets around the country.

Contax 645 with 80mm Zeiss lens, Fuji 400 NPH film, f/2 for 1/60 sec.

Above: A mere suggestion can have impact. The curve of a thigh or a hint of fishnet stocking evokes intimacy. Window light on a female form is always beautiful.

Contax 645 with 80mm Zeiss lens, Fuji 400 NPH film, f/2 for 1/60 sec.

Right: This image was taken in a park in Napa Valley. I often stand above my subjects, and I wanted to show how close I get to my subjects while shooting and how important framing is. Standing right above this sweet little girl was also a good way to get and hold her attention. Because I have a fixed focal length on my lens (80mm Zeiss lens), if I want to get closer, I move. This is an important part of how I work.

Contax 645 with 80mm Zeiss lens, Fuji 400 NPH film, f/2 for 1/125 sec.

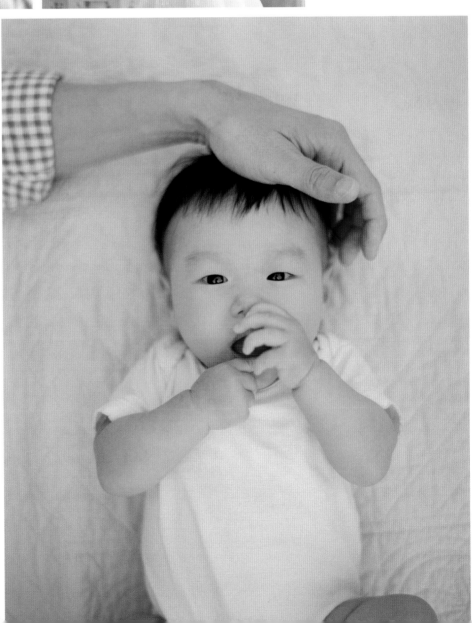

Other Ways to Promote Yourself

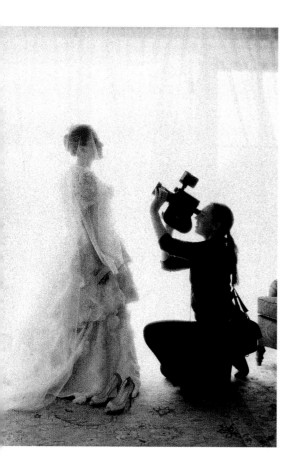

One way to promote your work is through presentation. Portfolios and albums are a crucial part of my business. In some ways, a job is not finished until I have produced a beautiful, formal album for my client. It is here that my editing decisions and aesthetic are the most apparent. When you share a wedding or a portrait shoot in an album or portfolio, you are giving your images respect and value. There are a plethora of album companies to choose from. I have several favorites that I use for a variety of reasons, such as Cypress albums for classic, elegant clients—Cypress's Silk Dupioni albums and matching boxes are exquisite—and Graphi Albums for their miniature duplicates of the big albums I create. I order dozens of these little books at a time. They fit into most pockets and are a wonderful and professional way to share images. (I often send these little books to wedding planners, photo editors, and the like.) For more artistic clients, I love to work with blissbooks.net. They create very personal albums with calligraphy and vellum overlays. These albums are true works of art, and proper presentation and albums are vital parts of any successful photography business.

While shooting a wedding with filmmaker Kristen Souders, I stepped back to give her room to get the shot she needed. We took turns going in and out, getting close and pulling back. Every photo shoot I do, no matter how big or small, is a collaboration of sorts. The more respectful you are of those you are working with, the more likely you are not only to get the images you need but to develop good working relationships that will benefit you for years to come. Although I was shooting with very fast film, I wanted to see the darkest part of the frame. Kristen's and the bride's faces were completely in shadow, so the exposure I chose allowed enough light in to see them both. I love the grainy feel of this film. The faster the film speed, the more grain you will get.

Contax 645 with 80mm Zeiss lens, Ilford 3200 film, f/4 for 1/125 sec.

Another tip is to encourage partnerships, which can be powerful in our industry, especially when you are first starting out. You can partner with people who need photos—such as a wedding cake vendor or an invitation company—and create a collaboration. You might, for example, shoot for a letterpress designer in exchange for free business card printing. Just make sure any partnership is mutually beneficial. Don't do anything you feel won't enhance your business in the long run.

I also make the effort to expedite my turnaround time with my client's images, whether it's for a wedding, an editorial job, or a portrait shoot. For a wedding, I try to get images back to the newlyweds within three weeks, while they are still relishing the joy of just getting married. I am able to provide such fast service by maintaining a wonderful relationship with my photo lab. I highly recommend nurturing your relationships with all the vendors that help keep you in business, from camera stores to website companies, photo labs, and everyone in between. Positive personal relationships are the foundation of any successful business.

One last, but crucial thing to mention here is the art of the exhibition. Presentation can be such an asset to your business. If you have an opportunity to show your work in a gallery, you are presenting yourself as an artist. If a gallery seems too daunting, consider a local coffee shop. Showcasing your photos in a place like that is a wonderful way to have your photographs seen by people in your community. If you want to be known in your town, get your photographs on the walls of local places—frame them and show them as you'd like them to be seen. Have business cards on the counter, go in once or twice a week, chat with people, and so on. Before I ever had a job, I exhibited my work on the walls of local coffee shops, at an architect's office, and at a friend's party. These were important stepping-stones for my career. Start small, start locally, and bigger opportunities will follow.

Insight

Every time you are out in the world, you are representing yourself (and your business), so carry yourself with grace and humility, no matter where you are. Anyone you are introduced to could be interested in your photography and be a potential client.

Presentation is paramount. If you want others to value and appreciate your photographs, present them with care and thought. This album was created by one of my favorite companies, Cypress Albums. I also love blissbooks.net and Graphi Albums. I use different companies, because the needs and tastes of my clients are varied.

Contax 645 with 80mm Zeiss lens, Fuji 800 NPZ film, f/4 for 1/60 sec.

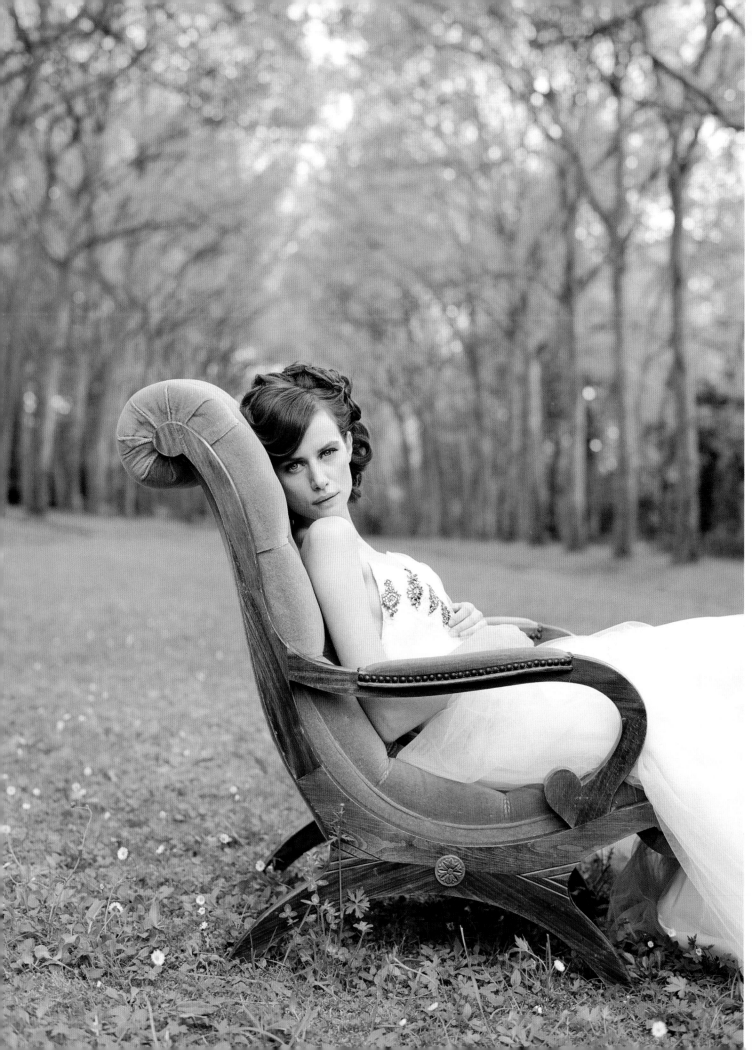

ACKNOWLEDGMENTS

I would like to thank my mother and father from the bottom of my heart—you have blessed me with so much love and affection throughout the often tumultuous turns of my life. Thank you also to my wonderful brothers, Jonathon and Giancarlo, both such compassionate young men. I am so grateful for my sister, Jennifer, for her loyalty and for talking me off the ledge countless times with her gracious sense of humor.

I would like to acknowledge and honor the village of incredible creative women (you know who you are) who enrich my life as well as my photographs. Thank you for the ongoing support and precious film that Fujifilm creates. Thank you to Image Source for handling my images with such care, and for somehow meeting my impossible deadlines. A heartfelt thank-you to all of those who have allowed me to document some part of your life. I am forever grateful. I'd also like to humbly thank the magazines and blogs who continue to publish my photographs.

I am especially thankful for Jacqueline Tobin; without her this book would not exist. You are an amazing woman. A very special thank-you to Julie Mazur at Amphoto Books, who patiently and kindly took my calls and held my hand through the evolution of this book.

My deepest gratitude goes to my children, who have taught me everything I know about love. Thank you to my husband, who shares me selflessly with photography and holds my hand every night as I fall asleep.

—Elizabeth Messina

I want to thank my three sisters and my mom for their endless support and unending ability to always calm me down in the midst of deadline woes and nagging insecurities. I also want to thank my father, Abraham, may he rest in peace, for helping me discover my passion for writing when I was just ten years old—although he was never able to see or hold my books in his hands, I know he is proud of my achievements.

My deepest gratitude to Julie Mazur at Amphoto books for sticking with me as I pitched one idea after the next, and then helping mold this one into a stunning book of awe-inspiring imagery and insight by an amazing photographer.

Thanks to Kim and Adam Bamberg for always making me feel special and knowledgeable, and for just being my pals.

A special thank-you to my niece, Lena, and nephew, Benjamin, the best friends any aunt could ask for, for being my sounding board and test audience whenever I needed an honest opinion.

And last but not least, thank you to Elizabeth Messina for your friendship and for sharing your incredible talent with me.

—Jacqueline Tobin

Here is an image shot on location in France at my 2010 event, called A Lovely Workshop. I love to set up and style shoots because they are a wonderful way to experiment and learn about light. This image of model Faye Dinsmore was created with the help of stylist Eden Rodriquez of end-design. Eden perfectly understood the look I was going for and carried this vintage chair under the alley of trees. I love the way the tone of the chair is similar to the color of Faye's hair. The overcast French light was the perfect accompaniment, beautiful and soft.

Contax 645 with 80mm Zeiss lens, Fuji 800 NPZ film, f/4 for 1/60 sec.

INDEX